VINCENT VAN GOGH
A BIOGRAPHY

By JULIUS MEIER-GRAEFE

Translated by John Holroyd-Reece

DOVER PUBLICATIONS, INC., NEW YORK

This Dover edition, first published in 1987, is an unabridged
republication of *Vincent: A Life of Vincent van Gogh,*
originally published by Michael Joseph Ltd., London, in 1936.

Manufactured in the United States of America
Dover Publications, Inc., 31 East 2nd Street, Mineola, N.Y. 11501

Library of Congress Cataloging-in-Publication Data

Meier-Graefe, Julius, 1867–1935.
 Vincent van Gogh: a biography.

 Translation of: Vincent van Gogh.
 1. Gogh, Vincent van, 1853–1890. 2. Painters—Netherlands—
Biography. I. Title.
ND653.G7M413 1987 759.9492 [B] 86-13428
ISBN 0-486-25253-1 (pbk.)

CONTENTS

TRANSLATOR'S NOTE

Julius Meier-Graefe is an author who has made a unique position for himself, not only as a critic but, by the achievement of this book, as a writer of fine prose. The forcefulness which lends character to the original text has no precise equivalent in English prose, because the author has employed what can only be termed slang, and he has relied largely upon a manner of expression which depends for its effect upon a subtle play of German words. His finest passages reveal their merit as much in what the author has left to be understood as in the actual phrases he has written; and he has created a new literary phenomenon by a vitality of rhythm which defies precise analysis. The factors here referred to combine to render adequate translation peculiarly difficult.

It is not the intention of the translator to praise the merits of the original text in such a way that his praise shall thinly veil an apology for his own shortcomings, but it is proposed to give the reader a clue, to enable him to enter as fully as possible into the spirit of the original text. Translation in the ordinary sense was clearly impossible, and the only solution I could find was to read the original until I had virtually committed the book to memory. I then took notes in English as if I were attending a lecture, and having completed my notes, closed the German book and wrote the first draft with the aid of my notes only. It had been my intention to write a very free translation, but when I re-read the original by the side of my manuscript, I was amazed to find that what I had hoped would be a free rendering was almost an exact transcription of every phrase and every word of the original. I was horrified, but all efforts at freedom of rendering proved a failure. Eventually I came to the conclusion that an English ghost of the spirit of Meier-Graefe had taken possession of me, and that, whatever the demerits of my manuscript may be, the method I was forced to adopt reflected the most essential characteristics of the original better than any other means at my disposal.

Such pleasure as the reader may derive from the book is due to qualities in the original so powerful as to break through the obstacles my translation presents and to the help I have received. My particular thanks are due and tendered warmly to Ronald H. Boothroyd whose special revision of the present edition represents, in my view, a substantial improvement upon the original draft.

<div align="right">J. HOLROYD-REECE</div>

vii

INTRODUCTION

This is a story of a man who lived from the year 1853 to the year 1890. The events of his life, his actions and his words are not imaginary but real. His name was Vincent van Gogh, and he was what you call an artist, a description that may mean anything. In this case it means a drama, a queer eventful history full of strange happenings. The action here related came to an end only a generation ago, although it seems as remote as the legend of St. George and the Dragon. The charm of our story, like that of any other, depends upon its presentation. The motives of our hero must appear, why he acted as he did, and the manner in which he expressed himself and his ideas. In the present case the story is not the work of any alien hand, but was in the main left by our hero himself. He acted the drama, wrote down most of it, and himself through the medium of a transparent symbolism pointed the moral. The text of the play, his letters to his friends, and especially those to his brother, have been published long ago both in the original and in an English translation. Their author, needless to say, never desired either to enact or to write this drama; in fact he longed only to live a quiet life, enduring not too much sorrow and enjoying some measure of happiness. He failed of his intentions as signally as he succeeded with his play.

The function of the present author has been confined to purging the play of superfluities and to filling out the gaps. The lines of the letters and what is written between them are the threads of the story, the rest has been gathered from the symbols already mentioned, which are the works of the painter. No attempt has been made to make a critical analysis of the pictures, which enter upon the scene only in so far as they concern the drama directly or indirectly. It is an open question whether the correct title has been found for our play.* Vincent is its dynamic force and his name should suffice, but since a certain duality is of the essence of the piece it might have been better to call it 'Vincent and Theo', thereby honouring the only man who attempted to approach to the heart of Vincent van Gogh. Theo was his brother, a plain man and yet a mystery. The play might also have been called 'Vincent and the Universe', or even 'Vincent and God'.

*The main title of the original edition was 'Vincent.'

The Uncertain Quest

Vincent was born on March 30th, 1853, in the rectory of Zundert in Brabant. His father was a quiet, dignified, ordinary man, from whom Vincent inherited nothing but a burning desire to enter the Church. This desire forms the background to our first act. His mother gave him his appearance, his sensibility and such powers as had to serve him through life. Her portrait suggests that she was a peasant, but she belonged, like her husband, to a cultured middle class. Vincent looked like a peasant who by an unkindly trick of fate had become a townsman, and perhaps for this reason he never appeared to best advantage. He was starved. His drama is a drama of starvation. Vincent longed for almost everything a man can long for, and it so happened that the objects of his desires did not appear to him to be altogether unattainable. In the light in which he regarded them, his desires were as legitimate and reasonable as his right to earn a daily wage. The first article of his faith was: I believe. This faith was not a toy for his leisure, but Vincent's only demand upon life. This need was far more imperious than any material demand of his physical senses. As a result he starved all his life. From the moment he became conscious of his existence the pangs of hunger never left him. The world beat him as Don Quixote was beaten, but the world's blows and his parries were more actual than the deeds of Cervantes' hero. But here is no phantasy: Vincent's illusions were almost tangible. Almost! The thread of probability was drawn so taut, the motive power was so great, that even after his downfall his starved desires remain a force as immortal and as noble as the aspirations of the Spanish grandee.

He longed for the world of men. Life without them was blank. Vincent demonstrated this theme in three or four professions, each of which is a separate act, rich in its variety of incident. He will appear in his relations to his parents, his brother, the women he loved, his teacher and his friend. These relationships, apart from the one to his brother, all alike ended in failure. Even his brother was an exception only by comparison. Art was Vincent's final profession, in which some time after his death he became famous. He never was an artist in our sense of that term, for is it not supposed to imply a form of accentuated self-

1

consciousness? Nothing was less accentuated than Vincent's self-consciousness. Artists are gifted too with certain playful, poetic, inventive qualities, and with talent, but of these powers he possessed less than the average man. But if the word artist denotes supreme self-sacrifice and the ability to give oneself up unreservedly for the world and for the service of humanity; if it is a synonym for a man of such moral tenor that he only sets a further goal to his aspiration as his consciousness gains in the deepening perception of Nature and her laws, then Vincent was an artist and the greatest of our time.

At the age of sixteen he started life as an art-dealer's assistant. This choice was not determined by any desire to be in some way associated with art, as if creative faculties had been denied him and he hoped by this means eventually to become an artist. He never even dreamed that he would want creative faculties. He did not fill his exercise books with drawings instead of Latin or algebra, and this generally accepted genesis of an artist's career was not Vincent's. The forces which led him to picture-dealing were more or less external. Three of his father's brothers were art-dealers, and he was christened after the most distinguished of his uncles, who was the manager of The Hague branch of the famous Goupil Galleries. His parents were without means, his rich uncle offered to take the boy in, and Vincent became an apprentice. If the uncle had dealt in coal, Vincent would have learnt that trade. The mere superficial contact with art sufficed to inflame his ideals. He saw in art a nobility, which he discerned in a purer and more convincing form in his father's calling, but art revealed no other quality to him. The only profession to which he felt called, and for which he longed, was the Church. He refrained from entering it only because he was shy of everything sacred; he felt that so ugly and so lowly a man as himself might not approach the Divine more nearly. His modesty, immaturity and poverty formed the obstacles. Dealing in pictures seemed to impose upon him the duty of proclaiming in his own way that austere nobility which art had revealed to him. And it so happened that his inexperience led him to think that this quality could be found in good pictures and that his uncle dealt in them. He found what he longed for in works of very dubious merit. Jules Breton and Rembrandt seemed equally admirable and his horizon never extended beyond Millet. Pretentiously designed rubbish enchanted him. He stayed at The Hague for four years and enjoyed his time. It was no mean honour to be employed by such a distinguished firm. He was, as it were, in a well-equipped yacht which slipped smoothly through the waters of the world. He was happy in his quiet home with his father and mother, and young Theo was already his confidant, with whom he had arrived at agreement upon a number of serious subjects. Theo was the more thoughtful of the two; he also wanted to become a dealer and was destined to join the Brussels branch

of the firm. He had the gift of vision and rapidly acquired the knowledge his brother could impart. Business of this kind meant contact with the noblest products of the human spirit and its conduct was a high office, of which one had to be worthy. Dealing in pictures was part of art, and belonged in no way to the common struggle for worldly goods. It was the office of the watchman who guards the bridge between the artist and the layman—a duty full of responsibility. The time might come when they could take the burden of material care from an unknown, unrecognized master, and smooth his approach to the heart of the community. They laid great plans and discussed the problems of humanity during their evening strolls. Theo was inclined to be sceptical. The world and art were at enmity. Vincent saw in art only purified and intensified humanity, therefore the interaction of these forces should produce harmony. Of course many people knew nothing of art, and lived in darkness. They must be guided. Few knew the path of virtue, and for that reason they sinned. The path must be shown.

One day they wandered together to the old mill at Rijswijk. If only ten people could be found in every country to come together with the simple intention of working for good, the world would blossom like a flower. Under the shadow of the mill these brothers pledged one another to strive all their lives only for good. It remained to be seen whether the good was attainable, but they could at any rate aspire to it with all their might. It was a promise, more, an oath.

At the age of twenty Vincent was sent by way of Paris into the London branch of the firm. He wore a top-hat like an Englishman and became the perfect assistant. In his free time he devoured books, and betrayed a particular passion for poetry. During his evenings he discussed what he read with the ladies at whose house he lodged. These evenings were perfect. There was a young girl there—an angel. She was surrounded with little children whom she educated. What a joy to watch her! What incredible bliss to love such a perfect creature! If it were not quite beyond the bounds of the credible you might turn artist, just to satisfy the profound desire to communicate such happiness. He drew his room to amplify his letters and to let his family participate in his life in London. What a divine world! Her name was Ursula.

Destiny had chosen other paths for him. One day after months of happiness it appeared that the girl had been engaged long ago. It had never occurred to him to ask her, for were not such questions superfluous? The girl he loved was bound to love him. Such things were surely not dependent upon mere chance. He was perfectly serious in his beliefs, for such was the faith to which he had pledged himself at Rijswijk.

This affair had disproportionate results. He was stung, and the sting awoke him. Was not happiness the portion and the duty of man?

Vincent, whose life had not known care, became pensive; he withdrew from the outer world and buried himself in his books. The girl was not to blame. He did not harbour a single unkindly thought towards her, on the contrary he felt grateful. She had entered his life at a crucial moment, but now he must change. He must become a better man, be sterner with himself and renounce all selfish desires. Christ was the example, the teacher. So far he had been one of a million of assistants, but his expression changed and the change had a bad effect upon his customers. Not that he became slack; his ardour was trebled. He argued with collectors instead of selling them engravings. He tried to rouse their sensibility, and met lack of understanding with angry opposition. His appearance was against him. His angular head was covered with red hair. Small eyes glittered below his enormous square forehead. His cheekbones protruded more and more. His contracted lips seemed a trap which held his speech silent, and when he spoke he spat out a string of disorderly words. His kindly chief, Obach, tried to talk to him. Vincent failed to understand, and allowed himself to argue the point. A day came when he began to talk not of art but of the Bible. In 1875 it was settled that he should join the branch in Paris. But even if Goupil had had a hundred branches, it would not have improved the situation. The sting had gone deep. In Paris the rift between his inner and his assumed life became an abyss. He learnt the art of picture-dealing thoroughly, and he stiffened with contempt. Men who dealt in divinity as though it were dirt disgusted him. His silent days were spent in the fashionable shop: at night he intoxicated himself with hymns in his dingy rooms in Montmartre. Where, where was God? Nowhere in that desert of a city. But there were at least works of art by pure-souled men, Millet, Corot, Delacroix. There were rooms in the Louvre which were very temples of sanctity. Happily there were also photographs which he nailed up in his lodgings to cleanse his vision from the dirt of the day. Happily there were Renan, Michelet, Zola, to purge his ears from the evil sounds of the day; happily there was his pipe.

At last Goupil's managers gave him notice, and Vincent breathed again. His presence had only been suffered for the sake of the Dutch partner. In the spring of the year 1876 he accepted a post in England as a teacher of languages, and shortly afterwards became a kind of assistant preacher in a Methodist school in Isleworth. He ought of course to study and pass examinations if he hoped for advancement in his new position. But are there any fixed rules to guide a prophet in his mission? Inspiration came from within, and there Vincent felt it. The fervour of his message seemed to burn his lips, yet could not pass them. Others mistook his silence for pride, and his harsh manner confirmed their impression. His head and his heart throbbed but speech was denied him. Perhaps he could write, if only he could write to everyone! Perhaps he

ought to turn author? His correspondence with his family took the place of conversation. He wrote home letters that glowed with kindliness, yet face to face with his own flesh and blood, Vincent was quarrelsome, hypersensitive and rude. His withdrawal into himself already exacted its toll of misery. This strong-limbed creature whose pulses beat so mightily was a slave to printed paper. His intercourse with the world was confined to books, letters, reproductions and he calmed his longings with religious aspiration. His thoughts were his food. What was to happen? Vincent's parents were worried about their son, who at the age of twenty was already a misfit. The intuition of a mother divined what ailed him. She wrote that he 'ought to live either with Nature or for art', and so named the two great healing forces which the instincts of her son demanded, while he tortured his spirit with monastic yearnings. He did indeed love Nature, and art was the throne of his Maker, but few were chosen. He was too evil; religion alone could help him. Religion was not a narrow moral law, but rather the faith of a hero-worshipper. Christ, the hero from the stable, was his ideal. Christ's love was great enough to embrace mankind in one community. Vincent felt within himself a love capable of all sacrifice, but he despaired because the use of his talent was denied him by his constitutional roughness and his uncouth appearance. When he tried to approach his fellows they fled before some hidden force within him. His love for them scorched him, and yet when he drew near them he was met with cold antagonism. He read the Bible to overcome his sin. Christ was the Teacher from whom he could learn how to love aright. Artists somehow possessed the great secret, and he read about them to discover it. He knew every word Millet had spoken. He loved Breton because he painted and wrote. The sensuous element in art would have seemed to him a deadly sin. Art was justified only because it was an equivalent to, and derived from, the love men bore their God. In the meantime his vision had gained by experience, and his critical faculty was developing. He remained faithful to Breton and other doubtful worthies, but his new loves were among the mighty. The only idea which never occurred to him was that he might himself paint some day. Occasionally he sketched a little, but only to illustrate something for his family. He drew like a child and yet his painstaking efforts reveal at once the basis on which his subsequent style was built. He may sometimes, in his dreams, have seen his efforts at drawing put to other uses, but when he woke he denounced himself for self-deception and arrogance. All he could hope for was to be a simple labourer in Christ. The ideal would be to become like his father, a balanced personality, beloved by everyone. There was something holy in the modest beauty of this country pastor. His father was not a very important divine, otherwise he would not have remained in the smallest village rectory, but he was pure. The words of the Bible flowed from

Vincent's lips like music; he added but few words of his own, but then it was not necessary to add anything to the sayings of Christ. Man could only hope to be his Saviour's mouthpiece, and confirm the power of Holy Writ by the purity of his actions.

At that time every line of the Bible inspired him, and he suspected some unselfish conviction behind everything that was said by the pastors he met in the rectory. Every word his father breathed sanctified the air. There must be something unclean in Vincent, otherwise his fellows would love him too. He was seized by a desire for self-immolation. He must seek out his God. Men who knew of Him and did not attempt to draw nearer to Him were surely the worst of criminals.

His father could not approve of Vincent's leanings. In fact, it might have given him pleasure to have such a God-fearing man for his son, only every act of Vincent's was so violent, so exaggerated. Of course one must render to God all that one has and do one's duty, but the bounds of possibility are to be taken into account, one's fellow-men, and attendant circumstances. Every day made it more difficult to discuss religion with his son, who ignored all obstacles in his desire to approach God directly—as if God were waiting there for him. He spoke of Christ as if He shared his bedroom. He talked as if other people, including even the clergy, lived in the outer darkness of a misguided faith. His father was also alarmed by the unexpected evidence brought forward by his son for the love of God. Vincent quoted the phrases of barely reputable poets with as much fervour as if he were citing the Sermon on the Mount. This confusion of sanctity and profanity was a pose. It was merely capricious to demand that all the practical details of everyday life should be guided by the Ten Commandments. Everything was exaggerated. Love of God must not be a furnace, but a hearth heaped with glowing coals. Nevertheless he could not feel justified in opposing Vincent's desire to enter the Church, as he appeared unfit for any other career, and so in 1877 he gave his consent. At last Vincent's feet were set upon the narrow path which would lead him to the figure of Christ crucified.

This transition implied no change of occupation for Vincent, but merely a further revelation of his inner calling. At any rate he saw it in that light. He undertook his duties with a holy glee, and though he could not hope to be either as pure or as upright as his father, he might perhaps move his congregation more deeply and work harder outside his church among the parishioners. These considerations, of course, belonged to the distant future, for you must study before taking Holy Orders. Many things go to the making of a pastor which really have mighty little to do with religion. He would enjoy the study of the Bible, he could never have too much of that. But before you came to the Bible you must learn old languages. He spent a year in Amsterdam preparing himself with a kindly teacher. He showed determination, industry and

self-denial, and did not allow himself the slightest worldly distraction, even the most innocent. He spent the few pence he managed to save, as before, on prints and photographs after the great masters, and he bought the works of Zola, which to him involved no deviation from the straight and narrow path. The art of Zola was as pious as a hymn-book, although his father could not see it, but it made studying much harder. God kept on pulling him away from his Greek grammar to his fellow-men. While he ground at his books the passion of Christ shone down at him from a reproduction of a Rembrandt. Could these complex syntactical regulations aid him in the attainment of salvation? His father did not need foreign languages to comfort his peasants. All these rules were made by people whose heads were stuffed with formulæ instead of human needs. They were invented to create a barrier between man and his Maker, between human beings and humanity. These weary years of preparation could only serve to chill the fervour that bound you to your calling. There were times when Vincent raged against this theological apparatus. He examined the machine more closely. Many a religious ceremony had come to be only the clacking of a prayer-wheel. Even in this holy calling there were men who traded in divinity. It would be wiser to repress such thoughts, but it would also be dishonest not to express your convictions. There were incidents which might damp your ardour for your vocation, but perhaps they were part of your novitiate. His ardour remained, and surely his purification was at hand. His piety lost its previous exaggeration. He did not evade any opportunity of speaking to God, but he plumbed profounder depths. The cue to such opportunity was afforded less and less frequently by religious ecstasy, and more and more often by the divine realm of the creation, by the perfection of nature, and by the works of blessed mortals. His letters of this period did not betray the theologian, but were pictures clothed in words. He conveyed the colour and the tone of the landscape to his brother by reference to paintings. Churches and cottages like Bosboem's, trees like those in certain prints of Dürer, the colour of an undulating plain like that in one of the pictures of the elder Breughel, Christ like the Christ of Rembrandt. His correspondence was a fluid mixture of art and nature, of experience and reminiscence, of simplicity and intelligence. Some power stirred in Vincent's being which he failed to identify, but it urged him on with a will.

Theo, who had always suspected the artist in Vincent, advised him to make drawings of the landscapes he admired. Vincent replied that he thought he would occasionally do so, and he enclosed a drawing of a very pleasing scene. 'But as it might keep me from my real work, it is better perhaps not to begin this sort of thing. When I got home I started a sermon on the unfruitful fig-tree. Luke xiii. 6-9.'

If only he might follow his own way in his studies! Study was all very

well to exercise your mind, and Theology was especially good for people
who wanted to learn about religion, not work in it and for it. He would
never be a scholarly divine. Moreover he did not possess the means for
so many years of University life, and even if he did he could not be
penned behind walls for so long. Very well then, he would not become a
pastor, but a helper, a lay-preacher. Lowly as he was, he could only speak
to the lowly, for instance, to the miners. These people underground who
live in darkness must need light more than others. In a small geography
book he had read of the suffering inhabitants of the Borinage, in
Belgium. They must be curious people and it was to them that he would
carry the Gospel. His father was obliged to give his consent. Even if a
lay-preacher would scarcely add to the laurels of the family, his son
Vincent might perhaps work out his own salvation in this way. God be
with him!

Even missionaries to the Borinage had to submit to rules and
regulations. Vincent had to spend a few months in the School for
Missionaries in Brussels. Once more he had to be imprisoned behind
walls, but this time it would be endurable. He worked hard. There was
really only one fault to find with him: he had to read his sermons and
could not deliver them extempore. How it humiliated him! In other
respects he was the best pupil at the school, but there was something in
his manner, in his slovenly dress, which the respectable headmaster
could not quite approve. Moreover his powers of physical resistance did
not appear to be unlimited. He suffered already from nervous crises. He
was allowed to go to the Borinage provisionally in the winter of 1878. At
last! Van Gogh entered this dark region as if he were entering the Holy
Land. The simple people, he had always known it, delighted him and he
them. His curse seemed to be dispelled. He held Bible classes, preached,
taught, visited the sick, and helped and comforted them. He stayed there
for nearly two years. He did not find his surroundings sombre. The dusk
contained rich tones with which he became as familiar as if he had never
lived anywhere else. These people developed finer expressions beneath
the coal dust than the people in the towns. Strong lines, graved by
danger and necessity, marked their faces. They were rough and crude,
but never false. For the first time in his life Vincent came into contact
with men who did not judge him by the carelessness of his dress, men
and women with whom you could be natural and without fear, people
who were poor like himself. The nature and the manner of all
intercourse was determined, not by conventions, but by necessity. He
took his duties as seriously as the men their work. Variety was unheard
of in this black hole, and he would have preferred to deny himself even
what brought comfort to his mind more readily than to theirs, in order
to be at one with his community.

Everything would have gone smoothly but for the authorities in

Brussels. They disapproved of the newcomer because he did not abide by their routine, because he made himself too cheap with the people, and because he shared their miserable existence. After all Vincent had been sent there only on probation, and on condition that he adhered to his routine like a proper lay-preacher. He would have done so if only the surrounding misery had not been so profound. There were some wretches in the village even poorer than he was. They suffered, starved, were without bed or clothes. Vincent forgot the authorities, forgot his promises to them, and remembered only the teachings of Christ. He gave away his money, his clothes and at last even his bed. What a scandal! Perhaps he betrayed too much sympathy with the people after the catastrophe caused by lightning in the summer of 1879, and perhaps even he did not turn his back on the miners when, shortly afterwards, they called a strike. He was given notice, and was allowed to preach no longer.

That was the end of this Church business. It was a bitter disappointment to our disciple, but a blessing for our hero. Not that the disciple in him ceased to exist. On the contrary, he merely entered upon a much profounder phase: he dispensed with all clap-trap, and also with a number of conventions, without which, intercourse with people outside was made more difficult. He had finished with the Church and with his father's calling. The much-vaunted balance of personality was the result merely of lack of sympathy. The teachings of Jesus and the love of the poor and oppressed were right enough, but Christianity as understood by properly dressed folk was a swindle. He remained in the Borinage. Why? Because he loved these men, these miners in whose cottages he lived, and for whom life smiled so rarely. He ceased to talk to them of the Bible, because he had become suspicious of all talk. He was workless and defenceless against starvation. He was quite used to living on bread, but he had to forgo even that for days together. This is what happens if you do not conform to the recognized code. His family despaired of saving him. Even Theo, who had been his one anchor, lost faith. Bitter letters were exchanged. Theo had been promoted to the head office in the meantime, and was making good progress. It was tempting to draw comparisons. Theo was by no means conceited, but it was a fact that he was at the head office of the best firm of its kind in the world, while his elder brother who had started before him, who was more gifted, and whose ambition had aimed so much higher, now sat in this black hole and could not and would not get out of it. It was a disgrace. The younger brother reproached the elder severely. There was no point in Vincent's existence, for reading books was after all not an occupation, and his philosophy of life did not earn him a living. All this talk of religion was merely an excuse to conceal the fact that he didn't want to work or to take his part in life. He took a positive pleasure in despair, and was

merely a peculiar idler, and kind of shareholder in misery. No sooner had he stretched forth his hand than he took it from the plough. This was the third time! From the moment when he left the Goupil Gallery he had sunk lower and lower. His parents had offered to take him back to Holland, where he could be near them again. He did not even answer their letters. What was he up to in that evil place?

Vincent stayed in his black hole. There were two ways of looking at most problems. There was, for instance, a perfectly tenable point of view from which Theo's activity at the Goupil Gallery appeared irrelevant although it merited, no doubt, the praise of every respectable citizen. It might be advisable too, before pronouncing judgement on men and circumstances which you were incapable of understanding, to remove the beam from your own eye.

Theo took no notice, but Vincent's intercourse with his family came to a standstill. His parents were not embittered so much by his incapacity as by his manifest lack of any desire to improve his situation. And to think of all the sacrifices that had been made for him! Even as a child he had been the constant subject of special consideration. Into the bargain Vincent's arrogance made him almost unbearable. You wanted to help him, if only for the sake of the family whose history had been irreproachable for generations without number, but he did not even want to be helped. He suggested cynically that the family could only supply him with bread, if you lacked that there was nothing you could do for him. Your advice was regarded as charlatanism, like the rest of your existence. He admitted his own faults, disliked them, but he maintained that at any rate he was conscious of them, and then suggested that you should make the acquaintance of your own. He did not put it quite so crudely, but you could easily interpret his meaning.

In the spring of 1880 he suddenly arrived at Etten. Good morning! How do you do? Just as if nothing had happened! His father felt inclined to forgive him and spoke of the return of the prodigal son, but the prodigal remained mute. His father adjured him in the name of the Gospel, but Vincent just walked out of the door, back to the miners of the Borinage and was not heard of again for months. How was he living? His struggle could hardly be an easy one. Possibly he was starving to death in his black hole. Theo could endure it no longer, for he had no one in Paris to talk to about the ideas that had bound him to his brother. For these ideas had kept their strength, they were only pushed out of sight. Of course the world was not as you used to see it. You had learnt more and knew something of the realities of life. But although your knowledge had increased, you were no happier than when you were by the mill of Rijswijk. In July he wrote to his brother as he used to write to him. 'Vincent, what is the matter?' He also enclosed some money. Vincent looked at it. The proper thing would be no doubt to return it, on

the other hand it would be very pleasant to have a square meal once more. Moreover he would like to make Theo understand a thing or two, in so far as he was still capable of it. He would soon discover, and so he replied to his brother.

He remained in his hole, and a hole he supposed it was. Perhaps he must always stay in it, perhaps not. He was like a sick animal suffering from distemper. Perhaps it was incurable and he would die of it, or perhaps he would recover with renewed vigour. In any case, the best thing to do was to go through such a process alone. His distemper was no doubt a very curious and weary illness, but at least he could say: 'I am a passionate creature, destined to do a number of more or less stupid things which later on I will have more or less to regret . . . but the thing is to derive advantage from my passion by all the means at my disposal. For instance, it is a necessity to me to be always learning something, and I am possessed by an insatiable desire for books. In other surroundings where there were pictures and works of art it was they which moved me in a similar way. I don't regret it, though I often feel homesick in this strange country for the land of pictures. You may remember that I used to know very well—and perhaps do still—what Rembrandt is, or Millet, or Jules Dupré, or Delacroix, or Millais, or Matthijs Maris. Now I possess these surroundings no longer, but I possess something else, called soul. I am told that the soul never dies, is always searching and searching. . . . Instead of succumbing to my homesickness, I have told myself that my home is everywhere, and instead of giving myself up to passive melancholy, I have chosen active despair, in so far as I have any opportunity for action. I have found a despair that hopes and strives. I have more or less seriously studied the books at my disposal, the Bible, Michelet's French Revolution, and last winter I read Shakespeare, a little Victor Hugo, Dickens and Harriet Beecher-Stowe, and then lately Æschylus, and other less classical people. . . . Medicine is another indispensable study. There is hardly a man who does not try to know something about it, or who does not at least want to know what it is about, and you see I know simply nothing. And all that occupies me and gives me something to think about. For perhaps five years, I don't know exactly, I have been straying about without an occupation, and you say, "For so long a time you have been sinking into the mire and have done nothing." But is that really true? True enough that sometimes I have earned my daily bread, and sometimes a friend gave it to me out of charity. I have lived as well and as badly as I could, and I suppose I have lost the confidence of a good many people. My finances are pathetic, and the future is not very rosy. Perhaps I could have done better. I have lost time in order to earn my living. I confess that my studies are wretched and desperate, and I lack incomparably more than I possess. But does this mean sinking and idling? I am simply out of a job because my ideas

differ from those of the gentlemen who have got jobs to give away, and because I mean to stick to my ideas with every ounce of strength that is in me. . . . You may ask why I didn't stay at the University. I can only answer that I prefer to die a natural death than to prepare myself for it at a University, and I once learned a lesson, which seemed to me more valuable than a Greek unseen, from a man who was mowing grass. As to improving my position—have I ever asked for it? If you are suffering from tuberculosis or typhus, are you wrong if you maintain that you want something more potent than barley-water, or even that it is essential to you? I must go on as I have begun. If I don't, if I cease to search, to think, then I will be lost indeed. That's how I see it all. The main thing is just to go on. But you will ask what my real aim is? Well, my aim will assume a more definite shape just as a drawing becomes a sketch, and a sketch a picture. . . . You say that we used to agree about many problems, and the other day you reminded me of our walk to the old mill at Rijswijk, and you suppose me to have changed since then. I don't quite agree. All that has changed is this: my life used to be less difficult, and the future was not so dark, but my real, my inner self has not changed. If anything has changed at all, it is that I now think, love and believe much more profoundly than I used to. . . .'

Theo and his parents regarded Vincent's passion for books as the root of all his trouble. They thought he had deserted art because he ceased to be an art-dealer. Theo had made excellent progress in this direction, and therefore held pictures all important. Vincent, however, loved his pictures no less than before, but there were other things to be loved and they all belonged to each other. The attempt to discover this unity appeared to him to be the real problem, almost the real religion. 'There is something of Rembrandt in Shakespeare, of Correggio in Michelet, and of Delacroix in Victor Hugo. And there is also something of Rembrandt in the Gospel, or something of the Gospel in Rembrandt. . . . One must learn to read just as one must learn to see and to hear.' Everything depended on it. It may seem curious to have chosen such a hole to learn in, but perhaps learning was as easy there as anywhere else. Perhaps he had a tendency to become rather 'abstracted', as Theo said, possibly also he deserved the reproach of being rather lazy about his dress, and the other details which were important in the outside world. Nevertheless it was quite possible that he did what was essential in his dark hole, while others who thought he did nothing only made mischief for all their importance. Perhaps he had chosen this spot because he discerned there through the mirk creatures whom he might approach. If he learned nothing else there, he could learn that he was incapable of helping his fellows, even those in that hole. 'Many a man has a bonfire in his heart and nobody comes to warm himself at it. The passers-by notice only a little smoke from the chimney, and go their way. . . . I am

drawn more and more to the conclusion that to love much is the best means of approaching God. Love a friend, any one, or any thing you like, and I tell you, you will be on the right road to learn more. You must love with a high and intense determination, with your will and your intellect, and seek always to deepen, expand and improve your knowledge, for that way lies God. If a man loves Rembrandt profoundly, then in his heart of hearts he knows God. Another man may study the history of the French Revolution, and he will not be a sceptic, for he will feel the power that shapes our ends. If you have attended the free lectures of the College of Misery, for a short time even, and have paid attention to what you have seen with your own eyes and heard with your own ears, you will reap a firm faith and learn more than you can express in words. He that hath eyes to see, let him see. Afterwards you can be a little abstracted at times, and dream awhile. I know that some become too abstracted, too dreamy, and it may quite well happen to me one of these days. They say the dreamer falls sometimes into the well, but afterwards he climbs up again. . . .

'There are wastrels and wastrels. There are wastrels who filch the golden hours because they are idle, cowardly and vicious. If you think right you may number me among these. But there are others, idle in spite of themselves, consumed by a passionate desire for action, who do nothing because they cannot do anything, because they have no tools to work with, and because they are hemmed in by circumstances. People like this do not even know what they could do, they only feel instinctively: I am good for something, I have a right to live, I know I could be different from my present self. What purpose could I serve, how be of use? There is something serviceable in me. What is it? These idlers are quite different, and if you think it right you may number me among these. A bird in a cage in spring-time knows well that there is some function he could perform, something he could do, yet he cannot do it. What can it be? He cannot remember exactly. He says to himself that the other birds are building their nests and feeding their young. He bears out his brain against the wires of his cage, but the cage remains and the bird goes mad with anguish. Look at the wastrel, say all the birds that flutter past, look at him! The prisoner is kept alive. There is no external evidence of what goes on within him. He is well and more or less merry when the sun shines. Times change, and he gets fits of despair. The children who clean out his cage think that he has everything he needs, but the bird looks at the storm-laden sky and revolts against his fate. I am cooped up in a cage and lack nothing, you idiots! . .

Such were Vincent's thoughts, but perhaps there was another kind of idler in him whom he himself did not know. Was he not face to face with the everyday work of the world, while he stood there waiting for it? Of course he had been younger once, had been in other surroundings where

he had strayed and wandered like an aimless tramp, simply because he could not find the right work, and because he lacked warmth. A single ray of sunshine would have sufficed. He wrote: 'Do you know what takes away the cage? Every profound relationship, brotherhood, friendship, love. They open the cage like a magic key. If you lose the key, existence becomes a living death. He who creates sympathy, creates Life! . . .

The drama proceeds, and at last we hear the throb of a regular rhythm beating through the vast, slow-moving mass of incidents. The action is no longer a series of isolated events, but is a summons sounded at the gate of humanity. Every one of us who reads this letter is either in the shoes of the writer or the recipient, be he an artist or anyone else. The *pièce de peintre* suddenly assumes the importance of a universal event. Art proves to be the highest incarnation of love—love of the world, love of mankind, love without any ulterior motive. Love, and you shall change your canvas into a flowering garden; love, and you shall call stones to Life; love, and your words shall resound to the end of Time.

Even at this period Vincent failed to fathom the ultimate possibilities of his consciousness. He saw nothing but his primary social functions, which served only to burst the walls which imprisoned his creative spirit. Neither talent, nor delight in beauty, nor ambition, but his need for love fanned to white heat, drove him into the world of creative art. And now we are faced by an artist innocent of art, untouched by all the negative or positive forces of individuality, an artist in all his nakedness. No man had hitherto beheld such a spectacle. Hunted and pursued, with all its blemishes upon it, his undying soul made this claim: 'No matter what the creature in whom I have my being does, I and I alone am its master, my kingdom is not of this world, my kingdom is the kingdom of love. Does it exist? I will seek it.'

Van Gogh's pictures do not constitute his distinction, the creations of other painters have been greater and more profound, but it lies in the manifest mystery of his vision, perceived by Vincent as through translucent crystal. As often as this mystery assumed plastic form, new joy exceeding all the pleasures of æsthetic appreciation was added to the world, and the desires of collectors seemed by comparison as mean as a bout of drunkenness. Art can only be achieved by an evolution such as Vincent's struggle from the depths of the Borinage. Art that dare claim to rival the past—Vincent never dared—can be produced in this century only through suffering, constant watching, relentless effort, perennial doubt and despair that yet preserves its essential force. An artist of to-day can make good his endeavour to find in chaos rhythmic order and stand his trial before God, as of old before his Guild, only if he pass through this ordeal. Then will his moral force gain an essential power which the children of happier centuries did not need.

Theo was by no means bourgeois; he had all the instincts of the

hermit. After Vincent's last letter, Theo's doubts of his brother had vanished. A few months later our straying tramp found the only road that was left open to him. Art had been the primary cause of his starvation, and art alone could satisfy it. He was no longer allowed to preach, and as all possibility of a higher communion with his fellows was precluded for Vincent except through sermons, he drew near to his neighbour by the self-expression of a draughtsman. He stored up with pen and pencil every form and outline which seemed to express his miners and his miners' lives. From this moment a feverish activity seized him, never again to depart from him. He was twenty-seven and there still lay ten years in front of him. Two-thirds of this period Vincent devoted to a minutely detailed and Spartan training. The tests of patience imposed by the old Guilds were child's play in comparison. A large portion of the last third of his remaining span was filched from him by sickness, but the years that were left sufficed to create the work of a very fruitful life.

Vincent laid down ten commandments for himself as a guide through his own School of Art: Only do what you like, do it thoroughly, fanatically; examine yourself closely, for you are riding a race horse, spare neither whip nor spur to get all you can out of your horse; choose your medium cautiously; choose your first milestone cautiously, then your second one, then your third always with care, then choose as recklessly as you can, and if you reach it you will never have passed the first.

He began humbly, with a very modest drawing. He copied all the painters whom he loved. First of all Millet, of course, and his 'Travaux des Champs', and especially the 'Sower'. This Sower became in Vincent's work what self-portraits are in the creations of other artists. Then after Millet he tackled all the other artists who painted scenes of toil. Theo had to send him every reproduction he could lay hands on. Perhaps—it was not altogether impossible—he could earn his living as a draughtsman, as an illustrator for the papers, like the people who drew for *Punch*. Vincent never dreamed of painting, which was of course for others. But even for drawing, experienced artists were necessary as teachers. How delightful it must be to be together with artists! A world of painters seemed like a fairyland to an inhabitant of the Borinage. One day he started out on foot for Courrières to make the acquaintance of Jules Breton. He tramped all day and slept under the open sky by night. The peasants gave him bread in exchange for drawings. The French air seemed curiously clear and pure compared with the sky that stretched over the Borinage. . . . When he got to Courrières, he found the imposing studio of Breton so unlike his mental picture of it that he dared not ring the bell. So he turned on his heel and went back to the bleakness whence he came.

Storm and Stress

Vincent longed for intercourse with people in similar circumstances to himself—he believed there were such—and this longing drove him to Brussels in the autumn of 1880. Theo financed the adventure at first with the aid of his parents, but from then on he supported his brother entirely with what he saved out of his salary. Theo made these sacrifices not only for the sake of his brother, but for the sake of an ideal, which was perhaps not very definite, but his spiritual happiness was in some way bound up in it. Vincent served his ideal and Theo wished to do the same. And thus the union between the two brothers was re-established. Vincent looked about in Brussels and found the town preferable to the Borinage in more than one respect. He found there were all kinds of opportunities to learn drawing. There was the Academy, where there were studios and models, and everything else a man needed and could not get, especially if he were a pauper. The Academy was one of the best and most famous in Europe, but this very distinction made it rather alarming to a beginner. Perhaps there might lurk, behind all this outward perfection, the same strange powers who had forbidden him to teach or to preach, authorities like those moving the educational and the missionary worlds, who had tricked him out of study and religion. An insignificant draughtsman, somewhere in a garret, taught him the laws of perspective. The rest he did for himself. He copied the printed 'Cours de Dessin' by Bargue, which had been sent to him in the Borinage, and which accompanied him from that time onwards throughout life. He plunged into the science of anatomy, and devoured the laws of light and shade. He learned it all from the books he borrowed from his friend in the garret. He drew the types which passed in the wintry streets and idle workmen, whom he induced to sit to him for a few sous; he drew the landscape outside the gates of Brussels, and he copied Millet again and again. Occasionally Vincent sent a few drawings to his father just to show that he was no longer in the Borinage. Theo was in the seventh heaven, for he felt already that Vincent would succeed somehow and that he would never join the ranks of mediocrity. Vincent, however, did not indulge in illusions; he could not despise mediocre artists, provided they were sincere, for he hoped for little

more than to attain to their measure of accomplishment.

His modesty was well founded. His talent seemed extraordinarily small. Scores of mediocrities started with greater gifts. He drew like a boy of twelve, not a line was straight, and in his drawings one can almost see his awkward fingers tracing the lines across the paper. Little did he guess that his gawky scrawls already contained the seeds of a painter's style, and he strove in vain to uproot them. He longed more than anything to depict a real workman, his expression, his clothes; everything must be absolutely accurate, and so he would go and buy an outfit. That was not easy, because such clothes cost money, and in order to save it he lived on potatoes, bread and chestnuts. If only he had done a few thousand drawings he would be a little further on his way. He had all the necessary patience, but patience alone was not enough. If he was to become an artist, something outside himself must enter into his work. What it was he could not imagine. Anyhow, it had nothing to do with anatomy, but it was of the utmost importance in life generally. Perhaps there was more in men than art could satisfy. Perhaps a little happiness might provide the clue.

After a hard winter he left Brussels in the spring of 1881, and went to his parents in Etten. There he met a cousin of his from Amsterdam, a widow with a small child. She was a little older than Vincent and was the daughter of a pastor. And before long he realized what he had lacked in Brussels. 'Il faut qu'une femme souffle sur toi pour que tu sois homme.' It need not even have been a woman. Vincent's sensuousness had of necessity become a matter of the intellect. A man with powerful sympathies, who could overlook what was superficial in him, would have supplied his desire for harmonious companionship. So far he had never found that companionship. Theo was only beginning to understand him. Their correspondence with each other gave both brothers many of the joys of friendship, but it really evaded all the difficulties of Vincent's personality, because Van Gogh, the letter-writer, naturally concealed all the crudities of Van Gogh the man. Letters also lacked the immediate warmth of personal contact for which Vincent longed. His relationship with his parents remained unsatisfactory. How could they regard him otherwise than as the failure, the dark blot upon the family? His art, this slender effort, was a mere caprice. How long would his new pastime last? Vincent regarded his parents as relations from a different quarter of the globe. He did not share one of their well-worn theories, and his father's calling which, not long ago, had been holy to him, was now little better than a tissue of lies. He did not cease to regard the rectory as his home, and was grateful for all that had been done for him there, but it was ever more important to make a home for himself. He was nearly thirty, and that was just the right age to marry. He could conceive no reason against it. His cousin had arrived in the nick of time.

This lady clung to the memory of her late husband, and sent Vincent about his business in a way that really precluded all possibility of hope. Nothing could be further from his mind than discouragement. The lady lived, therefore he would win her some day. It was just like art, he was not accustomed to attain his goal at the first attempt. To succeed meant sacrifice, hard work and patience. One day she would, she must see what she could be to him and he to her. She and her child—a charming child—were alone because her parents, Amsterdam clergy, were just like his own. He was alone. What could be simpler than to join their lot? He must be patient. His hopes had been shattered once before in London, owing to a misunderstanding that could only happen to a stray Dutchman in England. Perhaps it was his fault, because instead of fighting with all his might, he had given up the pursuit too easily. He had been too proud. But now he knew what love was, he knew what was at stake. Did she know it? She clung to the past. Was that right? Can love, the most vital force, cling to the dead? Was it not unhealthy, and ought he not to cure her?

She had absolutely no inclination towards him, and his father cast doubts on his means of existence. Surely he could not mean that seriously! Did he not exist? His existence was peculiarly in evidence, more so at present than ever before. His father would just have to put up with his ability to exist until the contrary had been proved. And as to his cousin's assertions, they were nullified by his assertions to the contrary, because she simply did not know what she was talking about. She probably dreamed of heaven knows what grandeur, ecstasy and the like, not knowing that these things mattered nothing beside that sense of the future which went hand in hand with true love. Patience! He would be patient.

Hope increased his confidence in his work. He drew twice as fast and his efforts became more alluring. He sketched everything, the plain near Etten, the cottages in the village, the smithy, the carpenter's shop, the clog-makers. He drew with simple lines, used a carpenter's pencil, which had the merit of being related to what he tried to depict, and his sketches did not altogether lack a certain rhythm. The economy of means employed created this simple rhythm. Vincent despatched his drawings to his brother in Paris. Perhaps Theo could sell one or two of them for a few francs, with which he could buy a ticket to Amsterdam, for his contrary cousin had gone back there. Theo warned him against exaggerated hopes. Material considerations could not be entirely dismissed, and in certain circumstances more might be achieved by reticence and patience. Vincent was in love and he despised such bourgeois advice. How could passive resistance demonstrate his will-power to the fair widow? Diplomacy availed nothing in either art or love. Emotion was everything, and he wanted to love without

diplomacy, he wanted to love for love's sake, because he loved reality. Nothing was so real as strong affection. Every phase of Nature was proof of it. Nature's law was: Who loves, lives; who loves, works; who works, has bread. Besides, all good poets and philosophers recommended love.

Vincent's parents were in despair about the aggressive attitude of their son, whose behaviour threatened to endanger their intercourse with their relations in Amsterdam. Vincent laughed and as soon as he had enough money went to Amsterdam. He was forbidden to see his cousin by her father, so he launched an attack against him. His worthy uncle lost the serene expression of a pastor. He told Vincent that his daughter would not dream of having anything to do with him. Vincent absolutely disgusted her—yes, disgusted her.

Vincent stretched out his hand and held it in the flame of a burning light. 'Let me see her only for as long as I hold my hand in this flame,' he begged. The uncle blew out the lamp and showed Vincent the door. . . . This was the second crisis of the same kind, but much more brutal than the first. He suffered terribly, but it happened too late to break him. The artist in him had already been roused, and he caught up his anguish with creative hands. He used his pain to strengthen his personality. The consequences were far-reaching, for this was the last commonplace experience the pastor's son was to undergo. He had done with the dead God of pastors and with the well-dressed maxims of his bourgeois parents. He had nothing more in common with his father, who refused to read Michelet and regarded Zola as a Godless wretch.

It was suggested that Vincent should leave his father's house. People like his father were respectable lunatics, with good intentions and only partial powers of perception. They did not know the Spirit in whose name they acted. They were blinded by mere words and phrases, and they were bourgeois. One could live decently in a very different way, 'in a gentler spirit.' Corot and Millet lived like that. They possessed the 'rayon blanc'. Everything else was relatively sombre, even the best sermon. Vincent's personality developed. He was accused of atheism because he ceased to go to church and because he had loved a pastor's daughter too violently. This evolution was a product, not of Vincent's intellect, but of his emotions. He had attained his maturity, and it showed itself not only in the works of the artist, but in every practical detail of his life. It vitalized his whole existence, and gave profundity to the drama. At that time Mauve gave him a box of colours. Vincent visited him occasionally at The Hague. At first the famous painter was very kind to him, gave him good advice, and taught him some of the elementary laws of painting. Vincent overwhelmed him with gratitude. At last he had found his master. He painted his first studies in oils under Mauve's supervision. He painted still-lifes of wooden clogs, potatoes

and so forth, but he regarded painting as a kind of personal indulgence, and remained faithful on the whole to his drawing, which had improved considerably. Nothing in particular kept him at home, so he moved to The Hague towards the end of 1881 to be near Mauve, and he actually dared to furnish a studio. Mauve helped him, and Theo, who had been promoted in the meantime, now offered him a regular income of a hundred francs a month.

Vincent's means of livelihood depended entirely on Theo's earnings, but he was never happy about his brother's career. He considered Theo's inner development far more important than his own income, and the assistant in the Paris Gallery was developing, in his own way, as steadily as the pupil in The Hague. Theo learned to differentiate between permanent and ephemeral values; he rapidly acquired an unusual degree of connoisseurship, and he gradually became an influence in the Goupil Galleries. He used both his influence and his knowledge in the interest of art. Theo's superiors of course measured the value of his ideas by the turnover they produced. The intercourse with Vincent helped him to stick to his guns without losing courage when his employers disagreed with him. In a corner of the Gallery he showed his customers the developments of modern art. Theo was an admirable art-dealer, but Vincent considered this profession too superficial, too cheap. In fact, it was not a profession at all. Every man who was hale and hearty ought to have some craft. Every letter, every word from Theo breathed living art. Why did he not exchange his frock-coat for a painter's overalls? Vincent's advice was no manner of speech. Theo loved art—no one could love it more—and he had vision and sensibility. Why not, then? Art was not to be trifled with. Modesty might present an obstacle, but then in painting there was a significance for every impulse, even for modesty. The obstacle might even be idleness, or a kind of cowardice. Theo was the more cool-headed of the two brothers, and he had to struggle to stand up against Vincent's hot impulse. Theo felt his seemingly false position, but in the Goupil Gallery his dearest ambitions, like his modern pictures, were relegated to a corner. His faith in Vincent became a silent cult, which nourished that part of Theo which would not compromise, and as he was always conscious of the obstacles which Vincent ignored, the part of Sancho Panza in this play fell to his lot, and was played with a tragedy no less profound. Vincent never really understood his brother, for he regarded him simply as his nearest friend and blood-relation, and also as the only tangible force in another world. Their common blood and the similarity of their outlook smoothed away superficial differences, but in reality it rendered all compromise infinitely more difficult. In order to influence Theo, Vincent renounced his influence over everyone else. If he could win Theo over to his side, it would perhaps be possible after all to found a

community. Theo was aware of Vincent's views and aims, and the responsibility this knowledge imposed on him only added to his burden. The fact that their intercourse was confined to letters helped to avoid many obstacles. Vincent would soon have exhausted the nervous reserve of his weaker brother if they had been constantly together. Theo was sufficiently circumspect to realize this danger.

Correspondence would have been better than actual contact even with Mauve. Their acquaintance had reached its zenith when Mauve had given him lessons in water-colour drawing. Could there ever have been a greater benefactor? Vincent's cup of gratitude overflowed; he wanted to stay permanently with Mauve, and never guessed that he had become a nuisance to his master long ago. The famous painter was annoyed by some preposterous piece of arrogance on the part of the pupil. This fellow in workman's clothes, with whom you could hardly be seen about, was really unfathomable. He seemed as modest as a worm, he listened devoutly to everything he was told, seemed grateful and industrious as he ought to be, and then suddenly: 'No, Mauve, that's not the way—just the opposite!' There was something absolutely incalculable, like a geometric progression, in this attitude. At last, to give him a real nut to crack, Mauve made him draw plaster casts. Vincent did not like plaster casts, he thought plaster execrable. He smashed the casts to pieces and threw them into the coal-cellar. He would not contemplate drawing them until they were white again. It was Van Gogh's exaggeration that was so galling. He exaggerated here just as he had exaggerated as a missionary. He mistook ideas for facts, and assumed that the motives of other people were as simple as his own. 'You are vicious,' said Mauve, and with that he washed his hands of him.

In a communal kitchen, at dinner, he met a woman who pleased him. She was rather faded, and she had a baby. There was a peculiar charm about these faded creatures. Her hands were not exactly the hands of a lady, like his cousin's, they were more like the hands of a working woman. 'There was something of Chardin or even Jan Steen in her curious appearance.' But she was not a working woman, at least not in the generally accepted sense. She belonged to that class which is abhorred by all pastors. She was a prostitute. This woman was very good to him, quite remarkably good. And she was not even expensive. 'Listen,' he said to her, 'you and I don't need to make ourselves drunk to feel emotion for each other. You'd better pocket what I can spare.' Of course, everyone must feel surprise at Vincent's behaviour in view of his great passion for his cousin, but working with hands and brain did not constitute the whole of life. He could not throttle his energy for his cousin's sake. She was something new in his life, and it might all have turned out very happily, but she insisted on belonging to the opposite camp, to the world of pastors, to a prison from which she would not

permit him to rescue her. The love he felt for this prostitute was something much older. He had always felt an affection for these fallen creatures, and he used to envy the men whom he saw in the streets walking about with them. They were like sisters to him. From this time on he visited prostitutes occasionally in their brothels. There was nothing very remarkable about his procedure, only it was done with a frankness which made it appear even more vicious.

He worked furiously. Poor people sat to him. Painting became much too expensive. A hundred francs a month did not go far. Models cost one and a half gulden a day. Theo could not always send money at the right time, and then he starved, which was not so very dreadful. But when he could not work because he lacked this cursed money, it became unbearable. He lived by his work, not literally, of course—he once sold M. Teersteg of the Goupil Galleries a dozen drawings for thirty gulden—but in the real sense he lived entirely by his work. Every drawing he made gave him a stronger hold on reality. He tortured himself a good deal, was slow and awkward and sentimental into the bargain. There was something heavy, both in his mind and in his hand, which kept him working hours at a few lines. Every new drawing made work a little easier, and sometimes his drawings reflected the weight of this heaviness. He noticed himself that he was slowly penetrating through the surface to the reality of appearance. At first he saw only what was superficial and banal, but gradually he plumbed the depths and made motion out of moving objects, and the limbs he drew began to function. Poor people and especially workmen, who were quite simple, were the best models. The whole of their life was written in the range of their three or four expressions. Other painters had an easier time of it, because they could pay for expensive models, pretty women for instance. They meant nothing to Vincent. Necessity forced him to concentrate on one type, to deepen his experience in one and the same direction and to forgo all superficial variety. The necessity stood Vincent in the stead of the advantages of more primitive times and of the clearly defined training of the Guilds. An old withered woman sitting before him suggested enough of Nature to rouse all the possibilities of plastic form. Simplicity contains a wealth of motives to creative action. The limitations of necessity made him free. He loved the necessity which exercised his faculties, and brought before his vision what he loved to see. He could have done nothing in other surroundings. Prostitutes were his sisters, and working men his brothers. Like them he was an outcast—an outcast who knew the peace of that despair which has long since given up useless strife. In the day he worked and at night he wrote letters to Theo. If only Theo would take up painting! He was more pliable, more lyrical, and less attracted to plastic, human forms. He was sure Theo could be a landscape painter. No doubt art-dealing

brought its own experiences. There were good moments in every walk of life, but they were nothing compared to the joy an artist experienced when he felt that secret power grow within him, as a mother felt her child grow beneath her heart. If Theo could only feel that for a single instant, he would not hesitate to send Goupil to the devil, and then they would be together.

His terrible longing had not left him, and in 1882 it spurred him to his most daring exaggeration. In January he met another such woman. She was not very beautiful, she was pregnant, not very young, she tippled, was peculiarly foul-mouthed; she had in fact sunk very low, but there was something marvellous about her. Life had ridden roughshod over her, and made a discordant harp of her body, of which her evil tongue knew nothing. Vincent painted the discord. It is the naked woman in profile, with her arms above her head, and Vincent also made a lithograph of it and called it 'Sorrow'. She is seated in a sad, imaginary landscape, beneath which he wrote Michelet's sentence: 'Comment se fait-il qu'il y ait sur la terre une femme seule délaissée?' And the whole picture is miserably bad, mere sentimental illustration, formless and lifeless. Vincent's compassion had gained the upper hand, he had forgotten the profundity of nature, he lost his sensibility in super-ficiality. The same thing happened to him in life. This pregnant woman had already another child, and a mother as wretched as herself. The poor creature was ill, and had to undergo an operation to be delivered safely of her child. Vincent intervened, made debts to pay her debts, took the poor creature to Leyden to a good doctor for her operation, nursed her back to health. The woman from the gutter was to be his wife. She lacked the refined speech of his cousin, she was a trifle rough and a trifle wicked. The gutter had left its traces upon her. How could she be good, if she had never felt any goodness? And because he was good to her, she was good to him and came to him like a tame dove. Her roughness matched his roughness. His darker side held no terrors for her. He had no rosy illusions, he saw the life of a working man before him. She had learnt how to sit for him in spite of her feeble condition. Everything went splendidly, she helped him with every drawing. All those drawings of her body pregnant with new life were made together. It was bliss merely to be able to say 'we'. No one was to imagine that he could call such women bad women. A woman from a rectory would of course be different—but better? Who had the right to call himself better? In a well-organized and pure society such women might be despicable, but in modern society they were like Sisters of Mercy. He would most decidedly not take Sien to see his parents, or any other members of the class to which he had once belonged. He had left this class long ago, and had become a working man. He wanted nothing better—to be a working man and to be left in peace. These exaggerations brought all

kinds of consequences in their wake. In a town where people were dressed in certain ways and where they judged according to appearances, no man could live for nothing. The few people who had looked him up occasionally, stayed away and thought he was not quite right in the head. He was faced by a storm against which he had no protection but his thoughts. It all depended on Theo. He had written and told him all about Sien. If Theo deserted him, everything was lost. If it must be so, it would be so. He acted as he thought, and he had to think thus. He must have a home at last, otherwise he could not work or find life worth while. Painting was not to be allowed to become the fiction of a philosophic hermit. Art and solitude were for him irreconcilable contradictions.

The days that followed were anxious. Theo's reply did not arrive. If he deserted him it would be a great tragedy, quite apart from the problem of money. But even these days passed. Theo would never desert him for such a reason. Theo would much rather cut himself off from Holland, or from the whole world, if necessary, and stand by him. Vincent's relations with this woman could only heighten Theo's respect for him, although they might add to the cup of his disappointments. In fact this was more than probable, but no man had a right to say anything against his action. Since Vincent willed it, it must be so.

The situation was not pleasant. In June Vincent fell ill. Sien had infected him with the traces of the gutter. He had to go into hospital for several weeks. In the wards set apart for the very poor, the doctors hardly pampered their patients, but it was interesting as a third-class waiting-room. If only he could draw these beautiful models! He had Dickens and his books about perspective with him—Vincent's father visited him in the hospital, but there was little opportunity for conversation. 'It was all a dream, just like the whole business of lying about idle in bed.' Apparently Vincent passed through a serious nerve crisis at that time. Sien had to go to Leyden to a maternity hospital, where she was delivered of a child. His birth involved another serious operation, which confined her to the hospital for several weeks. Vincent used the interval to prepare their new home, a garret in a suburb of The Hague. He divided the garret by a wooden partition, and made a most comfortable studio. The studio had—as a studio ought to have—a cradle and rocking-chair, and there was another room next door as well as a charming and picturesque kitchen. In these surroundings this work-man's family was to start its new existence. Theo raised Vincent's allowance to one hundred and fifty francs a month, which was not a great deal for four people, but to have his own hearth and the care of others was as good as a fortune to Vincent. The real wedding was to be postponed until Vincent had earned at least one hundred and fifty francs himself. He went to fetch Sien and the baby in triumph. She had made herself very popular in the hospital, most of the doctors said good-bye to

her, and even the head matron. She was a little mother, a tame dove, and the cradle and baby's clothes delighted them both beyond words. Vincent found a large corner in his heart for this child of another father. It was too small to disappoint him, and he washed the baby when his mother forgot him, and delighted in every sign of his growing life.

In this period, especially in the second half of 1882, his own impulses for the first time drove him to paint. It was the first time he had recognized the limitations of drawing as opposed to painting in colour. Earlier, in the Mauve period, painting in oils had been an exercise done at the bidding of his master and nothing more. But in 1882 nature occasionally forced the brush into his hand. He was at the time under the influence of his beloved de Groux, which speaks volumes about the quality of his pictures. Sentiment predominated, although unintentionally. By instinct he strove after solid painting. He explained to Theo how he set about painting an autumn sunset in the Bosch. 'The main thing is to get the depth of colour, the enormous force and solidity of the ground, and I did not realize until I came to paint how much light there is even in the dark parts. Then I had to catch the light and yet convey the depths of solid, fat, glowing colour. You can't imagine a carpet anything like as magnificent as the deep red-brown that glows through the trees in front of a sunset in autumn. Young beech trees grow in the soil, and one side of them sucks the light and reflects a green radiance, while the other side casts warm black-green shadows. Behind their slender trunks and the brown-red soil, the sky is a very tender, warm, blue-grey— almost without any blue, and quite glittering. And somewhere else against the sky stands a dusky edge of green and a network of trunks with yellow leaves. The figures of wood-gatherers are dotted about, making dark masses of mysterious shadow. Suddenly you see the white cap of a woman, bent to the ground, against this amazing red-brown colour. Her skirts catch the light and cast a deep shadow. Near the edge of the wood is the dark silhouette of some other creature, and perhaps the white cap and shoulders of another woman outlined against the sky. These large poetic figures seem in the darkening shadows like huge terra-cotta statues. . . . I had to paint quickly, as the light was changing, and so put in these figures with a few bold strokes of a thick brush. I was surprised to see how solid the slim trunks were in the background. I began them with the brush, but as the ground was already covered with heavy colour, the strokes simply disappeared, so I squeezed the trees and the roots straight out of the tubes and then modelled them a little with my brush. Now my little trees stand quite solidly in the earth and their roots support them. In a certain sense I am rather glad that I never learned how to paint. If I had done I would probably have missed effects like the one I have just described, and now I feel that they are just what I want. If I can't get them—well then, I can't. But I am going to try, even if

I don't know how to set about it.' He had no idea how he started his sketch. He simply had a clean panel in his hand and it got filled up. But he was far from satisfied. 'In mijn snelschrift mogen woorden zijn die niet te ontcijferen zijnfouten of leemtes—toch is er iets over van't geen het bosch of strand of figuur zeiden, en is het niet een tamme of conventioneelle taal die niet uit de natuur zelf voortkwam. . . .'

This was already the speech of a painter. People who can stretch out for their tubes like that to make their trees solid are on the way to becoming painters. However, he had a long way to go yet. Probably many sketches were started as spontaneously as the one he described, and then finished off at home with the aid of his memory. Frequently he forsook his painting for weeks and months together and began to draw again, because for Vincent drawing was like sowing and painting like reaping. The process of self-education was marked by a severity that is generally associated only with more primitive times. He went about his work like a peasant who makes up his mind to add to the few acres he already possesses only when, after careful consideration, he decides that he can cultivate the new land as intensively as the old.

Theo entertained high hopes of Vincent's new departure. He became almost impatient of his stubborn persistence in drawing, although he realized how much Vincent gained by it. Theo knew that there was a painter in his brother from the moment when he saw his first attempt. At times he had gently suggested to him that he should use a brush, but in vain. It almost seemed as if Vincent regarded colour as a will-o'-the-wisp. But now he had adopted colour of his own accord, and if he once took to anything, he stuck to it. The ménage with Sien appeared to work quite well, although Vincent never wrote about it. Theo had an idea of founding such a ménage himself. The gutters of Paris—was it chance or one of the invisible reflexes that played between the two brothers?—had presented him with a similar experience. He too had met a woman, who had suffered at the rude hand of fate, though not as cruelly as poor Sien, and her sufferings had been more ordinary. She was none the less deserted, helpless and ill. Vincent was quite right. Such experiences made you feel as though, amidst the turmoil of life, you met the gaze of an Ecce Homo, which cast a spell compelling you to act in a way wholly contrary to your reason. Theo decided to take this woman to himself, and he did it to pay one-hundredth part of the debt the world owed to the poor creature. She was faced by a terrible operation if she was to recover. All kinds of complicated details connected with her misery had to be settled. She needed peace. Theo saw to everything, took her into hospital, and found a suitable doctor who performed the dangerous operation successfully. He told Vincent daily how she was progressing, although Vincent knew no details, not even her name. Theo was shy and reticent, and unfolded the whole story to his brother only gradually.

Vincent's sympathy was so strong that Theo could have imagined his brother was with him the whole time. This was just what Theo needed, for there was no such sympathy in the world of business, and the relation of the two brothers became extraordinarily close. There were differences between the two women. Theo's patient was an intellectual woman who understood art and poetry—things that did not enter Sien's horizon at all—in fact it seemed as if art and literature were the very remedies that she needed. Vincent chose suitable passages from Michelet and Thomas à Kempis for her. He also saw to it that she got some landscape drawings, for what an invalid lacked, especially in Paris, was Nature. Theo must be persuaded to join his lot to hers as soon as she was well, and to forget all his doubts as to whether pity was a sufficient substitute for love. All that was essential was a powerful emotion; the name by which it was called mattered nothing.

According to Theo, however, the feelings of the other person had to be considered as well as his own, otherwise you might, with the best intentions in the world, only add to the woman's burdens. She might perhaps make sacrifices which would help no one, from gratitude, and at any rate Theo meant to weigh these considerations carefully.

Vincent longed to take the next train to Paris and discuss these problems, but he could not afford the railway fare. Perhaps Theo was worried about money too. After all he must make his own decision in a matter so important, but Vincent had always felt that it would be best for Theo to marry an intellectual woman. And Vincent personally would have regarded such a union as a miracle of mercy. And then, how could a woman fail to be happy with Theo? If only Theo's hesitation did not imply any consideration of the money which his brother consumed in Holland!

Since the fact that there was no market for his drawings worried his brother, Vincent thought of attempting to do popular work. He had really never intended to do anything else. Studies of the People for the People. He thought of drawing a series he would call 'Heads of the People'. He contemplated making lithographs which could be sold for ten Dutch cents a piece, if the cursed dealers could be excluded; he actually did make a number of drawings on stone at that time. If only he could find some permanent means of escape from financial worries! When Theo could not send him money at the right time, he sat there and starved, and not only he, but also Sien and the children; the new-born mite, who always squatted down near Vincent as soon as he could crawl. Vincent lacked nourishment. He was economical in the use of his lines, but they remained bare lines. And if he lacked the strength to draw, where was he to find the energy to paint? There was not enough food and not enough happiness in his home. Sometimes he felt faint, and his relationship with Sien developed as was inevitable. No

one but an idiot would have failed to realize it from the start. Perhaps Vincent had realized it, but had fallen into the trap none the less. The situation was not a bad one, it was simply impossible. He was here and she was somewhere else. He had believed that he could make a companion of her and could be as primitive as she was. But Sien saw in Vincent a queer stranger who belonged to another world and acted as he did from some mad freak of vanity. If a friend of Vincent's appeared she went away and hid herself. Her mother began to intrigue. Perhaps Sien was better off in a brothel than in a painter's garret, where you could not even talk freely. She thought nothing of going on the streets again. It was a hard and a dirty life, but everyone knows best what he is fitted for. Vincent gradually began to understand. Her feelings were the result not of a moral code that could be improved, but of an inherited instinct. The struggle wore him out, and his powers waned visibly. Then he became obsessed by the desire to work and work and work. How many more years would he live? Six years, or at most ten—he never thought he would live long—and he was still at the beginning. Theo came over to him in the late summer, saw everything, but said nothing. Theo was good, he never said anything, but as usual he noticed the rags Vincent was dressed in. This was one of Vincent's sore subjects. Theo evaded all questions about the lady in Paris and talked of something else. Their conversation was only designed to kill time. The difference between Theo in his letters and in conversation was really very odd.

Vincent thought of going into the country with Sien and the children, to Drenthe for instance, where they would be among peasants and where living was cheap. Sien made no objection, but she displayed no enthusiasm. As soon as Vincent's back was turned, she went to her prostitute-mother, who instilled very different ideas into her. How he loathed all this town life and longed for the open air; what bliss it would be to be absorbed altogether into Nature! Sien did not even oppose their separation, in fact she seemed to favour the idea. He wrote letters and went all over the town to find work for her, for now she was well and could do any work. At last he found a post for her, but her mother interfered and Sien did nothing to prevent it. Perhaps it would be better, even for Sien, if he went away.

Before he departed he said to her: 'I don't suppose you will be able to be altogether honest, but be as honest as you can. I'll try to be as straight as I can myself, although I can tell you right away that I shall never get through life as I should like. . . . Even if you are only a poor woman and a prostitute, as long as you act so that your children find a real mother in you, you will, in spite of all your faults, be good in my eyes. . . . I will try too. I must work hard, and so must you!'

September 1883 he spent on the moors in Drenthe, where there were flocks of sheep guarded by barekneed shepherds and turf-carts drawn by

black and white horses. Occasionally small, wretched women passed by
with children in their arms; a sight which called up other visions in his
mind. Sien of course was a bad woman, but Vincent knew her so well
that there was really nothing bad left. She was not a good woman,
because she could not recognise goodness when she saw it. He ought to
have shown it to her, but somehow he could not manage it. Perhaps he
was too bad himself. There were moments when Sien's face wore an
expression like a Mater Dolorosa by Delacroix, and somehow there was
an element in her being quite different from her mother, with her
instinctive longing for a brothel.

Gavarni once said: 'Every time I deserted one of them, something died
in me.' Vincent did not desert many, and it is by no means certain that it
was not he who was deserted this time. At all events the only escape
from shame and remorse was work. But work, which was ultimately the
most potent factor in his separation from Sien, was not to Vincent a
means of righting a wrong, and now that he had escaped from her, work
seemed denied to him. His peace was gone. The moors would be
desolate, were they a thousand times fairer, while the spirit of the artist
was divorced from the landscape. The black and white horses were just
horses, and the flocks of sheep and the cottages just sheep and cottages.
Subject to certain conditions Vincent's creative force would have
breathed upon them, and they would have come to life on his canvas, but
one of these conditions was his union with Sien. He ran away from her
to Nature, and he had—who knows?—separated himself from Nature
irretrievably. Theo wrote in a similar vein. There were difficulties at the
Gallery and he was dissatisfied with the compromise of his existence.
The peasant peeped out in Vincent's Parisian brother occasionally.
Theo had always hoped that he could keep his hold on Nature in the city,
and remain a human being in spite of trade, because Paris seemed to him
like Nature. His hopes were shattered. He felt that the town was too
strong for him, it made him wicked and unhappy. To trade in art was
revolting. Theo sometimes felt inclined to escape to America instead of
taking the obvious course of going into the country and painting.
Vincent sometimes felt inclined to enlist in the Dutch Colonial Force in
the East Indies. He had no home, no money, no tools to work with; he
was a tramp, just as in his worst days in the Borinage, when he went to
Courrières to meet a man of sensibility. Were there such people, people
who possess sensibility? Life was black like the corner of a peasant's
cottage in Drenthe.

Life continued, for it would be despicable not to continue the process
of living, and the mere continuation brought with it, quite naturally,
new hope. It was not hard to guess what ailed Theo. If only he would do
it! Every line was proof of his hunger for an artist's life, for simplicity,
which can be found nowhere but in the country. Nobody would attempt

to deny that a part of Theo belonged to Paris, but not the whole, nor the best part. Part of him was still *vierge,* and it wanted to take root and blossom. Could one not assist it?

Very circumspectly Vincent tried to seduce his brother, although he could offer him no allurements, he the vagabond, the sceptic, the hungry alms-taker. His experience with Sien had made him more importunate than ever, for was not Theo forced to give up his Parisian Sien too? Surely some conclusions could be drawn from this parallel. One of the brothers fought his battle alone in Paris, the other alone in Holland. Would it not be wiser to struggle together and to support each other? Two friends who have faith in each other must be invincible. Vincent had already learned something and could help Theo, and Theo could help him not a little. Vincent's own work would improve if he had companionship. Theo only refrained from taking the plunge because of some stupid theory about talent. What was wanted was the capacity 'to stretch out your hands and grapple with it'. It had nothing to do with skill and talent—that was sheer drivel. A painter became a painter by painting. He needed practice, industry and experience, but no high-falutin abstractions. He must love his work and have determination. 'Painters are in modern society what Puritans used to be. The point at issue is not some crazy religiosity or ecstasy, but something solid and simple. . . . ' The Pilgrim Fathers, a mere handful of men and women, left the Old World and sailed in the *Mayflower* to America. They were determined to live out their simplicity, and they overcame the primeval forest. Carlyle told their story in his *Heroes and Hero-Worship.* The modern solution was different. If Theo despaired in Paris, he did not need to go to America, where he would find only another Europe. And in the East Indies it would be just the same. Art is the America of the modern Pilgrims, and it must be sought elsewhere, certainly not in towns, somewhere in the country.

Vincent was Theo's conscience. In Theo the ideas of the townsman warred with the instincts of the peasant. He was not indifferent to the considerations which moved Vincent, but they failed to touch the nerve which would have stimulated him to action. His was not a fighting nature. The reasons which prevented him from following his instinctive leanings were innumerable as the houses of Paris. 'I'm not an artist,' said Theo. 'How coarse that is,' replied Vincent. 'How coarse, even to think it! Have you no patience to learn from Nature, to learn from the growing blade of corn? Are you so heartless as to believe that you yourself will not grow and develop? Why oppose your own nature intentionally? . . . If you want to grow, you must first dig yourself into the soil. I tell you, plant yourself in the soil of Drenthe, where you will blossom, and don't wither away on the pavement!' What was to happen? 'Theo, I assure you, I much prefer to think about how arms and

legs and heads are joined to the body, than to worry whether I am an artist in the highest or the lowest sense.' Work was all that mattered. You must do it with a strong conviction that it was worth while, like a peasant when he goes to plough his field. 'If you have not got a horse, you must just be your own horse. There are plenty of people who manage like that in Drenthe.' Theo must think about the people of Barbizon, especially Millet. The most detailed financial schemes were considered. The saving effected compared to the expenses in Paris would be enormous, but the main fact was: 'Cooperation does not double your power for good, it multiplies it. . . .'

Vincent's scheme seemed to Theo, who had learnt something of the world in Paris, like a fantastic dream. Of course there were occasions when he felt inclined to exchange the real troubles of the present for the impossible charms of Vincent's fantasy. There were people whose eyes were always fixed on such visions, and who, like Vincent, acted in obedience to them. There is often but a single step from such courage to levity, and what was strength in Vincent would be weakness in Theo. Besides he could lighten Vincent's lot, and what would happen if he failed him? In the meantime life had become smooth again in the Goupil Galleries, and it was possible even there to effect much. This was Theo's sphere of action; to leave it meant to give up the struggle. And the struggle was no less interesting in Paris than in Drenthe. Theo was sometimes prepared, but not always, to regard the events that took place in Paris as insignificant. But there were moments when this enormous structure was rather imposing, and these Parisians, these numbers of people of *esprit* and culture, did not seem like puppets. Did he lack the heroism to go to Drenthe? Heroism was a profession to which one must be specially suited, otherwise one was ludicrous, especially in Paris. When Vincent received letters written in this vein he used to reach out for the nearest object—then smash it, laughing strangely.

Nature alone kept her promises, kept them only too well. You might wander about with her for ever, and never come to the end. He managed to get a little nearer, but only a yard, a foot, an inch at a time. Sometimes Vincent's progress was almost imperceptible, although he worked from early morn till late at night. The slowness of his progress was due to the exaggerated thoroughness with which he attacked his problems. He attempted to advance at the same time along too wide a front, and with too great a variety of *motifs*. Not only personal longing made him cry out for his brother, but the nature of his battle demanded reinforcements to clear away the innumerable obstacles that lay in his path. The assistance of his brother seemed all the more natural, because according to Vincent the problem before them was one of amassing sufficient material, and not one of creative action. Once this task had been executed, then the possibility of future co-operation was assured. Theo

had metaphysical conceptions about art. Vincent saw in art nothing but a penetration into nature. Behind Theo's metaphysics he discerned the weakness of the townsman.

CHAPTER III

De Ardappeleters

Solitude drove the wanderer home at Christmas to Nuenen, a small village in Brabant, to which his parents had moved. Possibly Vincent was driven there not only by his loneliness but also by his miscalculation of his brother, who had perhaps refrained from carrying out his own wishes because he was too proud to shelve the financial burden Vincent imposed on him. It was no easy matter for him to accept money, not even from Theo, not even if he spent the money only on bare necessities and fared worse than a labourer. He could only take it subject to certain assumptions tacitly understood, but they were not always understood. There were dark hours when Vincent in his loneliness considered his relationship with his brother rather one-sided. Possibly Theo had a similar feeling. Vincent wrote ten pages and Theo replied in haste. Of course Theo's time was occupied, but still he could easily have made time, if . . . it was wiser not to think about it.

Once upon a time two brothers went over the snow-laden moors to the mill that stood at Rijswijk; they were two poor artist-brothers, and they agreed about Life and about their God, and but a single heart beat in their two breasts. Then one of them went that way, earned his living, became a polished man of the world, and thus forgot the old mill at Rijswijk. The other brother went this way, became crude and rough, never earned a farthing, but he stuck to the mill at Rijswijk. . . .

The immaculate rectory of Nuenen was invaded by a large shaggy hound with wet paws. 'He was in everybody's way, and he barked furiously. In short, a filthy brute!' Another kennel had to be found. 'The beast might get rabid, and bite someone, and then the keeper would have to shoot him. Well, that couldn't be helped. On the other hand, dogs can keep guard over houses, but that was hardly necessary in times of peace and quiet when there was no fear of danger. The dog, however, was sorry that he had not stayed away, although no one was nasty to him. The beast's visit was just weakness.'

The beast barked louder yet, for he was hungry. The inmates of the rectory sat closer together when he appeared, and they dropped their voices. They did not drop them so low that they were not understood, especially as no one suspected such a shaggy beast of having delicate

33

ears. And he really did not need his ears—the way they eyed him was enough. How they stared at his coat! Were those his parents? Did they but know it, he might have been much coarser had he been a respectable money-grubber. He was tempted to assume the brutality they suspected him of, and then they were surprised. His father wrote to Theo and Theo wrote to Vincent. No one dared to talk to him like that to his face, not even Theo. But letters could suggest the ingratitude of the son whose existence served no better purpose than to embitter the lives of his parents. Vincent felt inclined to break for ever with them all, especially with those who could write such letters, and he longed to cast their alms into their gold-filled teeth. But what could he do then? How draw, how paint, how pursue his business, which was after all more important than all his family and their cruelty to animals?

Vincent with difficulty prevailed upon his family to allow him to use the wash-house as a studio. No one could blame his parents for their hesitation, and no one could blame Vincent if their hesitation did not sweeten his temper. Fortunately there were weavers in Nuenen, and looms were to be found in low-roofed cottages standing on floors of clay—most of them were as ancient as the hills, and their age had given them a fine colour. An old man sat at one of them, and near him on a tiny chair, a little child, who watched the shuttle as it flew backwards and forwards hour after hour. A small space like the room with the loom, and those two people in it would be a splendid subject for a drawing or a picture. There were all kinds of lights that played between the clay floor, the ceiling, and the loom, and on the wrinkled face of the old weaver.

Theo wrote again in his old friendly way. Vincent must not forget that his pig-headedness made enemies for him even among those who loved him, and one day it might cut him off from everybody. Vincent could understand that, and he had nothing whatever to say in reply. People whose minds were full of their work were inconvenient, even if they were not the least little bit vain about it. But why did not his roughness and his pig-headedness repulse simple folk? Why did the weavers let him come into their tiny rooms and willingly huddle themselves together to make room for him to draw? They were not his relations, they did not even know him. There was no denying his family were a queer lot. He often felt a closer kinship with these wrinkled weavers than with his own flesh and blood. When his mother had an accident and hurt her leg this ruffian suddenly became the model son. He nursed her day and night, and displayed such tenderness that everyone wondered at his skill and experience in the care of others.

He went over to The Hague to fetch his things and incidentally looked up Sien. Strange to relate she had not gone under, but had fought her way through life for her children and herself as a hard-working washerwoman. But she was ill again and wretched. Probably she was

more miserable now than when Vincent was with her, and it was quite possible that she never really wanted to go back to her brothel, but had only pretended, to annoy him or to test him. It was an open question whether Vincent or the prostitute had failed to stand the test.

Once more a woman crossed his path. This time a respectable neighbour of his parents. Vincent went out for walks with her occasionally. Like her predecessors, she was much older than Vincent. She was a woman of a mystic turn of mind, 'a Cremona violin, originally a rare specimen, which had been tampered with by fumbling amateurs, but even so, the fiddle still possessed peculiar merit.'

Theo warned him as usual, and Vincent as usual refused to listen. He tried to mend the Cremona, and he succeeded. Her family said he disturbed her peace of mind: he said he stirred her dead melancholy. He succeeded in drawing melodious sounds from the violin—at any rate, under his fingers. If the fiddle were cracked, never mind as long as the sound it produced was in harmony! He succeeded in awakening her, and driven crazy by her family, she took strychnine to escape from her dilemma. This was Vincent's last adventure with the opposite sex; like his visit, it was a weakness. How absurd was their mysticism which they called religion!

'Didn't I tell you so?' wrote Theo. 'Was that necessary?' 'Yes, Theo, quand même, inevitable!'

The dog barked more and more furiously. The rectory was appalled, and Theo's ears fairly hummed when he read his mail. The baying hound in Nuenen resented his treatment; he was sick of their shallow tolerance, he could get on without any Parisian sarcasm, he loathed verbosity. Why on earth did Theo not sell his work? If the pictures were not mature enough for these Parisians who could see no art in wooden clogs, then the drawings, at any rate, were worth something. The yarn about the impossibility of selling them was too old a chestnut. If Theo was an art-dealer, why didn't he show them how to do it? How else could he help an artist? 'You can't give me a wife, you can't give me a child, you can't give me work. Money—yes. What can I do with it?' He barked loudly. To divert him Theo wrote about the Delacroix exhibition in Paris. Vincent loved Delacroix nearly as much as Millet, but almost any subject can be made the peg on which to hang aphorisms. For instance, the Barricade picture would probably be shown at the Delacroix exhibition. Perhaps Theo would imagine for a moment that they were not living in the year of grace, 1884, but in the year that picture was painted. In 1848 all kinds of ragged fellows stood by the side of the Michelets and the students, like the peasant-artists of Barbizon. On the other side, close to Guizot and Louis Philippe, were Goupil, Vincent's father, and his grandfather—all serious and respectable people. . . . 'In the year 1884 there are perhaps no barricades, but there is a spiritual

struggle. The old mill has passed away, but the wind which moved it is blowing still. And in my opinion we stand in opposite camps; there's no getting over that. Whether you like it or not you must join your lot and I mine. We can't help one another like two people who are on the same side. If we meet at all it would be in the middle of a hail of bullets. My bad temper is a bullet, not aimed at you, my brother, but at the enemy in general in whose ranks you happen to stand. . . . I don't regard your offensive superiority as being aimed intentionally at me, but you just fire at the barricade and you think you are doing good service, but I happen to stand behind the barricade. Of course this is all metaphorical, but who can say whether it be the result of human will-power or whether it is pre-ordained? Can you blame the clouds because some are the vehicles of positive and others of negative electricity? Of course men aren't clouds. . . . Is it your own determination or blind destiny which divides us into opposite camps? . . . Once upon a time there were two brothers. They stood by the old mill at Rijswijk, and they fell one after the other in the same cause.'

Although Vincent barked loudly during the two years in Nuenen he also created pictures. The landscapes he had painted in Drenthe were moods which had prematurely turned into pictures. They were like pen drawings in oils. The painter could not as yet resolve the successful element in his studies into a painted canvas: he still suffered from the illusion that drawing and painting were of a different nature, and that a painting had to be a kind of illustration. The influence of Millet, Breton, Michelet, which never escaped the incorruptible eye of Theo, was all the more harmful because Vincent knew their work only from photographs. The printed page was Vincent's only means of intercourse, even in Nuenen, but in the meantime he had come to Nature, or rather he had come to himself. His longing for Nature finally killed his tendency to illustration. Illustrating had been bliss, it symbolized the studio with the cradle and the rocking-chair, and had to be etched away by loneliness and despair. Only when Nature becomes a painter's sole possession can he paint her. An artist simply takes a piece of Nature, sucks it dry, lives on it day and night like a dog with a bone. Then, and then only, can he get to grips with his subject. Up to then Vincent's pictures had been interiors, men at their work, and landscapes with animals and human beings, but the kernel of his work now became the human face. He wanted to produce fifty heads of peasants—only heads; and when he had done them, another fifty, in order to create the one head that contained all the others; he called it painting a type. His eyes devoured the structure of hollow cheeks, angular chins, and turned-up peasants' noses. His own face grew like that, in it too could be seen traces of digging with a spade. He painted the features of men who lived in the earth and by it, his lines were the lines of peasants, his surfaces peasants'

surfaces. His pencil was a plough and thus Breton and the literary rubbish fell from him as the husk falls from its kernel. Look at his Sower! Read for yourself! Such heads will one day seem to others as the painted faces of Egyptian mummies seem to us. They prove more indisputably than the whole of history that thousands of years ago, before there was any such thing as art-dealing, there were men on earth like ourselves—incredible creatures, for they resemble us.

The isolated lines disappeared into a solid mass that forms a picture. Once the heads were all drawn nothing was simpler than to shovel them together to complete the rest of the peasant, and thus to plough over his work and his field. Vincent aimed solely at the peasant tilling his soil and the weaver weaving his cloth. He believed his aim to be a new goal, for the old painters of peasants had never thought, it seemed to him, of painting the peasant at work. 'The real aim of modern art is to produce what neither Greece, nor the Renaissance, nor the old Dutchmen ever produced.' He was right, because he succeeded in presenting in the structure of a peasant's bones the very essence of peasants, because we do not care whether we are looking at Dutch peasants or old Egyptians. The human element of his pictures was stronger than the species they represented. To Vincent there could be no separation between a peasant and a human being, and so he also ceased to separate drawing and painting, at any rate in his conception of them. He painted with his pen and especially with charcoal. His best drawings date from this period. The terrific weight and power of his hand gave colour to the blackness of his charcoal. He drew newly ploughed fields with the light playing on them, so that we gaze at them as if they were something tremendously good to eat. There is a sweet dampness in these black depths, and in the lighter patches it becomes soft like hair, almost like flesh, and yet remains the blackness of a ploughed field at morning and at night. There is something incredibly sombre in it all, something of Van Gogh's melancholy, and also a festive glamour which belonged to another side of Vincent. Vincent, who had been banished from the realm of light, had the power of giving luminosity to his melancholy.

In the spring of 1885 he painted 'De Ardappeleters', a room at night full of peasants at their meal. It is a collection of the heads he had drawn. At that time he was under the influence of Delacroix's theories, which he had pieced together for himself from essays. Delacroix once asserted in conversation that the best pictures were painted extempore. Extempore! The expression penetrated into the very marrow of Vincent, who had wrested every line so far from Nature. Extempore! That was what he had lacked when he tried to preach. He had taken it then for a sign that he had not been called. He had shipwrecked on that rock! If he was destined to be a painter he would just have to paint extempore. It seemed as if he could manage it: he painted 'De

Ardappeleters', the potato-eaters, extempore. There was a flavour—he said it himself—of dirty potatoes in the picture. A shaggy, gruff picture, with smeary heads, but it had a life of its own. You can read the story of a past and of a future in it. The picture found its way to Paris. Theo took it to Portier, the only dealer who showed any interest in the newcomer. Theo and Portier both complained of the dirty messiness of the colouring. What a palette, in the age of Impressionism, at a time when all the younger generation used light colours! Vincent laughed. He was going to paint in darker tones and much dirtier colours yet. There was often luminosity in the dirt, more luminosity than in the bluest of blue skies. Look at Rembrandt! Read what Delacroix had to say about it! Impressionism indeed! Was that a new 'ism'! They must be a rum lot, these Impressionists, who burst their sides with laughter at Millet and Israels. If they weren't careful they'd burst altogether! These Parisians must always have some new-fangled notion. He would, by their leave, be faithful to his old Dutchmen.

At that time an acquaintance, a tanner called Kerssemakers, took him to the Rijksmuseum in Amsterdam. In the waiting-room, his favourite haunt, he hurriedly made another sketch. Then came the train. Nothing could tear him away from the 'Jewish Wedding'. He stood and gaped at it. He would have given ten years of his life gladly if he could have sat for fourteen days in front of this picture. This journey exercised an influence on his work. In Nuenen he forgot the museums, which were like wonderful books. You could test for yourself all the theories of Delacroix, which he had read about, concerning colour and contrasts and tone-values. You could learn an immense deal in three days, and you learned things that never would have occurred to you in Nuenen. What you needed most among your peasants you had of course to learn by yourself, but once you had learnt it, then such picture-books as the Rijksmuseum were wonderfully helpful.

The studies Vincent made shortly after the *Ardappeleters* owe the softening of their previous earthy crudity to this brief span of passionate study. His *motifs* were still chosen quite at random. A few potatoes, a brass pot and a peasant's basket were all he needed to create a whole series of still-lifes. They were simple like peasant pottery, and his palette was constituted chiefly of an earthy potato colour. But these limitations of colour and subject produced a remarkably cultured style. There are luminous copper tones in his potato-greys and in his 'soap-green colour'. Vincent arrived at his effects with these tones, not with the local colour. Quite imperceptibly he managed, with soft broad strokes of his brush, to raise his subjects from mere naturalism into the realm of the old Dutch masters. These studies do not remind you of the men he honoured, like Mauve and Israels. They resemble rather in tone, painters like Van der Neer, Ostade and his beloved Chardin, although

they are not echoes of any one master in particular. His manner is absolutely personal, but such as might come from the close study of the old masters. Most painters who have had the good fortune to strike such a chord in their compositions content themselves for the rest of their lives with playing variations on it. Vincent was saved from this pitfall by his modesty; this was only a beginning. He felt he must approach the old masters still more closely. His letters simply swarmed with reflections on their methods of painting, and in between the heads of Nuenen peasants we see the ghosts of Hals and Rembrandt and many others. His correspondence began to resemble the *Journal de Delacroix* and Theo proved to be stimulating. It was delightful to discuss art with him. He was not smitten by the spell of Parisian fashion, and he did not look at art from the Boulevard, he was a sound judge and a thinker. He did not, for instance, accept the palette of the modern painters as a criterion of art, and he could distinguish very clearly between sincerity and charlatanism. When he accused Israels, whom Vincent over-estimated, of lack of harmony, it was by no means a caprice. Theo, on his side, enjoyed the powerful agility of Vincent's mind. Vincent substituted for lack of experience his intuition, which made giant strides. Every time Theo penned an opinion on an old master, or propounded a new theory he found that he got little change out of Vincent when his reply arrived at the end of three days. Vincent would dare launch conclusions, which Theo would never have ventured to embark on, from the slightest suggestion. It was very jolly to have such a brother. All his rural roughness and his crudities were just super-imposed colours which contained the most luminous qualities. Perhaps the public would never recognize him, and perhaps his art would never attain to the stature of the man: both were more than likely. But whatever values he created would outlive any theory of painting—that was certain.

Towards the end of November in 1885, Van Gogh went to Antwerp for a few months. Theo thought he went to see Rubens, but Vincent, the connoisseur, wanted to see a few pictures by Jan Lys. If the truth were known he also longed for museums and art schools. He worked at the Academy in order to get cheap models. Once again he was so short of money that he had not enough even to buy dry bread, and he began to feel the effects of this monotonous diet together with acute mental exertion. The fear of an early grave, which never left him, increased his passion for work, and his furious labours only brought the danger nearer. After all it would be a pity to depart this life too soon, because you might, if you lived, see all kinds of excitements—a revolution for instance. Vincent's simplicity, which was not too simple, divined the 'end of Society'.

And in Paris there were larger possibilities than in Antwerp, and a few free spirits. There was the École Julian and Cormon. In Antwerp

Vincent had of course made enemies of all the professors and students at the Academy. He longed to plunge deeper into the life of a city and to explore all the works the mind of man had created. He did not feel the longing for human intercourse, he had learnt to do without that, but he felt a desire to speed up the machine with which he could liberate himself. He might perhaps be able to learn many useful lessons from Manet, when all was said and done. Impressionism could not, after all, just be dismissed, and how much he could learn now from Delacroix! Ten years ago his head was stuffed with religion, and even if it did not prevent him from using his eyes, it had hindered him none the less from turning his vision into creative form. He was prepared now to carry off in triumph all the glories of the Louvre. The whole of his activity so far had been confined to the making of vessels in which to garner the harvest. Even then he was working at fifty heads and fifty baskets and pots for the fruit that was to come. He made studies, too, from the antique to understand structure better, and he painted valleys, cottages, rivers, animals and every creeping thing. Now he felt ready for the world that hustled and bustled in the distance. Up and at it! He longed to turn over the pages of the great picture-book of the Louvre with Theo, and then go home and smoke a pipe and unpack all their mutual discoveries. Would it not be glorious? They had never really been together. How curious not to have noticed that before!

Of course, it would be very jolly, Theo confessed cautiously. Theo was afraid he might disappoint Vincent. Oh, he was cautious, just as if he were dealing with someone whom he did not know. But were they not two creatures who had no one in the world except each other? Perhaps Vincent ought to go first to his widowed mother in Brabant and help her to move out of the rectory. Vincent grew impatient. His father was dead, he could not restore him to life. Possibly he had died long ago, and one must live—yes, live! Going to Brabant meant going backwards, and he would lose time, which was perhaps more precious now than ever. He suffered from fever. The doctor thought that if he did not take care of himself he might develop typhoid. Fevers like that could only be cured in Paris. Theo suggested that Vincent should come in June, and he would take another flat and have everything ready for him. Vincent's fever grew worse, and it had to be cured at once. He would come in April, or better still in March! Antwerp was dead, everything was dead except Paris.

On the 27th of February a note was handed to Theo in the Gallery. He was to go to the Louvre at once, to the Rembrandt in the Salon Carré.

CHAPTER IV

The Brothers in Paris

Paris was Vincent's real training ground, not only for art, but also for life. He found here something besides duties and burdens, and he shouldered what he found without having to stoop for it. If his foothold had been less firm he might have been bewildered and slipped in the confusion of his new impressions. Art in Paris was a different world from art in Holland. It was a kind of lantern, by whose rays you found your way about even in the heart of the city; it illuminated the soul of the metropolis and gave you the eyes of one of her citizens. Paris was to Vincent far more than a prodigious city; it was a world properly divided into streets and squares filled with men and their stories, and it contained, beside the fleeting present, the past and future. Of course Paris would have been quite different without the gentle guidance of his brother. Theo was at first almost a nurse, so carefully did he prepare this immense material in advance for Vincent. His almost imperceptible guidance led Vincent straight to the spot he wanted. He began to read the great tome of French tradition, and also the smaller volumes, the Boulevard publications. The Studio of Cormon was just one of these, which owed its reputation not to the profundity of its founder, whose views barely differed from the theories of the École Julian, but to its tolerance. Vincent joined Cormon's studio for the sake of meeting the students, and because Theo's little flat was not large enough to paint in. There he made the acquaintance of the funny dwarf Toulouse-Lautrec, who was really a count, and whose ability was simply incredible, and he got to know the lanky Anquetin, the little Émile Bernard, all young fellows whom he could talk to. He discovered before long that this object could also be achieved outside the studio, and these conversations did him good. For ten years he had been dumb, and his silence had developed into an impediment. But here everyone had their own doubts and disappointments, and they helped each other. In Holland he had been a stranger, and his solitude there had been all the more oppressive because he was surrounded by familiar objects and people who spoke his own tongue. In Paris all these sinister ghosts had vanished, and he found himself listening to confidences in a foreign language. These people behaved like that quite naturally, and just because everything seemed to

41

be treated with a kind of professional candour. What were intimacies in Holland were the order of the day here, and perhaps intimacy only depended on the choice of subjects that it was worth while to discuss in common. Theo was a master of all these delightful mysteries. Everyone appreciated his cool, workman-like manner. He hardly ever made any promises to the many young men who came to him, but he always did more than he had undertaken for them. The manager of the Goupil Gallery had at last allowed him to exhibit in the *entresol* of their house on the Boulevard Montmartre the more promising canvases of the younger generation and at that time Paris was full of such pictures. You could find good art in other galleries. Durand Ruel had acquired a large collection of Monet and Renoir, as well as of Manet and Degas, but he confined his collection to these great lights and refused to add another name. Theo exhibited not absolutely representative works of the older generation, but studio pictures that painters liked to see, and also the plain confessions of the younger apostles. The small *entresol* brimmed over with life. These rooms were of course part of the Goupil Gallery, and Theo was obliged to sell poor stuff, but he kept it for Americans. Vincent entered and stared. Theo's letters had given him an idea about Impressionism, its theory and technique, but its practice was a revelation. He felt like a foreigner who had learnt the language with a dictionary and then suddenly received a proposal of marriage in French. Painting in Paris was one long proposal, for art was too personal there to allow dogma any play. Moreover Impressionism in those days was not a one-sided dogma, but a well-ordered attitude to life. The Impressionists were men before they became painters. The year 1886 found them all at their best. Claude Monet, still possessed of his dramatic powers, was painting his Belle-Île seascapes, and had not yet embarked on his weary series. Renoir had already parted ways with Monet. Though few realized it then, he was demonstrating the possibilities of his group in his own way. Pissarro, Sisley, Guillaumin were at the zenith of their power and were surrounded by many others. The one quality they all had in common was their light palette. The common link that bound these diverse natures together was proof for Vincent of the permanent quality of their art, in fact it constituted to his mind a miracle which extended far beyond the sphere of painting. There seemed to be other things in this world besides misery, greed and hatred, some power that could unite these new concepts. Vincent had believed that such a unity could only exist among peasants in the country. He had imagined a city to be filled with idiots, idlers and adventurers, who robbed God and mankind, tricked Nature of her forces, and the sun of his golden rays. And suddenly he found sunshine in the city and its inhabitants had become new creatures. He had pictured them as flashy conversationalists, cautious and calculating, and he found plain country people,

with simple emotions, able craftsmen who knew their business and got on with it instead of talking too much about it. Everything was plain sailing. Now he could understand Theo; of course he would not exchange Paris for Nuenen or Drenthe. Here a common inspiration made a community of individuals, and spurred them to creative work. Vincent's life seemed so changed that he was almost alarmed. He felt as if his specific gravity had suddenly lightened. Was there ever such another spring? Theo and Vincent had moved into their new rooms, high up on top of Montmartre, with the Moulin de la Galette on one side of them and a faëry world on the other. People nodded to him as he passed. Everybody knew him, the fat old woman who brought his vegetables, the singing postman, and the flower girl in the little square. Children played about and old women gossiped. There was not a discord and Vincent felt as much at home as in a corner of The Hague. Nobody laughed at his queer manner, nobody was surprised at his clothes, and if they smiled he wanted to join in. Life was a dream, and he almost felt as though he had got rid of his clumsy body altogether. There was music in the air, and he longed to join in the chorus.

The immense sea of houses stretched out before him like the ocean. This was the only city which was a miracle of human creation, a well-composed picture whose surface was ever changing, not an accident made of bricks. Everything performed its well-ordered function; the streets were like throbbing veins under a glistening skin. You descended in a fine sweep down to the Boulevard Clichy. Cheerful couples sat in the cafés, and on the Boulevard there was nothing but couples. Words bounded from one pair to another like little red balloons, and life marched merrily onwards, gazing up at the clouds meanwhile. Then there were the secondhand bookstalls, where he found some new treasure every day for twenty centimes. He discovered the most wonderful Japanese prints, and he had never suspected such a world as was revealed in them. Their beauty dazzled even the dreams of the painter, helped him to throw overboard all his superfluous ballast, and opened up new possibilities of colour schemes. The most amazing sensation of all was the realization that all these marvels had been made just for the benefit of Paris. Paris could swallow a whole civilization as easily as an oyster. All the painters of the East had toiled only to give this city a new ornament, just to make Paris smile for an instant. Japan was the prop of Impressionism, and Vincent fingered these prints for hours. The real connoisseurs, of course, despised these crude products, and no doubt the old specimens on proper paper were much finer, but they were neither so cheap nor so gay. Just their crude gaiety of colour delighted Vincent, and he found it hard to tear himself away in order to hurry to new discoveries. At the Boulevard Rochechouart, he mounted the top of a bus and rattled behind three horses down the steep Rue des

Martyrs. There the scene changed. Everyone walked more hurriedly and the houses looked more solemn. At the corners life teemed like a river that had found a new outlet, and the stream broke up into gaily coloured strips. The three nags trotted on through the silent Rue Laffitte. Every window-frame contained a glowing picture. He had to drive, otherwise he would never have reached his destination. In the distance the air over the great multi-coloured boulevard throbbed and tingled. The huge orchestra began to tune its instruments, and a thousand voices joined in the refrain. Suddenly he was in the midst of rows of carriages and shouting multitudes. The house-fronts loomed before him like giant trees covered with exotic birds. Carefully he climbed down the winding steps of his bus and put his feet gingerly into the rushing torrent. Then he steered over to the pavement where the Boulevard Montmartre opened out. He felt as if the buses, carriages, lorries, street-lamps, and even the advertisement hoardings, would tumble over the quay. And then the golden letters over the Gallery beckoned to him. There he would find his brother, and that was his home.

Inside he felt as comfortable as if he were sitting round a log fire in the winter. He could watch the working of the vast machine in whose wheels he was himself a tiny cog. Some guiding law governed the turmoil and ran through all the strange commotion. The movement rose and fell like a wave, and he felt its rhythm. There were always surprises, monuments that took his breath away, but even they fulfilled their appointed function and gradually he became accustomed to them, almost familiar. This colossus of a town had the capacity to control its vastness, and the leisure to smile occasionally. He could talk to it. Was its history not an intensified, multiplied record of human existence? Vincent had never dreamed of such a life. Great God, what if Theo had followed him to his peasants!

Theo smiled, and sometimes tired lines played about his lips. Theo was like his brother, only he resembled him as a soft, smooth cast resembles its original mould. Life was very pleasant. You developed and grew, or thought you did, because Paris was in continual process of evolution. You absorbed something of its rhythm, in fact you absorbed a great many things without noticing it. Living in Paris was like swimming without arms or legs. You simply breathed, the rest was done for you. You could not observe whether your being waxed or waned, and your personal contribution became less and less, in fact your personality seemed to vanish altogether. Vincent did not mind. What was his personality? Did it matter? Was it not infinitely better to merge it in a wide community? If only he could do it! It seemed to him that he had brought altogether the wrong baskets and pots and pans with him to Paris. All his vessels were much too clumsy, and he really ought to

begin again from the beginning and make them lighter.

He painted flowers. Never had he painted such things before, nor painted as he did then. These flowers supplanted his wooden clogs and his potatoes and even their atmosphere. His earthy colour and his soap-green tones were replaced by the colour of the outside of the Louvre, by a certain rhythmic swing, by the smile and the pathos that lay over Paris, and the rough strokes of the peasant painter gained a pliable grace. Vincent formulated a mighty baroque out of the curved ovals of the petals and the bursting buds. His baroque was as heavy as fruit and as tightly stretched as a bow. He did not paint the ephemeral objects in the vase that bloomed before his eyes, but he created a nobler bouquet, a whole town of bursting buds. Vincent painted Paris in his flowers, and Paris fell into the hollow of his hand like a blossom. The force which guided him was not, strangely enough, the influence of this or that painter, but the pressure of a cosmos, a new Greece, a new Italy. The phenomenon was the more peculiar in that Vincent placed himself deliberately under this influence, and instead of swamping his personality it merely isolated and emphasized it. He not only remained a Dutchman, but the one and only Dutchman who never lost his individuality in Paris. These flowers contain the same power that was revealed in the masks of the ploughmen and weavers of Nuenen. These roses, if you look close, are shod with wooden clogs, and their fragrance is mingled with the smells of Dutch dunes and moors. He came to Paris and reaped the selfsame harvest which, a century and a half earlier, a typical Frenchman—Watteau—had garnered in Holland. Just as Watteau's spirit was united to the spirit of Van Goyen and Vermeer, so was the heart of Vincent wedded to the baroque of Carpeaux and Delacroix. On looking back you can almost believe that you found some tendency to the baroque style in the earlier drawings. This tendency became the source of his style. Many of his flowers are like seascapes whose waves have become leaves. They remind you of simplified still-lifes by Monet, but Monet's hand seemed to glide easily into his forms, as if they were a garment held up for him to slip into, whereas Van Gogh's instinctive powers of resistance moulded his forms and his patterns to suit his will. His powerful colouring was inherited from Delacroix, only he did not use the light tones which Renoir loved, but the lustrous deep carpet tones of Delacroix. Vincent's glowing optimism found expression in colour schemes that resembled Delacroix without the eastern element. His universe was at this time a small one, and seemed to contain nothing but flowers, but this limitation was self-imposed. His still-life is portraiture, and looks as if a legitimate grandson of Rembrandt had taken a Delacroix portrait and had deepened the furrows of its expression. Where was the peasant now, the Ardappeleter, the barking shaggy dog? Where was the sinister past of

the anarchist? The Dutchman began to sing melodies from lungs which had nearly atrophied; they were tunes no one had ever heard before in Paris. The traces of his roughness added a new cadence to his art.

His conversation was just the same. There was a rich sonority in his rough speech, and everyone who heard him had to take notice. 'Il est drôle,' they said, but anyone who took the trouble to unravel his ill-strung sentences moved his chair a little nearer. No one knew his past history, which he kept to himself, for it would not have interested anyone. He came from some hole. Where else could he come from? Every place was a hole except Paris. The deep note Vincent struck was just what this circle of young painters wanted; there was something primitive and homely about it. The Dutchman transformed Parisian fashion into nobler form. Vincent simplified Paris, and the generation that was just coming into the inheritance of Manet—people like Seurat, Signac, Gauguin, and Lautrec—were looking for the very element he supplied. He got to know them all, and they were close enough to their predecessors not to break the continuity of tradition. Every one of them contributed his mite to the whole, and in so doing gained the strength and help he needed, just as the others had done before them in the seventeenth century in Holland, and earlier in Italy. Nevertheless there was some friction, how could it be otherwise? The little *entresol* was heated, not with *chauffage central,* but with controversy. These Frenchmen had a queer way of talking about art, partly in jest and partly in silly phrases, which suddenly turned serious. They mocked at the chic and virtuosity of masters who possessed neither. Corot was 'plain honest Corot', and Delacroix, whom they really respected, was the great 'Manitou'.

Vincent soon tumbled to Manet's novelty, and he found that Claude Monet and his friends, although they painted in the suburbs of Paris, had created an incredible new landscape. But someone in the *entresol,* about whom Vincent knew nothing, was bored to death by these landscapes, and thought Manet's methods merely a bourgeois routine. Van Gogh disliked this mud-slinging against such men. Manet was a fencer of the good old tradition, he fought not for himself and the present generation, but for the Spaniards, and he did it with the fist of a Frans Hals. 'Bravo!' someone thundered from the far corner, and so loudly that it might have meant the opposite, and then he heard a perfectly ludicrous story from the same corner about boxing and fencing. The voice in the corner belonged to Gauguin, who had a head like a Red Indian and an enormous nose. Anquetin told a joke of Degas' about Courbet, but his joke was drowned. Only little Émile Bernard, who always talked about religious pictures, took Vincent's side. And a contemptuous voice in the far corner thundered again: 'Quality lies in your fingers!' It was the Red Indian with the enormous nose. He had a

weird walking-stick with a painted mask instead of a grip, and wielding it like a spear he let it fly at Henner's *Odalisque,* and then, an inch before it touched the canvas, he drew it back. Vincent flinched, although he disliked Henner's picture. 'These worthies,' continued the thundering voice, 'could only think with their paws.' Lautrec made some obscene comment. 'These worthies'—and the spear flew once again at the *Odalisque*—'have made a manual exercise of painting to tickle the vulgar palate of the bourgeois. They are nothing but agile apes. Art has gone down the hill since Delacroix, and is dying a slow death. If the doctors were not so confoundedly clever it would have died long ago. They perform remarkable operations, cut out a piece of skin here, and graft in another piece somewhere else. Not one of them cares a tinker's curse what is under the skin. The same thing is happening to Europe.'

Van Gogh sat there and gaped, open-mouthed. Whenever he was in Gauguin's presence he felt that he must contradict him, if only because he thundered so vilely. Then suddenly his voice would become piercing as a dagger, and plunge into Vincent till he fairly writhed. Yet each time he noticed in Gauguin a profounder power of perception, almost a new instinct, and he wanted to make him a deep obeisance as though he belonged to a superior race. Gauguin noticed it—Vincent was not the only one—but the others concealed it. Sometimes Gauguin seemed like a brilliant actor who knew all the tricks of the boulevard, and then suddenly shed his Parisian guise and judged like a man who saw a bird's-eye view of Paris, and could point at once to the three or four eminences that really mattered. And it so happened that Vincent had never before noticed these pinnacles, which he seemed to pass over with a word. Degas was granted an inkling of the structure of art and the forgotten glories of Gothic France, which he built up again in the limbs and faces of French cocottes. Degas and Cézanne, another constructive builder, knew what mattered. The rest could not even be apostrophized with the famous expletive of General Cambronne.

What amazed Vincent so much was his immense intellectual prowess. Gauguin would on occasion not scruple to draw his weapon against himself. Once there was a quarrel in the *entresol* about Guillaumin and Pissarro. A youth from the École des Beaux-Arts was pouring contempt on the pointillism of the elder Pissarro. Gauguin, who had been Pissarro's pupil, gave the greenhorn his views on the honest craftsmanship of Pissarro compared with the cant of Bouguereau and company, with such vigour that the rest of the assembly simply heaved with laughter. Such a performance was just what Vincent adored. He liked the old Pissarro and his landscapes. Gauguin suggested, a little later, that in future Pissarro's technique would probably be included in the curriculum for girls' schools, but it was nevertheless quite beneficial to invalids, and provided a kind of antidote to the Parisian plague.

Lautrec, who stood close by, looking like a dwarf beside Gauguin's bulk, amused himself by observing the perplexed countenance of Van Gogh, to whom he proceeded to recommend a dentist in Paris who filled your teeth in exchange for painted canvases. One day Lautrec told Vincent the story of Gauguin's life. First of all he had been a sailor, then he had spent eleven years in a bank and had become a cunning stockbrocker. He had earned a lot of money and the means to support a family, and had been a proper bourgeois, like the sixty thousand other bank clerks in Paris. One day he simply threw up the bank and his comfortable income, and put on a painter's smock. Ever since the young man had starved. Vincent could not believe his ears. A bank clerk for eleven years—just fancy that! It was very odd. The dwarf suggested that, as Count of Toulouse, he himself had given up regal honours, for he might have wielded, instead of a painter's brushes, the baton of a marshal, and ridden beside the King of France, provided of course, that there was a king, and that he had learnt how to ride. Vincent did not regard Gauguin's history as a joke. In spite of all the differences he found a certain parallel between his fate and that of Gauguin. Gauguin's progress was, of course, far more important, and his sacrifices had been far more convincing, just as the rest of him, for all his Parisian *blague*, of which one might cure him, made him one of the most remarkable of men. Theo talked of the vanity of the Parisians, and said that very remarkable people could be found at every street corner. 'But not such artists!' cried Vincent. Every canvas of Gauguin was proof of his sincerity, and Huysmans was quite right in saying that he was the greatest hope of the age. Gauguin was really ahead of the Impressionists with his light-coloured landscapes, for neither nature nor his palette could mislead him, and he managed to preserve his lyrical quality. Theo smiled. His brother must always have an idol. He did not doubt Gauguin's future, but there were others whose conceit was inferior to Gauguin's but whose work was more promising.

These landscapes of Gauguin's, painted under Pissarro's influence, exercised a tremendous fascination upon Vincent, just because of their light luminous colour which he struggled vainly to attain. All his earlier work seemed heavy and over-emphasized to him. He strove to be more delicate, and tortured himself in trying to grind to powder his own powerful rhythm, which would not allow these delicate tones. In the attempt Vincent lost a good deal, he lost that simple and convincing quality and the pathos of his flower-pieces, and even his baroque style. Theo watched this process anxiously, said nothing, but needed to say nothing, because his brother could read his thoughts in his eyes. Was he to plant Brussels sprouts and potatoes in the middle of the boulevard? . . . Theo thought that, as a matter of fact, he should do so, and that he had really pictured Vincent's activity rather in that way. Vincent,

however, regarded such a procedure as merely misplaced affectation.

Nevertheless he knew quite well that he was losing something. His landscapes were lifeless, his colour went to pieces, and he could find spontaneous expression only at rare intervals. As soon as he left off painting landscapes all his old faculties seemed to come back to him, in fact they seemed to have grown as if they had been resting in the meantime. The obvious conclusion Vincent drew was that he must become a landscape painter at any price. One autumn evening, after an unsuccessful day spent on the banks of the Seine, he found on the dining-table, on a plate, two kippered herrings, which Theo had prepared for their supper. Vincent ran quickly into the room which he used as a studio and painted plate, herrings and all at one swoop, and it seemed as if he had suddenly been transported to Holland. The crackled yellow-gold skin turned into Dutch tones, which were placed on the canvas luminous and firm, so that the dead creatures were suddenly restored to new life. A Rembrandt in miniature! Theo was overwhelmed with wonder and amazement. Nobody could paint like that. This certainty that did not spend itself in the play of beautiful substances, and this almost tangible charm that was just thrown in with the whole vitality of the canvas, were qualities none of the younger generation could rival. Only a northern temperament could possess such terrific force. And Vincent painted other canvases like the fishes. Whenever his manner returned, so to speak, to Holland, his pictures simply flowed from his fingers, which proved to Vincent that Holland was worthless. Anything that seemed to come of its own accord was bound to be rubbish. He ceased to see with the vision of Van Goyen and of Ruisdael, and it would have been as difficult for him to imitate these masters as it was for him to approach more closely to the manner and the method of the Frenchmen. His studies after the nude presented even greater obstacles. He painted from models the whole winter, as long as he had enough money, and he asked everybody who came to see him for a sitting. On Sundays, when Theo tried to recover from the strain of his work and sat down to read a book, Vincent gazed at him, grumbled and mumbled till Theo took off his coat. A little later he had to strip his waistcoat, then his trousers, then his shirt, but in spite of his unceasing efforts Vincent made little progress during the winter. The palette of the Impressionists remained a dead thing in his hand. His pictures, painted with pure colours, were dirtier than the old ones with soap-green tones. His nudes were banal and even his drawing became halting. Colour impeded his work instead of giving it vitality.

Theo proceeded to put in his oar. Why should he force himself to paint in a manner alien to his nature? A year ago he had despised these Impressionists. Was there no one else on earth except them now?

No, there was no one else, except idiots and cowards, people who

would remain on the bottom rung of the ladder for ever if you did not kick them. There always had been and there always would be animals who could live only in herds.

Theo suggested that Impressionism was perhaps only a different herd, and he pointed to Monticelli, Vincent's demi-god, who had surely cared little for the palette of the young Paris painters.

But Monticelli—what sacrilege to drag him into such a discussion!—was what he had to be. He felt at home in his closely woven texture and could express what he wanted. To demand Impressionism from Monticelli was as asinine as to call on Rembrandt for the colours of the spectrum. Of course Vincent could have painted like Monticelli, why not? Only he would have to feel as he did, he would have to acquire Monticelli's thick coat of brush-work as you would acquire a new skin. Vincent would have loved to have a crocodile-skin like that. He was familiar with every phase of Monticelli and revered this painter who was despised by the mob; this besotted drunkard who cheerfully ended his days in a gutter; he revered him as a nephew of the old besotted, drunken Rembrandt, as a close relation of his own besotted kind. No one demanded Impressionism of Monticelli, but of Vincent, the plebeian of the present day. He demanded it of himself, just as he demanded honesty of himself. Monticelli's crocodile-hide would be a flimsy pretence for him, just as it would be a flimsy sham if he crawled back into his own Nuenen skin, supposing he could get over the disgust of putting it on again. The clear understanding that he was striving for was a clean palette; a dirty palette meant to him a dirty mind. He thought not only of Monticelli but of the Japanese. Did Theo know the meaning of their gay prints? Did Paris exist only for greedy collectors? Did it not also exist for the dream of gay and new prints? Paris would never be where it was if it did not cherish such longings. The simple pure air of Pissarro's landscapes was a necessary step towards realizing the Japanese dream. First he must learn to paint like that. He did not need to be a Gauguin to see the limits of Impressionism, which was a start, a very healthy start, but nothing more.

Theo suppressed the fact that this was Vincent's seventh start at least in the last couple of years, and that in Paris anybody could do something new every day. Vincent heard everything that Theo suppressed, and he immediately saw the dealer before his eyes. Vincent supposed that a dealer did not make very exacting demands upon an artist's conscience. In the trade it was perhaps not important.

Bitter words were exchanged occasionally. No one meant to be cruel, and the wisest plan was to take no notice, but if the other brother really took no notice, it was worse than ever. The unhappy *Odalisque* of Henner was a continual source of trouble. Theo had to leave the picture there on account of his chiefs, who admired Henner, and Theo had to

suffer much at their hands, because they wanted rows of Henners instead of pictures by these ruffians who puffed their smelly tobacco into the *entresol* every afternoon. Vincent saw a personal insult in this picture by Henner. Lautrec cracked jokes about it. Gauguin thundered and hurled his spear at it. Late one night, after Theo and Vincent had passed a tolerable evening, Vincent rushed into his brother's bedroom. 'Theo, take down that Henner!' Theo had the patience of an angel. 'All right, Vincent, I'll take him down!' 'To-morrow?' 'I can't to-morrow, because I've got a customer coming to see him.' 'A customer for Henner? What an ass the man must be! Theo, you mean to say you let anyone buy a picture like that?' 'I can't get rid of it any other way. I can't resign my job, because I——' 'Yes, you can—in fact, it's so disgusting that you ought to.' 'Then we would have nothing to eat.' 'Does that mean that you want to reproach me with living on your money? Yes, be straight, that's what you really want to say!' 'No, Vincent, I don't. I only wish you would realize——' 'I know, business!'

Sometimes Theo lost his patience. Henner was by no means the worst of them. Was he any worse than Ziem, whom Vincent valued so highly? Lautrec simply held his sides with laughter at Vincent's admirations. Ziem! the fellow with strawberries and cream! Vincent was wild. You might as well call Renoir a goody-goody. His palette was not at all the point. Ziem had fought for Delacroix when those present were still in long clothes, and you could accuse Delacroix of all kinds of similar oddities. Somebody announced that Vincent was going to write an article for the *Gazette des Beaux-Arts* about the inner life of Monsieur Ziem, and Lautrec stood in front of the Henner and declared that the nymph had a striking resemblance to a niece of his, a countess, and that he would undoubtedly have to proceed against the villain for defamation of his family.

This wretched Henner cropped up again and again all through the winter, even after it had been sold. And then there were other Henners, and the managers of the Gallery found the sale of Theo's pet pictures insufficiently lucrative. Vincent had an unfortunate habit of stewing over a subject, which he would throw into your face on the slightest provocation. If Theo attempted the meekest protest, Vincent immediately threatened complete rupture. The winter was always Vincent's worst time, because he could not let off steam in the open air and had to swallow his temper, which was very indigestible. The two brothers often sat opposite to one another in complete silence. Sometimes Theo would really have been glad if Vincent had taken rooms somewhere else, but he said nothing, and suffered all. It is questionable whether his silence sprang from fear of his stronger brother, or from patience. At other times, without any reason, Vincent was suddenly a different man. He would go and fetch flowers, although they were dear in winter. Then

he would run all the way to the place where he could get the particular
Dutch brew which Theo loved to drink.

'Theo, I know I am horrid. I torture the only man who is good to me,
but I am like that, I can't help it. What you think you see in me really
does not exist, and I often think that my inner nature is vulgar. But
perhaps my nature tortures me as much as it tortures you, possibly even
more—and possibly there is something besides my rottenness in me
which may some day gain the upper hand. I don't know, but it may.'

As soon as the winter was over he started his landscapes again. He
painted a great deal in Asnières with Bernard, who lived there with his
parents. His determination succeeded in making his pictures a little
lighter. Nobody helped him, but it may have been good for him that
Gauguin had left Paris for the Antilles. Vincent seemed on the way to
becoming a real Parisian painter, and of course one of the most modern
kind. It was the spring of the Neo-Impressionists. Seurat had exhibited
his *Grande Jatte,* and Signac was showing his first important canvases.
Both of them had a number of adherents, and the barely concealed
accession of the elder Pissarro into the New Group added greatly to its
prestige. To the horror of Messieurs Goupil, Theo exhibited these
pictures. He gathered together in the *entresol* the simple seascapes of
Seurat which made the *gens du boulevard* laugh, the more powerful
canvases of Pissarro in which one could still see reminiscences of Monet,
and the symphonies of Signac, which made most people scream.
Vincent spent whole nights with Seurat. His every instinct really
revolted against the new creed, which was quite clear, logical, prac-
ticable and all the rest, but as opposed to the soul of a Rembrandt or a
Millet as anything could be. It was all very well to be a craftsman, but to
reduce all painting to a rule-of-thumb was surely stuff and nonsense.

Seurat bowled him over with his simplicity. He was not concerned
with great deeds, nor was he a genius. No single act, not even that of a
genius, could counterbalance the frightful waste of energy of our times.
Was there ever a greater artist or a nobler mind than Delacroix? He had
realized the fate destined for our culture, and he had staked everything,
not to achieve personal distinction, but a general language, an art in
which others might share, without making it common. What had
happened to his efforts? Museum pieces for rich people, and painted
stocks and shares; that's what they had become. When they were
painted, the whole boulevard passed them by. Not even ten Delacroix
could check the interminable stream of sycophants who outraged even
the innermost shrine. One folly succeeded another, and the more
painters there were the more misunderstanding and paradox was put
into the world. Was there a happier creature than Renoir? But who
shared his bliss? Did even Renoir's extraordinary productive wealth
raise the level of contemporary art by a hair's-breadth? But Renoir and

Delacroix thought of the community, and they were equally remarkable as social pioneers and as artists, while the rest hankered only after their own glory, and were unintelligible even to the few experts.

A spark and Vincent was aflame! All that Seurat told him was merely the articulation of what had struggled for expression in his soul. In the Mauve period he had suggested something of the kind to his master, who rejected it as rubbish. Even simple spokesmen like Delacroix and Renoir were too complex for the masses. Perhaps others would be as great—Gauguin and Cézanne. But would they and their work help the people, art, or the world? They came and went, left large passages in art books behind them, and their work was so much cash-value on the shelves of the dealers or the walls of the snobs. The world remained ugly, and became uglier every day. Had it ever occurred to Vincent that one hundred picked works of modern art could not produce one single specimen of harmonious architecture, and that not one artist could be found to create anything of use to mankind. Art was a holiday, and what was more, a holiday for the people who had no weekdays at all; for people who did a decent day's work, especially for the best of them, art was an unattainable luxury.

Vincent stared. He confessed it had never occurred to him. Slowly Vincent's eyes perceived the graceful image of a benignant Muse—a brother of working men, a friend of beggars and of prostitutes, an outcast and an anarchist. Vincent did not blush before the gentle gaze of this goddess, and her all too human simplicity had for him the dignity of honour. Was not a similar quality in Rembrandt and in Millet the real secret of their greatness? And Vincent was the man Seurat wanted to liberate from the fetters of idealism and pledge to the production of useful objects! It was possible to feel all kinds of sympathy with mankind, in fact this sympathy was the real motive power of creative art; even the great destroyers had acted under a similar belief. Not the motive but its expression had to take on a more social form.

Vincent confessed his shame, because he had never considered these problems. Once more he looked into the abyss of his soul. How had he spent his life? Where had he passed it away? He felt himself face to face with a man before whom he was as dust.

Vincent's modesty seemed to Seurat to hold open the gate through which they could escape to freedom. There was to be no simulated simplicity. Nothing could be more offensive to Seurat than a heroic pose, and he detested anything that savoured of archaism like the plague. Vincent and Seurat were soon in perfect agreement. The communism they aspired to must of course be limited by the extent of natural possibilities. The individual, or psychic element of creative invention, for example, was to remain a personal affair. What they aimed at was a form, a style like that of Gothic art. Vincent was

transported with delight. But such a style demanded a profound faith, or, if not faith, an equally profound scepticism. Seurat regarded the faith of the Gothic period as ultimately nothing but the externalization of the social cohesion of the era, of which religious faith formed but a part. But was there a general tendency strong enough to create a common style of expression? If you were modest enough, you might perhaps find one. The aims of the idealists were dismissed off-hand, and only demonstrably sound convictions entered the sphere of their calculations. The new divinity was not God, but causation; no one doubted that twice two are four, and they attached some weight to chemistry and physics. The danger of being too scientific was not as great as the imminent chaos which faced the world, in fact it ceased to be dangerous altogether as soon as science was accepted as the frame and not the content of life. Since colour was the natural medium of modern painters, they formulated laws of colour. The discoveries of Constable and Delacroix gave them a full warrant for their procedure. The optic sciences, led by Chevreul, had already established laws governing the choice, arrangement, division and graduation of colours. So far these phenomena had been ascribed to the realm of subjected appearances, from which they must now be extricated. The linear structure of a picture could also be subjected to rational laws. The greater the number of regulations a painter had to observe, the more complete would be the abstraction of his picture. Were these rational laws a heavier burden upon artists than the regulations of the Mediæval Guilds or the Canons of the Church? If an artist's vision collapsed under the burden, his vision was probably not worth preserving. And if perhaps some really valuable creative conception was strangled by the new gospel, it would, at any rate, be better for the few to suffer than the many, and the world's burden would no doubt be lightened. The expansion of such a progressive school of painting might reasonably lead to the production of frescoes, and be the first signs of a general democratic style.

The new gospel seemed fairly convincing, but Vincent was more convinced by the general attitude of Seurat's mind than by his specific arguments, and even more by his uprightness. The situation was not quite so simple with Signac. Signac rejected everybody who disagreed with him in any particular, without further ado, and his intolerance formed an obstacle for Vincent, although he had more sympathy with Signac's craftsmanlike manner than with the slightly classical element in Seurat's art.

Thus he became a Neo-Impressionist, at any rate in theory. Vincent failed to grasp Seurat's final aim, which was to liberate pictorial art from the confines of frames, and to substitute for the easel, walls. How could Vincent, without a home, dream of interior decoration? Later, far away from Seurat, this possibility became a practical experience. All that

Vincent understood was the common-sense element in the new method and the honesty of its inventor. He began to *pointiller*, which was a bitter business for him. His hands slipped all too easily in obedience to his better instincts, and he lost the balance of his painfully constructed surface. Before he knew what had happened he found himself using a colour that was not purely chromatic. He had to confess, gnashing his teeth meanwhile, that his ego refused to submit to the rules of the craft. He failed to achieve the brilliance of Signac's surfaces, and still more the quiet structure of Seurat's work. Nevertheless he managed to paint a number of landscapes which conformed more or less to the new canon. They were lukewarm Van Goghs, not without charm, but lacking all real substance. Theo compared Vincent's efforts, though he did not say so, to the attempts of a man who tries to speak without words. The two brothers did not talk much about Vincent's latest passion, but when others were present Vincent would sometimes break out into glowing praise of Seurat, and enlarge on the merits of the new theory without substantiating his arguments. He disliked the name of the new movement, invented by Signac, because it seemed too pretentious. He belonged to the Impressionists *du petit boulevard*. Pissarro, Monet, Sisley were the Impressionists *du grand boulevard*. Seurat of course stood above all coteries. To Vincent's mind he combined the craftsmanship of an old mosaic-worker with the intelligence of a man of to-day. Seurat was the child of Classic Ages. Vincent was awestruck, for Seurat had seen the Greeks.

There was an oddity in Vincent's reference to the Greeks. He thought it rather absurd himself, and his speech became confounded when he had to refer to the subject. Lautrec called Seurat the 'Giotto du petit boulevard', and he compared Vincent to Orcagna. Signac, who detested unprofessional discussions, declared that Vincent had nothing whatever to do with Seurat and that he had better stick to his Dutch peasants. It would be easier to make a cat into a racehorse than Vincent into a Neo-Impressionist.

And he was right. There was something in Vincent that nodded agreement to Signac's rather brutal rejection of him. But Mauve and so many others had tried to stop his progress, and he had succeeded after all. Anyhow, he would not give in. He continued to divide his canvas into little points; he divided his very existence into spots, which lacked all luminosity, and he railed against the opposition of his nature, which really saved him. He refused all compromise, but occasionally, beneath his network of dots, could not help seeing a design which no amount of system could altogether blot out. As soon as he relaxed his efforts his own forms glided to the surface, and the little dots danced like water on a sheet of glowing metal. Theo met him once, on just such an occasion, somewhere near the Seine, and he snatched the picture from Vincent. It

was a hundred times better than all the 'Neos' put together.

It was a landscape. Vincent saw a kind of coarse Monet in it, whereas he wanted to produce a Signac. Theo saw the similarity to Monet, but what Vincent thought coarse was rather an enlargement of Monet's horizon. The whole picture shone like the sun at dawn; the landscape was divided only to grow together again as a luminous whole, more compact than the original which had inspired him. The technique employed was subject to no rules laid down by the painter before beginning his canvas. The whole was the answer to the demand of an instant, and consisted of dots and lines, as speech consists of various sounds.

Theo's approval was encouraging, although of course isolated praise, especially from a brother, was not worth a great deal. None the less he returned to his old methods, although he desired the opposite, and in his drawings, the beginner of Nuenen could be identified with ease.

'Thank the Lord,' said Theo. Now Parisian culture had been added to the solidity of the man from Nuenen. Above all, Vincent's personality was in his work. Hitherto he had been hampered by his old rags, but suddenly he had liberated himself from all encumbrances. His new colour was not assumed but the expression of his nature.

It was a curious fact that Vincent's development came about in direct opposition to his own will, while men like Seurat literally painted with their will-power. Therefore Seurat was bound to be right, and if Vincent produced a landscape that had luminosity, colour and composition—then it was chance. Vincent was convinced that efforts such as his could never produce a new Paris or a new Delacroix. Once you knew how painting should be done and failed to do it, as he did, you were merely vulgar. Such vulgarity would bring its own revenge. Every step forward in one direction was sure to be retrogressive in another, and he detested the idea of being a slave to his senses.

He tried to struggle with the new system again and again. He made himself persevere with his dots, and then the last five minutes generally sufficed to ruin the whole system and to save the picture. When the winter came he was painting portraits, and portraits always broke down his determination. He just let his brushes rip. One day, when he was with Émile Bernard, he painted at one sitting the Père Tanguy, who sold him his colours. His brushwork was as clear-cut as sword-thrusts; he surrounded old Tanguy's rough face with an even rougher kind of Japanese wall-paper, covered with masks, because Père Tanguy also sold him Japanese prints. Tanguy was no fool, and kept the picture, so Vincent painted him again at home, even lighter, even more Japanese—what Vincent thought Japanese—even flatter and bolder, though he wanted to be particularly careful the second time. In the same way he painted the street where they lived, and one day in a slightly

tired, almost happy mood, he painted the table with the French books
on it. It was a still-life, more profoundly organized even than his juicy
flower-pieces, and betrayed a finer mental activity, more like the spirit
of good French prose. He painted his friends, everyone who wanted to
be painted, and most often of all he painted himself, but his portraits
were not always as happy as the one of Père Tanguy. Occasionally the
ghosts of Nuenen appeared and spoiled his Japanese manner. Some-
times dark tones made their way into his palette; sometimes, worse still,
his lightness became too thin, and Vincent wandered in the dark with
his brush, like a blind man with his staff. Theo suffered agonies at such
times. Van Gogh was never completely an artist, even in his own
consciousness, and he lacked every form of pretension, but his nerves
lagged behind his sensibility. Art alone could keep them poised, for art
was for Vincent the only means of resolving the tension his mind and
soul experienced. This tension increased. The more he struggled with
any particular method, the more explosive were his pictures—at any
rate, the best of them. Seurat, Signac and the others, with their theories,
and even his own thoughts, had the same effect on him as ropes on a
balloon; they must be cut before the balloon can rise. The whole of Paris,
everything he saw and experienced there exercised the same influence
on him. Theo was well aware that the balloon was getting fuller and
fuller—almost to bursting point; he saw how this tension tortured the
man, though it was the greatest blessing to the artist. This was what
forced the brush into Vincent's hand, and not his model or the river in
the landscape. The objects he painted did not always exhaust the
explosive forces he brought to his task, so he found other outlets. He
said what he ought to have painted, and what could not be put into
words. Theo did not always make sufficient allowance for this latent
force, which multiplied its violence, if it met with the slightest
opposition. This characteristic repelled many, with the unfortunate
result for Theo that the circle of his intimate friends was broken. His
business of course brought a certain amount of intercourse in its train,
for material interests tied the artists to his *entresol*, but when Vincent
started, one by one they slipped away, and outside their comment was:
'Quel rasoir!' Vincent continued to hold forth, and noticed so little of the
change in the general attitude towards him, that in the winter of 1887 he
believed he had made considerable progress with his scheme for
founding a community of artists, which of course depended first of all on
the good will of the artists towards himself and each other. Vincent's
best side was hidden more and more from everyone except little Émile
Bernard, who, being the youngest among them, was more tolerant of
Vincent's mannerisms. Bernard got excited about some rival of his.
Vincent calmed him by pointing out what immeasurable bliss it was to
be a painter at all. Vincent simply leaped over his little friend's miseries,

and in the process tore himself away from his own. He would admit that you worried yourself to death for a hundred days on end, but then came one day which wiped out the memory of all the others. Perhaps being a painter did not mean much, still less how you painted, Impressionism or Neo-Impressionism. But it was marvellous that in this evil world there were still people who thought of God, although they were foul-mouthed, and went to brothels, and swallowed alcohol in buckets. They fought on God's side none the less, were reviled for His sake, praised Him with their coloured splodges, with curious hieroglyphics, with dirty lips, and miserable habits—all for God and only for God! They were all the same at bottom; Delacroix the cold man of the world, Manet the dandy, Monticelli the drunkard. Millet was not alone in his piety, Lautrec and Gauguin were not less so. Gauguin was a painter of saints, pure and simple, and he went to the colonies so that he should not be made ashamed. Where was God in Paris if not among the artists? And as there were not many of them, the only hope was for the artists to stick together in the fearful mass of Godless wretches.

Theo was roped in. Theo made millions for Messieurs Goupil et Cie. Theo with his kindness and his vision, Theo the most important man in Paris, more important than all the Vincents, spent his life in money-grubbing, and for others at that. Why? Did he want to be a capitalist? A man with such a kind heart and such a vision? Never! Why did he not bid a polite farewell to the Gallery and start something himself? Not a beastly shop, but a glorious undertaking for a community, for the sake of art and all good artists, and for the sake of mankind. The scheme was highly practicable, simplicity itself, and bound to succeed. He dreamed of a community of independent painters, based on a common idea, a common need, and a common hope. All Theo's friends would join in a modest start. He would choose the right people, choose their best work, and run a co-operative business. Not the individual, but the undertaking as a whole would trade. The receipts would be given, not to the painter of the picture, but to the community, from whom every member would obtain money, bread, wine, colours and canvas. Theo was to run the business, for everyone trusted him. He would cease to be a tradesman, and be the father and patriarch of the community. For the first year or so there would be difficulties, then the undertaking would gradually make itself felt. People like the Père Pissarro would join too. Of course he would have to get more than a young *copain* without a family. These details did not require discussion, for Theo would do the fair thing. The undertaking would become famous. They would then go to the provinces, to the country bourgeoisie, and also to the peasants; then abroad to Holland, where a few young spirits were sure to support them, and then on to Belgium and Germany. The proper way to do it of course would be to take a caravan round everywhere, and just put up an

exhibition like a circus. Then the undertaking would go farther afield, across the water to England and America. The rich people would roll up, for they would by then have heard something about it, and the community would be famous; then it would hail dollars. Once that happened they could travel about with ten caravans, with a hundred even, and found branches like Goupil et Cie, and thus serve God everywhere.

Theo felt like Sancho Panza who had to act on his master's fancies. He loathed his business life, and longed as much as Vincent to do other things, and sometimes he even believed in the possibility of new schemes. Pensive and cautious as Theo was, he suddenly became enamoured of Vincent's dream, and made wild plans for the new community in the course of excited evenings. Why should a co-operation of artists not succeed, as soon as you were convinced of the reliability and capacity of your members? Naturally the undertaking could not be put into practice as easily as Vincent imagined; it would require capital to begin with, and the overhead charges alone would probably amount to quite a considerable sum.

Overhead charges meant nothing to Vincent, and work and canvases were capital as well as money. He was prepared to begin still more modestly, by exchanging his own pictures for those of others, in order to acquire a stock. That could all be done on the quiet, without letting anybody notice it. He would swop with Signac, Seurat, Gauguin. Masterpieces by Monticelli could be bought for twenty francs, and he could also swop with Pissarro. Even the future members were to be told nothing, otherwise they were sure to let the cat out of the bag. And once they had got about a hundred pictures, they would have enough capital for quite a flourishing community; the cash expenditure involved would be almost negligible.

On the morrow Theo saw everything in a colder light, and he slunk to his shop with the feeling of having betrayed his employer and Vincent alike. Vincent sat at home, empty like a pricked balloon, staring into the rain, his head full of the wine of the night before, unable to work. Perhaps it was all nonsense. Was there really a link between people of such different temperaments? Lautrec, Gauguin and the others—he thought of their jokes. They were always cracking jokes. Were they really thinking about God when they fooled like that? . . . The rain rattled against the window-pane.

And so time passed by. Everyone had his work and his worry, and a thousand incidents intervened which did not improve matters. As everybody was trying to exhibit, Vincent went to the Père Tanguy with Lautrec and Bernard, gave him what he wanted, and the pictures were hung up in the Café Tambourin in the Avenue Clichy. If only he could sell something so that he could hope at any rate to pay for the expenses

of his colours and his canvas. All the others sold something. Lautrec's takings were enough to live on. Even Bernard got rid of a canvas now and again. Vincent alone sold nothing. He had placed his hopes in the Café Tambourin, because the lady at the cash-desk liked him, or pretended to. Theo warned him. The affair ended in the bankruptcy of the café, and he lost not only his pictures but even the frames.

In the light of such experiences it was not always easy to make plans for the future. The brothers met at night, and neither dared to open his mouth. Theo waited, Vincent waited. With great efforts they set the creaking apparatus of their enthusiasm in motion once again. It was easier when the lamp was lit, and especially if there was anything to drink. You had to get a bit drunk sometimes. Theo thought they must remember two difficulties; first, that the new community would have very few attractions for the public; secondly, that it would have immense attractions for all starving painters. The future would be better? Pissarro had hoped for thirty years. Monticelli had hoped himself into the gutter.

Vincent realized quite clearly that if he failed to rouse his brother from his present scepticism, the whole scheme would be buried in the limbo of forgotten ideas. As to the public, the public had been the same for the last thousand years, they had not changed since the days of Christ. Did Christ mind the public? Were they to wait until the public invited the artists to form a community, whose object was to screw the neck of the public till they could not even invite each other to tea? Sometimes he vowed he would not say anything more, but he continued to talk from habit, and because of the drink on the table. He lived in his dream, like a snail in its shell, and the place reeked of alcohol. His brother allowed himself to be convinced, also from habit. Others, too, could be convinced, if they were tackled properly—until the next morning.

Suddenly he gave it up. One evening when Theo instead of Vincent happened to be optimistic, he declared that he did not care about his scheme any more, and he pushed the bottle away. Why? No definite reason, just because he was tired of the whole affair. He was tired of his shell, he was tired of being in a place where you could keep warm only so long as you stayed at home. He wanted to go away, far away from everybody's theories and jokes, from their drivel and from this town! What was the cause of his brother's weakness? Paris might be better than The Hague and Amsterdam, and every other city in the world. For this very reason, Paris was all the more dangerous, because it absorbed the component individualities which made its strength. The stronger the town, the weaker its inhabitants. Everybody swaggered about the *entresol,* rode a high horse, cursed and swore and railed at God and the world. Once they were in the street, they became pedestrians who ran to

catch the 'bus. Everybody here could make a revolution, but nobody could build up anything out of it. Paris swallowed all power of action. It was due to money, which was more important there than elsewhere, and even more to something intangible, the asphalt or the air.

At last the peasant broke through. Strange that he had been silent for so long, but his yearning for the open was the more acute. Suddenly Vincent came to the conclusion that he could not endure Paris for another day. Where he went did not matter, as long as it was in the open, in the country among peasants. He would go anywhere except to Holland. He felt no longing whatsoever to return home. He had no home. He might find a home much more easily in this crazy town, or at any rate, a substitute, but as he did not want a substitute it hardly mattered where he went. He wanted to be left alone, alone with his Maker. Consequently he would live wherever it was most convenient, preferably in the south, where it was warm. The chill of this ocean of houses, where you only kept warm with alcohol, had nearly driven him crazy. Perhaps he could go to Marseilles, where Monticelli had lived. Bread was cheap and there was plenty of sunshine. Perhaps it would be easier to found his community there than in Paris. The south would make it easier for people to understand and share in the longing of the modern painters. Was there anything more absurd than this cult of sunshine in a town where the sun never shone? The allowance Theo had given him in Holland would be sufficient for Marseilles, and probably he could live there more comfortably.

Theo agreed to everything without being asked. There was no other solution, and all that mattered now was that this solution should be carried through as well as possible. It touched Theo very closely. He had often longed for his former mode of life, especially during the first winter he spent with his brother in Paris, when Vincent was so unbearable. What had hitherto been a perfectly legitimate excuse for a separation from his brother now suddenly assumed the aspect of burdens shared equally in the joint attempt to scale some height. Had they reached the summit, and, if they had, could they stay there? Vincent would reach the top undoubtedly. The progress he had made since the Nuenen days was staggering. In less than two years Vincent the Dutchman had become a European. And where was Theo all the while? . . . After all, what had annoyed him was really nothing but the progression of Vincent's development. The restlessness of creative activity prevented Vincent from leading a humdrum companionable existence. It was trying at times, of course, but it meant that you were sharing in his progress. If he lost the ability to share in his brother's life, he would have nothing left but a weary routine. He did not want that, he would rather be an adventurer, though he had not the least talent for such a career. He saw, clearer than ever, his way to founding Vincent's

community of painters. Vincent decided that if his brother really felt like that, he would probably translate their dreams into reality. While he founded a colony in the south, Theo could conquer England. There were Dutch art-dealers in London, old acquaintances with whom he could collaborate, Van Wisselingh, for instance. The public in Antwerp and in Brussels were already beginning to take an interest and to buy a few pictures. If Theo arrived in England with fifty well-chosen canvases he was bound to succeed. Even Theo thought it possible—in fact, probable. He became voluble on the subject, he could sell pictures all right if he was in the right mood, and had the right stuff to sell, especially if Goupil et Cie were not standing at his elbow. He could have sold a hundred times as many pictures in a different *entresol*. Why should he not make the attempt at once? Theo suddenly wondered why they were to part at the very moment when they saw everything eye to eye. At any rate Vincent's flight from Paris need not be permanent. An absence of a few weeks, as he insisted on seeing the south, but no more, and then they would join forces again.

Vincent was firm. Whatever Theo did in Paris was ten times as important as anything he or anyone else could do in the south, but he had to go. His blood froze in these streets. He had once found something in Paris—it was lovely, it was wildly beautiful—but he could only reach fuller expression in solitude. Perhaps he was filled to overflowing with the beauty he had seen and experienced, but he must be alone once more in Nature. Possibly he was wrong in going south, but he could not find out without going. He had visions of a different landscape, different from the Parisian landscapes as were his thoughts from the thoughts of the Parisians. Monet was splendid, Pissarro was splendid, and he could never do as well as they had done, but perhaps there was something in Nature, even more real, something that was perhaps too simple, too easy for these masters, but it lured him on. 'Theo, I must start all over again, I must go down into the earth, naked, once more—only for three or four years, that's all I have, but one more effort I must make. Somewhere beneath an open sky I must find it at last. There is wind down there which I long for. I must feel it on my skin. In Paris I have lost my sense for the wind altogether, in fact I am losing my very skin by degrees.'

They agreed to choose, not Marseilles, but Arles. A friend had told wonderful stories of the plain near Arles. Moreover living was cheaper there than in Marseilles, and he could get good peasant models. Peasants were the only possible people.

His brother nodded sadly. Vincent decorated their rooms on the last day while Theo was at the Gallery. He scrubbed and polished and tidied everything for the first time in his life. He pulled out his rolled-up canvases from beneath his bed, flattened them out and nailed them up

on the walls, so that Theo might still feel his brother's presence about him. Then he fetched flowers and put them in the middle of the table. They seemed pale by the side of the painted flowers which looked down on the deserted Theo with their great soft eyes.

CHAPTER V
Happiness in Arles

Vincent arrived in Arles on February the 26th, 1888. It was cold, and snow covered the streets. The plain and the mountains were wrapt in a white shroud, and only occasionally the wet blackness of curiously shaped trees could be seen. The inhabitants were queer, large-limbed creatures. Everything seemed very strange, but the atmosphere of Paris still clung to Vincent. He sent Theo the draft for a letter to Teersteeg, the obstreperous partner of Goupil in The Hague. It was a most important document for the campaign in England. Teersteeg, if he wanted, could open his doors to all the Impressionists, but of course he would only take those *du grand boulevard*. Somehow he had to be treated in such a way that he would have to approach the *grand boulevard* through the *petit boulevard*. Should he, however, fail to evince the necessary degree of attention, or even permit himself to be insulting by refusing to answer—which seemed quite probable—then one could play him a trick against which no defence was possible. Mauve, Teersteeg's most intimate friend, had recently died. How would it be to send his widow a picture by Vincent in the name of the new community, mind, in the name of the new community! Mauve presumably was worthy of the presentation of a picture. In addition, a letter might be written, without a word against Teersteeg in it, but between the lines it should appear that it was rather surprising to be ignored by him. Anybody who could not recognize the renaissance of painting was obviously blind. Or something to that effect should be put into the accompanying letter. Perhaps one might go so far as to suggest, quite casually, that his silence was little short of amazing. Amazing was just the word. It was high time to found the community. Gauguin had returned and was lying ill in Pont-Aven without money.

The white cloak that lay on Arles began to loosen and the townsman to thaw. Fortunately it took time. A sudden transition from the dusky sea of houses and buses and masses of people to the splendour of southern colour would have been insupportable. Arles was lovely, the squares, the Arlesian women, the Zouaves, the children, the hippopotamic priest in his surplice, even the brothels. The beauty here was overwhelming, and he slunk about like a Protestant in a cathedral

during High Mass. What had he, from the north, to do with this riot of colour? His journey seemed to him a preposterous intrusion. He hardly dared to touch anything.

Curiously enough what he saw before him did not seem altogether new. He had seen it all in the Japanese prints, not in detail, but he had seen this gaily coloured clarity of atmosphere which was so different from the northern sobriety. There was the Japan of his dreams, lucid and simple. In fact he had painted such a landscape already, or tried to. His own view of Impressionism or some such theory had driven him to the palette of these prints, but it seemed artificial in the unsuitable conditions of the north. The snow melted, and the almond trees began to bloom. A new landscape unfolded itself before his eyes that demanded this very palette if it was to be painted in its naked truth. Every day nature added a new treasure of colour; everything budded here ten times as fast as in the north. The rapid growth of Arles mocked his tentative search for the right tones. The mistral swept the plain, the rocks in the distance shimmered and the earth revealed a prodigal wealth. In Arles the first green of spring was the signal for a gigantic orchestra to start its overture with a fanfare. An immeasurable sky bent above him and shone into the farthest crevice, into the darkest corner of everyone's heart. The atmosphere took a load off his shoulders, and he moved as if borne along by wings instead of vulgar shoe-leather. He laughed once more and the heavy grooves of his face became radiant.

He began to paint. What else could he do? Painting was the only possibility, especially here, for if he ceased to paint the glory of the countryside would smother him. Outside the gates the blossom stood in rows of pink and white fountains. The air was thick with stars of pink and white and heavy-laden with the scent of almond-blossom. The trees formed long white tunnels which dissolved in the shimmering distance and melted into the rising mountains. A breath of air held this magic spectacle in suspense. There was a luminosity in the atmosphere that not only did not blur the impenetrable wonder, but actually gave edge to the tiniest details. The smallest leaf hung in the air clear like a suspended letter of the alphabet. The foaming glory of bloom was caught up in the twisted branches as if they were brown muscular arms, and every separate blossom in the foam shone like a star at night.

Vincent painted ten pictures of the flowery gardens of Arles in as many days. He considered his paintings not a thousandth part as fair as what he had seen, but regarded objectively, they were not so bad, they were a beginning. If he could work like that for a few years he might achieve something. But he could not wait a few years, only a few days, if he wanted to catch the almond-blossom. In a week it would all be gone. He dare not pause for a moment, and rushed early in the morning to the gates of Arles. The inhabitants stared curiously as this red-haired

creature raced past them.

At night, when he returned, he was exhausted and ravenous and swallowed his food. He had to feed well to paint like that, and not drink too much, although he could have gulped buckets-full. The brothel was no good either, for his blood had to flow quietly. Painting really required the health of a bull, and as none of the Impressionists of the *petit boulevard* could boast such health, art suffered. In bygone days artists were healthy people.

At this time he painted the drawbridge near Arles, with the yellow cart and the washerwoman by the stream. The canvas simply smiles at you, and there is already something of the south in it as well as a touch of Parisian spirit. Perhaps he would dedicate the picture to Teersteeg in gratitude for his kind answer to Vincent's letter. Theo had really sent one of his early garden pictures to Mauve's widow, and Teersteeg had taken the trouble to write a line in its praise. Such a success was not to be underestimated, and there was now some hope of winning his support for the new community.

Vincent probably led a double existence in Arles. Perhaps everybody in similar circumstances would have done the same. His painting was a sensuous surrender to a strange form of nature, really a wild orgy. He was like a sailor who comes into contact with women for the first time after he has dreamt all kinds of ideal dreams about them as mothers and sisters, and then is suddenly confronted by feminine nature, not mothers and sisters, but paradise and damnation. Paris had been a different experience, for there a mental relationship was given and taken in daily exchange. Physiological demands were resolved into interminable conversation. Paris was art, which was his own subject, and was full of painters, who were his own colleagues. In Arles there were Arlesian men and women, mountains, the sky and colours—things that had to be accepted in silence. In Arles everything was still shapeless and unpainted. In a few hours the diligence took him to Les Saintes Maries on the Mediterranean, and on the way he passed through country that reminded him of Ruisdael. On the shore there were boats, which he at once proceeded to draw and paint. He thought of the picture of the *Barges* by Monet which Theo owned. He felt that if he just painted everything he would approach the heart of the country more nearly. The plain of Arles extended from the gates of the town to Mont-Majour. Without its colour the plain reminded him of old Salomon Koninck.

Was it ever possible to substitute painting for life? Was such an existence not largely a pretty dream? Sometimes the sheer idea seemed to him a wild caprice. How had he stumbled upon the idea? None of the people whom he painted had ever thought of it. He hit on painting because he did not belong to these people. The normal course of action

would have been to talk with these people, to share their work, to visit
the brothels with them. But that life brought him nothing. Silence and
painting constituted his external existence. During the evening he sat
and read. Daudet's 'Tartarin' was a suitable book; these good Gascon
people little guessed what a *Tartarin* they had among them. He read
Zola, the Goncourts, Maupassant, everything he could get hold of. Zola
especially. Zola was his bread and butter. At night he devoured
literature as he had devoured light and colour in the day, and he did it to
counterbalance the strain of the day and to fill his exhausted brain again
somehow. What had reading to do with life? Or else he wrote to Theo at
the other end of the world about ideas that were never realized and
realities without an idea in them. He wrote too of his eternal lack of
money, his lack of colours and canvas, his frantic desire to paint more
and more, which was ruining his brother and did not bring in a penny,
but which drove him on irresistibly. His letters became a string of
requests, although they were prompted by the desire to give. Sometimes
he was so tired at night that the words of his letters danced on the paper
before his eyes. What had writing letters to do with life? Yes, he talked
to the postman, a charming fellow whom he painted, and there was also
a lieutenant in the Zouave regiment, a small friendly chap with a neck
like a bull and the eyes of a tiger. Milliet was his name, and he painted
him, for painting was Vincent's method of speech. Roulin, the kindly
postman, sat for him as often as he could and became his friend, the only
friend Vincent ever had except Theo.

He said a good deal in his pictures. His colours were as clear-cut as
brief questions and answers, and the words flew to and fro on his canvas.
Whether Theo gained anything by it or not there was life in the pictures.
Perhaps they contained a different life from that in the houses of the
little town, weaker and less simple, but to give them up meant giving up
art. Or was his passionate painting something other than the activity
generally referred to as art?

Sometimes he inclined to this view because he was carried away, could
not resist his impulse, and never thought while he painted. Occasionally
he felt it absurd to call such efforts an activity at all. Was there too little
of the animal or too little of the artist in him? A man like Courbet would
have adapted himself to such new surroundings with a playful ease.
Courbet therefore was the real master. What had Gauguin called him? A
hand without a head, a painting machine! Was he too a painting
machine?

He wrestled with art as with a deadly sin. It would have been more
decent to go to a brothel, and more sensible too. When the sun had gone
down he forced himself to take stock of his work. He discovered this
patch of colour which he might lighten, that stroke he could strengthen,
but he could only do it if he could feel that unifying rhythm which he

could no more control now than when he had painted the Père Tanguy. Though he could not control this dynamic rhythm, it pleased him when it had taken shape, for it seemed to be the most organic factor in his canvas. What eluded him was the relation between this organic rhythm and the brain whose hand produced it. He resolved to be careful and to place each stroke as deliberately as he used to in Nuenen or Drenthe; he determined to co-ordinate his rhythm to his will. It was his last thought at night. But the first ray of the sun which woke him brought the old impulse in all its strength back again. All day he was but the servant of his eye, the slave of his hand. What a miraculous country, with its golden sheen and its incomparable luminosity! Van Gogh had waited for these things too long already, and had starved while he waited, nor had he even known why. He saw no finished shape before his vision, but Nature raised to a higher potentiality, to an insatiable yellow. Wherever he turned he was driven, torn by overwhelming beauty. Nothing could keep him back. Before him was not the impenetrable work of human hands or human minds, but blossoming trees.

The difficulties before Vincent were immense. He felt the burden without seeing it. As a thinker, he was a disciple of Rembrandt and of Delacroix: as a painter, which he had become as the result of profound self-tuition and experience, he was a naturalist of the first water. He possessed a number of undeveloped intellectual aspirations, which might have stood him in good stead, but he put them on one side because he regarded such means as impure. The members of Pissarro's circle regarded as literary all painting which was not directly derived from Nature. Van Gogh followed their practice of painting visually as if it were one of the Ten Commandments. In fact he was not conscious of an alternative.

Herein lay the suffering of Van Gogh the individual. What had driven him out of Paris if not the desire for spiritual experience, and the quest after forms to express such an experience? The sensuous magic that sharpened the wit of the Parisians had surfeited him. And now he was faced by charm raised to its zenith, innocent of all the obstacles of Parisian scepticism. This overpowering charm was ultimately even more sensuous perhaps, but to Van Gogh, spiritual; it was the source of all French magic, the cradle of the race, and its exquisiteness tortured him. Spring here called for poetry, the country-side was filled with an ancient wealth, here the sun let men live and die. The inhabitants really ought to have worn Greek garments, their eyes were mirrors of an antique faith. What could Van Gogh contribute to the wonder of this spell? The prose of a Courbet or a Manet, a theory about blotches, a colour analysis—tools untouched by any magic.

Herein too lay the blessing for Van Gogh the artist. As he could only produce prose he had to penetrate more deeply than anyone else had

done before him. His eyes bit into every object, into trees and soil, like an axe. He kneaded the ephemeral air into a solid mass to create an equivalent to the magic. As everything was yellow, he had to paint yellow, but so that you could taste, hear, smell and touch it. He painted till he made the stone talk.

Now the struggle began. He had already acquired a style. His necessity invented a shorthand script instead of shapes and forms; in the process he had to discard the very last rags of superfluous manner. He painted like a man who, surprised by robbers, makes a fortress of his bedroom. He bent the nearest object into a shield and used the next one as his weapon. Van Gogh's need enriched his powers of improvisation. His oppressed self-consciousness rallied the forces of every experience. His style was the product of his Paris flower-pieces, his weavers from Nuenen, his peasants in Drenthe, but his latest acquisition, Impressionism, left the strongest traces. And the result resembled his earlier work as an event resembles the epic which immortalizes it. A tree painted by Vincent in Paris or Holland did not resemble the tree in its totality but was rather an incident, comparable only to its bark, its roots, or its branches. A tree painted by Vincent in Arles was like the life in a human face; it was so placed that had it been left out you could imagine nothing else in its place, just as you take the emphasized line between two eyes for a nose. Organic function took the place of the object. He ceased to paint trees, but growth, tree-like existence; not blossoms, but bloom. His drawings, mastered with incredible patience, used to be merely descriptive, and now became a monumental cohesion, which announced incomparably more important complexes. His trees became possibilities which might give birth to a hundred other organisms. The stroke of his brush, which had hitherto been a skilful instrument mastered by sheer determination, now became an organic entity with a life of its own, and the palette he had wearily acquired burst into flames.

In Paris, Van Gogh might have been described as a lyrical poet with occasional spontaneous inspirations; the sun of Arles made him the dramatist of modern art. This dramatic quality is his to such a degree that it has given him a place apart in modern painting. Time, who allots to every man his appointed place, will for once be at pains to discover his position in order of merit. Vincent, who always attempted to be with others and like others, was more apart than any other man of his age. The solitary position he occupies will always be an argument against him, for such positions are always suspicious. Delacroix was a dramatist, and the later Courbet, also the early Cézanne. These three names suffice to show the range of meaning which may attach to this concept. As long as Delacroix lived, a dramatist in art was also a poet, for his muse forged the past into the present. Delacroix's vision embraced cosmic spheres.

In Courbet's hands the dramatic quality was narrowed down to heighten his personality. *The Wave* in the Louvre is not only the strongest and the purest Courbet, but also his most ephemeral masterpiece. Cézanne attained his maturity by overcoming the dramatic element of his early dark legends. His individuality became more elusive as he exhausted it. Van Gogh, like Delacroix, had a tempest in his bosom, perhaps an even wilder tempest, perhaps an even more radiant 'sun in his head'. His super-dramatic gifts threatened to become physiological. He could neither achieve the self-mastery of Cézanne, nor could he pour his forces into the many and wide channels of Courbet, before he rose to the bold singularity of his masterpieces. On his own pinnacle there is room only for Van Gogh, no matter how many he has lured to follow him there. The drama of the man was predicted in his pictures. The tempest in the bosom of Delacroix was free from all physiological taint. His completed canvas is like the furioso of a Michael Angelo. Van Gogh fought against the painting machine that was in him, and longed for the cosmos of Delacroix. A more glowing heart never beat against the portals of humanity. He wanted to be a Delacroix, but from behind the portals all life had departed. The portals alone remained, though they seemed to beckon to him often. They opened upon chaos. And ultimately Vincent only saw with the vision of a Courbet. If he could see the visions of a Delacroix, or if Delacroix still lived, he would be his bond slave. Necessity made him into a Courbet, but a Courbet of heroism and tragedy. Necessity bent every stroke his brush ever set on canvas, and if it limited his art it intensified the artist; if it destroyed the bridge to Delacroix it destroyed every wall between ourselves and him. Much could be said against his pictures, but never that they could be different. Nothing was left but the crazy race to the summit and this dramatic element can be claimed by no other master in this century of great art. We race along with him, breathless—whither? No matter, for we follow a man, a hero, perhaps the last!

For these reasons something must be deducted from Vincent's claim as a European artist. Van Gogh belongs, as its first member, to a new anarchic Europe for which he wanted to save all the fundamental qualities of the old masters. This desire ennobles the anarchist against his own volition and raises him above Courbet, who wanted to preserve the old master's recipes. Van Gogh remained a Dutchman when his pictures had acquired a ponderous force hitherto unknown in the art of his fellow-countrymen, even when his eccentricity had broken through all the conventions peculiar to his quiet country. He remained a Dutchman, even in his colour. His work does not fit into any Dutch gallery, but no more do the old Dutchmen fit into the houses of modern Holland. The garden-houses of the sea-faring people had long ago become familiar with the gay colouring of their colonies, and in their

dwellings Van Gogh's bold contrasts rouse no incongruity. He was a Dutchman too in his incorruptibility of vision, which, even in the tumult of his strongest impressions in Arles, only dictated the portrayal of what was reality to him. He had the healthy naturalistic instincts and all the good characteristics of his race, but in a gigantically distorted form. Seeghers, the seventeenth-century etcher, may perhaps have been a spiritual relation of Vincent's on a small scale. The rudiments of Van Gogh's *écriture* may be found to an amazing degree in his work, and there are other men who show traits that link them to Van Gogh. The last of them drew on the assiduously stored treasures brought together by the vision of the minor Dutch painters of landscapes and interiors; in converting their hoard to his own uses, Vincent also became the master of another kind of creative action. In this well-constructed action there is an element which only one other master of the Netherlands, incomparably greater than Vincent and all his other countrymen, has achieved. Rembrandt, by his dramatic force, raised Dutch art out of the world of craftsmanship, skill and good taste into the higher and wider realm which appeals to all human hearts, even those that possess neither beautiful interiors, nor education, nor good taste. He raised Dutch art into a domain where it becomes the Mercury of a development which passes the bounds of international and social progress. Van Gogh did almost the same thing for Impressionism. The forces Van Gogh struggled with were not of course such organic and such vital complexes as Rembrandt was faced by, but they were that peculiar conglomeration known as Impressionism, and it is strange enough that it fell to the lot of this man, who once seemed an Ardappeleter by profession, to unite the forces which constituted this conglomeration of French art. Whether he succeeded in enlarging it is another matter. Van Gogh's contribution was not nearly as unqualified as that of Rembrandt. But was this many-sided conglomeration really capable of enlargement? Could it be given anything but solidity and synthesis? The action of Van Gogh was, too, a far less spiritual kind—and here the difference between the two Dutchmen widens into the gulf which divides two worlds—nor was it an exclusively personal achievement. If Rembrandt was the genius of a circle which he broke, Van Gogh was the servant of the idea which attempted to unite it again. He never regarded himself as anything but a vehicle for others' uses. In view of the means Van Gogh had at his disposal, we incline to regard his action as heroic. The finest element of his heroism was his wish to give a social significance to his deeds. Had Impressionism ever had a social meaning? The trick of the *Déjeuner sur l'herbe* was perhaps an effort in this direction, but at most one on the lines of Courbet's reaction, which was directed against a class, the bourgeois, for example, and never attempted to indicate a constructive ideal in place of its own destructive attack. And French art,

after all, in spite of Daumier and Courbet, and in spite of the quiet opposition of the Barbizon group, continued on a higher level, and perhaps less consciously, in obedience to the bourgeois instincts of the minor Dutchmen of the seventeenth century. French art gave less to the public and risked everything to reach the ultimate heights of sensibility and intuition. Intuition had not yet become a weapon in the subsequent warfare against popular tradition, for the artistic aims of the painters predominated. The revolution of Monet and Pissarro, at that time far more complete than that of Renoir and Cézanne, whose sense of tradition was uppermost, confined itself to the means an artist employed. They fought for a lighter and more gaily coloured interpretation of Nature, a theory they supported by a more or less scientific doctrine. The really decisive subjective factor lost more and more of its importance. This subjective factor is really part of the means Monet and Pissarro strove to revolutionize. Their art was art for art's sake, or rather for the sake of the light and colour of the air. Such a doctrine is ultimately the best means to destroy all art. And even Manet's work, though a piece of bravery, was only comparable to a bold performance before a circle of satiated amateurs. Every battle against such cultured mannerisms seemed possible only by means of a violent breach with such art, and the process threatened everything personal and everything of value in the nineteenth century. People were ready to accept almost any superstition, just as in Holland after the zenith of Dutch art had passed. We can see the prelude to the collapse of our own day in the fevered activity of the *Indépendants* after Vincent left Paris.

Van Gogh, the revolutionary, saved the tradition of Impressionism, or whatever portion could and should be saved, just as the Impressionists had saved the tradition of the old masters. The little boulevard came to the rescue of the big one. But this help was destined to be of use to an even larger community. Every simple-minded creature possessed of sensibility was to benefit by understanding this form of art. Van Gogh's work was a simplification, not of isolated means, but of the whole modern complex. To Van Gogh the senses were the road to the soul. His simplification was not for art's sake alone, but for the sake of the whole of soulless and thirsting humanity.

More painting, more colour, so as to reveal the play of sensibility and of new life, was the cry of Courbet and Manet. But how could the oppressed and burdened of the community play with life?

'More drawing!' said Vincent, for by drawing you reconstruct the world that has been torn to pieces. You must draw, not according to some ancient dusty scheme of rules, but with the brush-strokes of the early Manet and Monet, who were inspired by Courbet seascapes. You must draw with the secret baroque of Delacroix. Colour was in its shape, luminous as the blue sky or red fruit, but its form was solid as metal. Let

your brush revel in yellow, blue and orange. What eyes could resist the charm of such simple pleasures? Heighten your surfaces with the undulation of your brush, let them flutter like flags in the breeze, but master your colour with your drawing.

The pictures produced in Arles have a new flavour, they are richer. The Dutch ones savoured of earth; the new flavour seems to emanate from a certain structure of lines and from colour harmonies. The flavour is quite unprecedented. His very first still-life in Arles, the blue coffee service on the yellow ground, is full of it, although these enamelled blues are too hard against the yellow. The same flavour permeates his mature picture with the candlesticks, the onions, his pipe and tobacco, also the Gipsy Camp, and almost all the other landscapes produced in this fruitful summer. We are confronted by a phenomenon of taste, for they do not suggest any of the refined things that we are accustomed to honour as the height of good taste. Van Gogh does not exceed these canons by rising to an even higher level, but by an unexpected and improbable change of effect.

Was it possible for this creature from Drenthe, this proletarian *sans milieu*, who committed the most hair-raising breaches of taste in life, to show real taste in art? If he did, then so does the Serbian peasant in his embroidered linen smock. Vincent's colour harmonies are almost like traditional habits carried on from generation to generation without apparently any individual effort. His pictures look as if a whole nation of simple peasants had contributed simultaneously to his canvases, peasants who used his colour-scheme from an age-long tradition. If whatever other quality we feel in his colour is taste, it is related to other factors, stronger than himself, which carried him away and raised his work to an unusual level. The forces that are gathered together in the still-life with the onions radiate from the centre beyond the frame, and what seems to us good taste in the picture is not the tone of its colours, but the cohesion of these centrifugal forces which Van Gogh has bound together. What we call good taste in Van Gogh is a phenomenon diametrically opposed to the usual concept: it is the surprising fact, now grown visible, that onions, candlesticks, pipes and tobacco can in certain circumstances possess action of their own, that they can have unheard-of relations to one another and to ourselves. The good taste displayed in the picture is the pathos of its objects. If we perceived not onions, but a hero, Danton or Brutus, we would be careful not to describe this glowing pathos as good taste, and we do so in this case because we strive in vain to find the explanation of why we are moved so deeply, and so we seize upon the least adequate concept merely because it lies near at hand. It would be more appropriate to judge the passions of a painted Danton or Brutus by the canons of good taste, because a competent painter would probably create a peaceful still-life out of the stirring heroes of a

revolution.

Van Gogh exalted and dramatized Nature. His demon roused the object which had slept in the hands of the old Dutch still-life painters. Impressionism as such only succeeded in cleansing it without destroying its traditional semblance to reality. Van Gogh's irresistible force created a new pictorial reality. His taste consisted of his ability to let his onions remain onions, in spite of the emotional force he gave them; in fact his onions are more essentially onions, because the accident that hurled them into his canvas revealed the organic potentiality of their substance.

It is not difficult to find comparable examples of a kindred taste in the history of art. The portrait of 'L'Arlésienne' is like an actor's head by Sharaku. Van Gogh would undoubtedly have appreciated Sharaku more than any other Japanese painter, if he had known his work. But Vincent's kinship with Sharaku does not explain the demon in the European painter. Van Gogh's demoniacal naturalism is about as near to Sharaku as Eastern Asia to Europe. We can paper our walls delightfully with a Japanese effect, and what we enjoy first of all is the easily applicable element of bold Japanese designs on their silvery background. In addition Sharaku's faces please us, for we can just perceive their suppressed emotion. The Japanese method can also be applied to European art, especially if this art is either not sure enough or too sure of its Europeanism. Degas applied this method slowly, Whistler rapidly, and Van Gogh, at any rate in his most harmonious pictures, left it out. Sharaku added a certain exaggeration to the conventions of his countrymen, and thereby gave a new power to Japanese rhythm. Degas contributed a special anatomy, which was a reflection of modern psychology and modern manners. All these artists contributed industry, care and even sensibility to their work, and they succeeded in stirring a similar emotion in the spectator, but none of their contributions produce growth and progress. Van Gogh produced a vital tension. The whole course of his evolution seems, up to this point, to have aimed at dragging the tension that was always in him to the surface, where it touches a fuse and then explodes. His painting is comparable to burning guncotton. The flames resemble radiant gardens, flaming trees, chasing clouds, glowing suns. By comparison, the Paris flower-pieces, in which the glow first showed, look like hothouse plants. We enjoy these flames in his carefully dominated baroque, in his curiously curved arabesques which we take for onions, candlesticks and tobacco. We rush to interpretation with the violence of these flames. Perhaps there are as many interpretations to be found in Sharaku, and Degas contains matter for a host of them, but nothing urges us to their interpretation, for the violent flames are lacking. This motive is so strong in 'L'Arlésienne' that I once inquired about Van Gogh from an

old woman, who could be no other than his model, in the small café on the Place Lamartine in Arles, twenty years after Vincent's death. We talked about him as if he had just left the table and was coming back again shortly. In one of the two versions of this picture the tension is a trifle weaker, although in composition and in colour it resembles the other closely, and its decorative element immediately represses our impulse to interpretation. We are faced almost by a Sharaku.

There is nothing new in Van Gogh's method, and the attempt to ascribe the invention of a new theory to him, such as Expressionism, is to debase the artist. His method is the method of Rembrandt, Rubens, Greco, Delacroix, raised to a demoniacal pitch, because he spent his art upon a table with tobacco, candlesticks and onions, because this romanticist with the hurricane in his bosom turned the Pegasus of contemplation into a war-horse, because this Don Quixote fought for the fiery emblem of his spirit with sunflowers and peach blossoms. The contrast between the old world and the new has never appeared more drastic or moved us so much.

As the summer drew on with the intensity of its life throbbing in every blade of grass, Van Gogh revealed himself in all his nakedness. He painted as in a trance, intoxicated by the south, and as if the brilliant colouring acted like whip and spur to his senses, because the light had been denied to his race from the day of its inception. He felt Nature standing above him, and it seemed as if he were not painting the pictures, but as if the sun throbbed and beat on his brush, as the blood throbbed and beat in his veins. His agony was due perhaps to the fact that he was conscious of the demon in him, whom he served, and whose northern extraction forbade him to surrender to the ecstasy of the south.

In the midst of his wild enjoyment of his work, he guessed the insufficiency of his creation and he experienced Hyperion's desire for other joys. What he did was not real life. 'It would be less costly to bring children into this world.' Would it not be better to be with others? Certainly more healthy. His body suffered from many years of starvation. He continued to live very simply, although he chose his food with greater care. 'I have to live as if I were suffering already from a serious nervous complaint. . . . Most important of all is not to do anything silly, to be tempted by women or real life!' Paris had done him harm. In Paris he had blamed Drenthe, in Drenthe, the Borinage. Perhaps there had been too much drink in Paris. Now he painted more and drank less, but it hardly improved matters. Theo complained too, quite frequently. The doctor said there was something wrong with his heart, but he probably meant his head. There was something wrong with everybody's head. Art is to blame, your brain goes to pieces, but art flourishes.

In order to have a home for his pictures he rented half of an empty

house in the Place Lamartine. The house was yellow outside and white inside, and the floor was covered with gorgeous red tiles. The rent was fifteen francs a month, but he simply could not leave his pictures for ever in his hideous room at the inn. In the house they looked splendid against the white walls. He would like to have lived in the house, but that meant buying furniture. He had the doors and the window-frames painted white, and that cost another ten francs. The effect was magnificent, only it was a shame of course that Theo might have spent it on a holiday to get better, especially now that he had to help Gauguin, who was starving in Pont-Aven. The best solution was really to let Gauguin come to Arles. Two together spend only a little more than one if things are managed the right way. There was room enough in the house; they could cook their own food. . . . If Gauguin did not like the idea he might tell Bernard or one of the others. There really ought to be a whole colony of artists in Arles who lived and worked together like the old Dutch painters. Of course the colony might also be in Brittany, and he was quite ready to go there at once, only of course the south had advantages—light and colour. If the future produced a great master he was sure to be a colourist.

In no time Vincent had produced another scheme, a continuation of the community he had wanted to found the year before. Vincent had, as a matter of fact, never really abandoned the original scheme, and he exchanged pictures regularly with his friends, with the result that Theo had quite a collection of the works *du petit boulevard*. This exchange, however, was a pure matter of business, and he was now concerned with something altogether different. He was convinced that by working together new values might be attained, far richer, more general and more useful than if the one toiled in Pont-Aven, the other in Arles and the third in Paris. Apart from the fact that such a communal existence would really lend meaning to a painter's life, it would also obviate the necessity of playing the clown among the Arlesian peasantry. Vincent cautiously began to prepare his brother for his new idea, although he was silent on what was to Vincent the most vital element, his burning personal necessity. He wrote to Theo about painting and the practical advantages of the scheme. He threw out wild hints to Gauguin at the same time. Gauguin did not care a fig about Arles; he would sooner be surrounded by a herd in Pont-Aven, provided he did not die of hunger, and he was planning a scheme for Paris, art-dealing on an enormous scale, with half a million of money and himself as manager. Vincent waited patiently, he would not dream of interfering with Gauguin's scheme in any way. Perhaps it was even immodest of him to have suggested such an idea to an artist like Gauguin.

In the meantime he lived on ship's biscuit for a few weeks, because his models ran away with so much money. He only paid them their meals,

but even that mounted up. Roulin, the postman with a head like
Socrates, liked to sit to him. Roulin was a splendid creature and a
revolutionary. When he sang the Marseillaise, Vincent could have
fancied he was living through 1792, and he thought of Daumier. If he
could have afforded it he would have painted only men like Roulin. The
human body afforded him the strongest means of expression, especially
people like the postman, with whom he stood in close relation, or, for
instance, Gauguin. His portraits made him realize that he owed much
more to the ideas of Delacroix than to those of the Impressionists. His
powerful colouring, his haphazard methods, his not at all haphazard
sensibility and vision, were not like the Impressionists, and were more
and more divorced from their *pointillism.* Of course he divided his
surfaces as they did to make them luminous, but without in any way
following a theory, and he gathered his colour with powerful strokes
where the drawing demanded it. The Impressionists used colour as a
description for Nature, not exclusively of course—every one had his
own palette—but half of it served this purpose, while real painting only
required the other half. For Vincent colour was the spring-board from
which he vaulted over Nature; local colour provided him with his start.
He painted a head of somebody whom he liked, for instance, as true to
Nature as possible, fair or brown as the case might be. 'Then comes the
really important part, the wilful heightening of the colour scheme.
Blond hair is raised to orange, then to chrome, or even pale lemon
colour. Then the stupid wall behind the head is taken away and a simple
background of rich blue extends to infinity. And with a simple
combination of two rich colours it is possible to give luminosity to a
head, as mysterious as a star in the azure sky.' Of course he could not do
that every time, and he could not paint a Parisian bounder in that way.
He had started to paint the Père Tanguy in this fashion, because
Tanguy's appreciation of not at all bourgeois delights made him, too,
into a kind of revolutionary, and Vincent was fond of him. When he
painted this portrait he had not dared to follow his impulse altogether
as Delacroix had done, but he had followed Monet's methods. He
wanted to get to a point at which his own relation to his original was
defined by the use of his colour, which necessitates a close acquaintance
with the model. And for this reason it would be an excellent thing to
have people about you, Gauguin, for instance. Gauguin could deliver a
picture a month to Theo in exchange for his keep in Arles. It would be
rather expensive for Theo, but twelve pictures a year by Gauguin were
not to be despised. Gauguin might not want to be so far away from Paris,
for he belonged to the group that still hoped for success. Vincent had
given up the idea of success long ago. But whether Gauguin would come
or not, it would be as well to get the house ready so that he could sleep in
it and be able to put up a friend. Living in hotels and eating in cafés did

not agree with Vincent at all. There are bohemians who would enjoy such a life, but a working man must have some place of his own. Cafés were poison to anyone who inclined to sinister thoughts; hence the wild colours in his 'Night Café': 'To show that it is a place where you might go mad or commit a crime . . . with a subterranean atmosphere, suffering and darkness which haunt you in your bed at night.'

Theo inherited a small sum from his uncle in The Hague, which he spent on Gauguin and on fitting up the house in Arles. Vincent bought white kitchen chairs and a solid white-wood table which looked splendid with the white walls, and put this furniture in the studio room with the gorgeous red-tiled floor. A large number of portraits were nailed up on the walls, some of Vincent's, but especially other people's. Theo was to continue to exchange as many pictures as possible. Anybody who wanted a picture could have one or two in exchange for a self-portrait. Such a studio with a series of painters' portraits was very jolly. 'It will have a character *à la Daumier,* and I dare to prophesy that it will not be banal.' But the best room of all was the guest-chamber, which contained a peasant bed of walnut wood. It was a double bed, because a double bed looked somehow more restful and solid and peaceable. He hung up his 'Sunflowers' opposite the bed. He managed to buy a white bedstead for himself, second-hand, which he thought of decorating. He would paint the figure of a woman on one side, or perhaps a cradle. He spent four hundred francs on furnishing the house, and it would be a pity if no one was going to occupy the guest-room. Theo could at any rate spend his holidays there. Gauguin of course would only come if it was to his advantage to do so. There was no harm in that, a great artist could suit his own convenience, but if Vincent acted in such a way it would be another matter. Above all, Gauguin was not to be pressed to come; the best plan was to let him go his own way. He could, however, be sure of one thing, and that was that he would not find a better friend anywhere else. The time was perhaps ripe to ask: 'Are you coming or not?'

This period was the happiest time of Vincent's life. His little yellow house gave him a sense of security. If Gauguin would not come, somebody was sure to pass through Arles every now and again and spend a night with him. Even if no stray travellers turned up, there would be others after him to whom he would leave the house, people who would continue the work he had done there and who would do it better. Continuation mattered more than anything else. If he painted awkwardly and badly—Vincent had no illusions—he would hand on a roof to abler successors. The house was a real artist's home for people who had no place in the world. For in these days art had grown superfluous, and would not exist much longer. Only fragments stirred here and there. And for how long?

By a happy chance Theo had just been to Bing's attic and acquired a

number of fine Japanese prints which would decorate the house magnificently. The yellow home was to be a small Japan, an island. He would lead the quiet existence of the great Hokusai, and anyone who entered would see at once that only peaceful work was done there.

Once the hope of having a wife and children had spurred him on. Now his energy was increased by the prospect of sharing his house and his work with others. Gauguin wrote he would bring a few others with him. The more the merrier! The yellow house would soon become the great studio of the south, with Gauguin at the head of it. His joy overflowed into his pictures and his colours sang. He painted day and night, and lived on bread and coffee to save his money for his work. The mistral was particularly malicious that year, and while it blew he could not leave the house, but he did not waste a second.

He painted his pictures of the local park. The park was close to his house. The park was like a garden that poets dreamed of, not the work of any gardener. The oleander was still in bloom, and there were veritable fountains of blossoms. As soon as a bloom faded ten new ones appeared. The cedars and cypresses added their powerful green. He had to paint the park just as it grew and blossomed, and to exaggerate the effect if possible, not the trees and the plants, but their wild riot of colour, and at the same time the picture must preserve the solemnity of the cypress trees. Pairs of lovers wandered about on the pink paths; they fitted admirably into the scene.

A whole cycle was created here called the 'Poet's Garden', for he could fancy that southern poets like Dante, for instance, had their visions in such gardens. The cycle was to be hung in Gauguin's room, for he was bound to arrive soon. The pair on the edge of the wood belonged to the cycle; two people, a luminous chord made with three strokes and painted with his fist—blue, yellow and pink—in front of a row of burning cypress trees. He linked the human forms to the landscape simply by his rhythm, not as Courbet did who added one element to the other, but organically, as Vincent thought Monticelli painted landscapes and figures, with one impulse. He despaired of recapturing Monticelli's adorable magic, which resembled the amorous droning of bees in the shade. He supposed that he needed a lighter heart, and that he ought to have tasted the honey instead of carrying with him in his heart the image of forbidden fruit.

The progressive continuity Vincent believed in was achieved. He lightened the heavy impasto of Monticelli, substituted clear structure for Monticelli's vague vibrations, and symphony for his droning bees. Vincent's hard struggle led him miles beyond the retrograde performances of his beloved Monticelli. He lacked that amorous charm which was in reality much too insignificant for him, but he possessed instead a nobler consciousness of humanity. At this time he had sinister

thoughts, as always. He fought with all his might to exclude the trace of them from his pictures, and saved them up for his leisure hours, when the mistral blew. Above the goal towards which he strove there shone high in the sky a star to which he raised his eyes in secret: the genius of the man with the hurricane in his bosom and the sun in his head. In Delacroix he found the secret of that order which tames the wild confusion of unruly impulse. His fondest hope was to be master of his little field as Delacroix was of all the world. Delacroix's colour flowed like fiery lava from a crater, but a miraculous system of canals spread his colour all over his canvas. Vincent surrendered himself as completely as the great Master to his impressions, but whereas the vision of Delacroix was fed by many sources and demanded therefore a richer mind to control them, Vincent's impressions emanated from a single source; for this reason they flow forth with a proportionate violence. The methods were more primitive, the canals, which Van Gogh spread over his pictures, were wider and arranged more hastily. You can see his haste— like a man setting his house in order when Death is knocking at the door. There is an element of madness in the way Van Gogh surrendered to his sensibility, and of violence in his reflection. It is a miracle that he brings his forces to success, but he hardly ever failed at this time. He painted with 'the blindness and the clairvoyance of a lover'. The amorous couples in his pictures increased. The ringing tones of the colour of their clothes suggest that they love each other. In the south everybody was in love—provided there were two of them. Milliet, the lieutenant in the Zouave regiment, always had as many Arlesian ladies about him as he wanted, so much so that he was almost bored with them. On the other hand, of course, he could not paint them. Vincent painted them, but it was the only approach he made to them.

Autumn began to assume its colours. There were more and more new yellows, and the vines spilt their red blood. He wanted neither to sleep nor to eat, but merely to look at the world. His eyes could hardly bear the strain. Sometimes he longed to shut himself up in a dark room to write letters and to rest his eyes. His pictures were festivals of harvest in the vineyards and in the fields. His colours fell from his palette like ripe fruit from the tree. He needed a thousand hands to paint with, and he longed sometimes for the density of the idler, for it would have prolonged the glory.

Gauguin seemed depressed and dissatisfied with his work, and still ill. He wrote that he would come as soon as he could. He had written that for the tenth time. He sent his portrait instead, which revealed a colourless, neglected, sinister face. Vincent could have screamed in anger at the folly of people who were ill in the north and lacked the energy to recover their health in the south. If only Gauguin would not stay in Pont-Aven! Perhaps he would never come. People were lazy;

Vincent had never felt such a mastery over his energy. The little yellow house became fuller and fuller of radiant pictures, and it was due to the south. How else could he explain his progress since he left Paris? He wrote and told Theo so in every letter. He wanted to recommend every painter, no matter who he was or where he came from, to try the prescription to which Delacroix, Monticelli, Renoir and Cézanne had owed their health. It was this light without shadows, the warmth, the simple people, the food and the wine, all of which might have a very different complexion elsewhere, or a different mood. But the best thing of all was the yellow house, with its white rooms and red-tiled floors. Who could tell whether the yellow house was not more important than Arles and the whole Provence?

The house at any rate helped to give his painting a new direction. At first he nailed up the pictures that looked well on the white walls, and then it occurred to him one day to paint a cycle specially for the house. It consisted of fifteen pictures of equal size. The series was not intended to be a sequence in the narrower sense of the word, but there was to be some sort of connecting link between all the pictures. They were conceived like the four pictures of the 'Poet's Garden' and formed a group, each picture being an entity in itself, but fitting into the rhythm of the series. Once he was out of doors he forgot his immediate intention, but he remembered instinctively the image of the yellow house with its white walls, the 'home of art' for others. This latent consciousness tamed his impulse, widened the violence of his vision, and emphasized his rhythm. He was subject to other restraining influences and impulses at the same time. Delacroix was ever at his elbow, and the vision of a faëry Japan shimmered like a mirage over the landscape. It was as if these forces made a path along which he travelled, after his own peculiar impulse had set his work in motion. And now Vincent understood several things that Seurat had told him, which at the time had seemed only the sudden flash of light in the alcoholic fog of his nights in Paris. He suddenly realized the meaning of the word 'decoration'. Seurat had made his search for a new democratic style the substance of his rationalism. Seurat lacked nothing but the essential flaming image. He perceived the necessity for action, he possessed the implements and the materials for the construction of a community, but he lacked the convincing experience and the fundamental faith on which his new church could be built. He was a primitive like Van Gogh, in some respects perhaps even more primitive, and certainly too primitive in his seclusion from the world. Seurat was a noble being, kindly and virtuous, but he did not possess the associative impulse. He could have made his dots in any corner of the globe; he was a scholar and a specialist. The Japanese, whom Vincent dreamed of, would have counted Seurat as one of themselves far more readily than Van Gogh,

but Van Gogh did possess the associative impulse. It was the Alpha and the Omega of his life, his joy, his motive and his destiny. It had driven him through various peoples and countries, through various professions, and it drove him on now to enlarge the boundaries of his present occupation. It led him to decoration, if it should prove to be a suitable path to the community and to humanity. The search of such seekers is always unconscious. If they were conscious of their search they would never find anything worth looking for. They serve their longing as others serve their employers, and they fail to notice that they no longer control the form of activity they believe themselves to have chosen. Vincent was most surprised to recognize decorative possibilities in his painting; it had never occurred to him to see in this development the inevitable evolution of his natural impulse. And for this very reason he produced more than mere ornamentation. Decoration was to Van Gogh nothing but the externalization of his activity, and it retained its dramatic quality in every line. Accustomed to attribute every step forward to the help of others, he wrote letters of glowing gratitude to Theo, who had given him the yellow house. The house had helped and guided him in this work, and he requested that Seurat should be told how often he thought of him, and how indebted he felt towards him. He suggested to Theo that he ought to buy all the important works by Seurat for their community, and pay not less than five thousand francs for each picture. Van Gogh never suggested that he might find his way to decoration along a road which went in the opposite direction to Seurat's path. Seurat had aimed at something of the kind, and that was quite sufficient. His cup of gratitude was full to overflowing.

He might also have remembered his own feeble efforts, such as his drawing called 'Sorrow', the naked woman who illustrated misery, and which was decorative in a very cheap way. At the time he made this drawing his sensibility was not less impassioned, but the contrast between his sensibility and his form was as banal as possible. The evolution of Van Gogh is the history of his effort to master this contrast. His success was not achieved by any lessening of his sensibility, or by applied rationalism of any kind, but by the growth of his spiritual forces. His sensibility rose from the depths of an imagined life to such a height, where he maintained it with the utmost exertion, that all his failings slipped from off it like mud, and left bare the solid masses of a rhythmic structure. Seurat dreamed of organized ornamentation, and hoped for the day when he might mechanically construct new legends suitable for wall spaces. He believed that he might be able to substitute physical speculations for the eclecticism of Puvis de Chavannes and his own classical tradition. He was a new type of academician, milder and more intelligent than the old variety, but his substance was old wine in new bottles. Van Gogh never speculated. His faith was that if he painted

what his vision saw in men and in trees, and if he let his sun glow like a red ball of flame, made his clouds chase, cut into sods like a plough, in fact if he painted as he felt, he must be right, and the result might possibly be decorative as well. Even decoration was nothing but expression raised to a certain level.

Van Gogh's new trend brought new qualities to light in his work. While he was working at his series of fifteen pictures he painted the Pont de Trinquetaille and the street-tunnel under the railway. Both these pictures were painted without reference to the palette he had chosen for his series for the house and without the least idea of decoration. They seem to contain a formula of unheard-of power for the cold, strait-laced elegance of this era of machinery. Van Gogh's railway bridge possessed the new style that we dream of for modern architecture, and as a matter of fact the decorative charm of many of his pictures can be traced directly to their architectural form. In some of his pictures of olive-orchards the intertwined trees resemble the structure of northern columns. His quadrangular fields have the air of plans for immense halls. His picture of his Spartan bedroom with its heavy-footed furniture on the straight-lined floor has the pomp of a primitive temple. His palette gave a scintillating vitality to his yellows, violets, blues, greens, crimsons, scarlets. All that he prayed for in his temple was sung by his colours.

When he knew definitely that Gauguin was coming he had gas laid on, and he sacrificed half his month's allowance in order to complete the furniture in the guest-chamber. The four pictures of the 'Poet's Garden' hung in real frames on the white walls. Theo could not help making a mild criticism. The installation in the yellow house and the ever-increasing expenses for colours and canvas had made a large hole in his pocket. And this time Vincent even failed to evince his usual contrition for his wild extravagance. It had cost a heap of money, but it was worth it. For the first time he could look at his work and judge of it. Something had been achieved in the last eight months. Where was the *pointillist*, the Paris gabbler, the sick man, the Paris tippler and pessimist? It had cost a lot of money, but he had a lot to show for it. And he was only about to make his real start. After having got over the worst by himself, everything would be child's play when two of them were working together. The harvest had never been so rich. Grapes weighing pounds hung in clusters on the vines, and there was barely enough room to store the olives. Autumn was aflame in all its coloured glory, and the yellow house stood in its midst like a vat in a vineyard.

The Brotherhood of the South

Gauguin arrived in Arles on the 20th of October, 1888, exactly eight months after Vincent's arrival there. Gauguin was the most remarkable creature. Vincent had expected to find a suffering invalid, and instead he met the athletic giant he had seen in Paris, one mass of muscle and sinew. He was a mixture of a Parisian and an aborigine. His exterior was cold, and yet he possessed a touchingly soft heart, and he was a unique artist. You could guess that even from his rapid grasp of the necessities of life. He would settle in an instant what presented a labyrinth of problems to Vincent. Gauguin was as practical as a man could be and his decisions were arrived at instantaneously. You saved no end of time with such a man, a perfect treasure in the house, and it gave you a sense of security. He was a most remarkable artist and a most extraordinary friend. He was a trifle short with acquaintances, and laughed when Vincent stressed a point of Roulin's or spoke of the kindliness of all these folk. None the less everyone submitted to his will, and he seemed invariably to find the right word on the right occasion. His habits were the habits of a ruler. In fact his was a ruler's nature as every artist's should be; he was a Rubens. Undoubtedly he would have made a good statesman, he knew all about politics, and had his own opinion on Carnot, Clemenceau, Rochefort, Freycinet, Jules Ferry and on parliamentary republics. He was also a distinguished financier, a faculty he had presumably acquired in his earlier profession. His clear perception of every detail enabled him to triumph over circumstances with ease. Money, to him, was not a sinister power to be afraid of, for it obeyed his intelligence. You could make as much money as you wanted, only it was rather boring sometimes to bother about it. He had some justification for talking like that because Theo had just sold one of his Brittany pictures for no less than five hundred francs; a sum which compared to the high merits of Gauguin seemed almost modest. Gauguin forbade Vincent to take such a view. He considered that one hundred francs or ten thousand were equally little compensation for creative effort. His belief in the fictitiousness of money-values had driven him to give up the banking humbug, in which millions could be acquired. He now amused himself by getting along with as little money as possible. Theo's

monthly allowance was sufficient for a princely existence, provided the materials you had to purchase were not bought from an apothecary.

Vincent had already made this last discovery for himself and he hastened to compare his own powers of economy with Gauguin's and told his companion all the cheapest sources of supply. He had found a little carpenter the other day who made very decent frames for three francs each. Gauguin laughed. He never bought frames at all, but simply nailed narrow laths on to his stretchers and then painted them white. Gilt frames were only meant for the bourgeois, and a very fine white frame like that did not cost three francs but three sous. Gauguin also bought his colours in a crude condition wholesale and then ground them himself, thereby saving sixty per cent. He even prepared his own canvas, and apart from saving nearly a hundred per cent., he obtained a better surface to paint on. Would the old masters ever have dreamt of giving work of such importance for their métier to hirelings?

Remarkable creature! Vincent saw it more clearly every day—everything he lacked Gauguin possessed, especially agility. Art was not a sentimental affair, but was produced by bodily activity. An artist was a fencer endowed with imagination. A man who was incapable of nailing a lid on to a box, must be subject to inhibitions. A proper painter ought really to be able to sole his own shoes, or if you put him down in a wilderness, he ought to be able to build a yellow house with his own hands. An artist who was dependent on so-called civilization—Gauguin spat when he used the word—was independent only in his deluded imagination.

Gauguin did not merely talk in this way, although he talked a good deal, but he was as good as his word. They ate at home, and Gauguin looked after the cooking. Vincent could never remember having been so well fed. Gauguin might have been chef to the Duchesse d'Uzès. The food he cooked was not so heavy and indigestible as Marseilles cooking. The vegetables retained their natural flavour, and the meat its maximum nutriment. Gauguin was not proud of his accomplishment, nor did cooking take up his time. He did it off-hand, in a minute, and it was simply one of the advantages of his great inborn ability. Vincent had never felt his limitations so acutely.

It was difficult to extract a precise judgement from this remarkable man about Vincent's pictures. Gauguin praised certain details, such as the expression of the Sower. He also approved of the Sunflowers, and he seemed to have some affection for the pictures in his bedroom. When Vincent considered the matter carefully he decided that he could never expect his pictures to please Gauguin seriously, and it was superfluous to ask questions. His pictures seemed to him by the side of Gauguin's like butcheries; they lacked Gauguin's controlled repose of colour. They suffered from the weight of their rhythm, which was nothing but

ponderous materialism. As soon as Gauguin and Vincent were together they each painted a picture of the same women reapers in the vineyard. Vincent had really hoped that their first work together would be portraits of each other, to symbolize their engagement as it were, and Vincent would have regarded it as no mean honour to be painted by Gauguin. Gauguin, however, required a considerable intimacy with his model before he would launch upon the creation of a portrait, for he painted portraits, like everything else, from memory, and the necessary intimacy could not possibly exist as yet. Some day their acquaintance would ripen into intimacy, and meantime working together in the vineyard had its good sides too. Vincent recognized his limitations. Gauguin's work was a closely woven web, which brought out his large figures and united them at the same time. Fair, well-balanced harmonies warmed the vision of your eyes as you beheld his pictures. The most important feature of his work was his method of binding one figure to another by a form of decoration taken from the expressions of his models. His well-ordered style was yet bold, and it possessed repose, distinction and clarity. In Vincent's pictures everything was topsy-turvy; his colours flooded the canvas. It was a mixture of human beings, leaves, soil and clouds, and it flamed like red wine. Vincent did not co-ordinate his materials, he was not the painter of his picture, but the labourer in the vineyard who sat in amongst his vines. His pictures were part of the events they portrayed, and were still in the process of evolution. Perhaps a certain co-ordination was to be found in them, but it was buried by their own activity. Vincent felt ashamed of himself as soon as he saw both pictures side by side and wanted to throw his own into the nearest fire. He determined to find a new method. Gauguin's pictures were more restful, just as Gauguin's personality was more in repose. Nothing seemed more desirable to Vincent than this quality. He could not, of course, alter his temperament and it would be folly even to wish to, but there was a tranquillity which could be wrested from any form of Nature, perhaps experience would bring it. The few years by which Gauguin was ahead of him were insufficient to explain the difference. Gauguin possessed a far more penetrating mind, he was, in fact, a most remarkable man. When he spoke of art he created a panorama before your eyes, which he drew across your field of vision sometimes slowly, sometimes quickly, and sometimes in leaps and bounds. He started with the old Egyptians and ended up with Manet and Cézanne. If you paid attention properly you could perceive the logical sequence as he proceeded, but you had to be very attentive, because Gauguin would unfold several smaller panoramas by the side of the big one. It was difficult, and you became quite nervous if you failed to keep the various sections of the panorama distinct, if you proved to be, in short, a stupid listener. What was most odd was the fact that many

figures in Vincent's conception of the panorama were missing. Where, for instance, were Millet, Breton, Ziem?—Vincent asked in all innocence. Gauguin gaped. Breton? Ziem?—He remembered, this creature had had similar notions in Paris. Gauguin inquired whether Meissonier should also be included.—Vincent replied at once that there could hardly be any doubt of it.—Gauguin often felt inclined to scrutinize Vincent to discover whether he was really serious or not. Vincent enlarged upon the merits of Meissonier. Gauguin's laughter was still as sharp as steel, just as it had been in the *entresol* on the boulevard, and sometimes his muscular thorax thundered as of old. Meissonier! But why, what was the matter? Vincent stammered in his bewilderment.—Oh well, Meissonier. . . .

Gauguin discovered evil moods in the owner of the yellow house. He was prepared to admit certain qualities in Vincent's pictures even if his own belonged to a different sphere. But whence his absurd banality? And at the same time he talked of Delacroix and was intimately acquainted with the work of Rembrandt. Meissonier and Rembrandt! There was the same disorder in his dress, his studio, in everything, and it all came from his endless naturalism. Nobody who was so incapable of serious thought could ever build a career for himself, much less create an art of his own.

Vincent admitted his slovenliness, he did think a good deal, but no doubt in the wrong way. If Gauguin would teach him to think in the right way, he would gladly be his pupil. Only perhaps it was not altogether necessary to thunder so much and to laugh so shrilly.

As there was plenty of time in the evenings Gauguin undertook, in addition to his management of their domestic affairs, the task of instilling sane views into Vincent. The mischief of modern civilization was just this very inability to differentiate between Delacroix and Jules Breton, this capacity to swallow them both. It was part and parcel of naturalism to swallow everything or not to swallow at all. Vincent had intoxicated himself with Nature as he used to intoxicate himself in Paris with bad wine. It was just a matter of taste.

Vincent confessed that he was not at all satisfied with himself. He had often felt similar misgivings, and his painting had probably nothing whatever to do with art. Nevertheless he had made some kind of a start.

Gauguin explained that Vincent's work was much more than a start, no one could deny that it revealed an astounding temperament. He possessed the ability to juggle with this temperament and to make his brush serve it. He had a passion for chrome-yellows. His work showed even something more, it showed a flawless honesty, even Impressionism of a more systematic kind than that of the excellent Claude Monet, and almost as sound as the Impressionism of the worthy Père Pissarro.

No doubt Gauguin was right. As soon as Gauguin went out Vincent

thought about his words and then he found the right conclusions, but at the moment that Gauguin said these startling things it was well-nigh impossible not to contradict. His icy tone was annoying, and so was the way in which he dismissed any subject in two sentences. Had he already finished with Pissarro? Surely that was going a little too fast and too far. A year ago he had spoken very differently of him. Was it not a little unkind? Had Gauguin not learnt from Pissarro?

Gauguin replied that he had undoubtedly learnt from Pissarro. He had learnt a pile of nonsense and *pointillism*. He owed the loss of three years to Pissarro and the pleasant task of unlearning all the tomfoolery he had acquired.

Vincent presumed that everything was not nonsense that Gauguin did not produce. 'Yes, almost everything else is nonsense,' was the cool reply. And not only in art. The panorama of art revealed ever weaker pictures as it drew near modern times, and this degeneracy was due chiefly to the disintegration of society, which could also be represented as a panorama. Gauguin was full of panoramas. Anyone who had once grasped the direction of modern evolution and realized the impossibility of arresting its progress, could not do better than turn his back on Europe and sail to the colonies to live among so-called savages. That was his object. Everything he did here was only a means to get out of Europe. As soon as he had enough money he would sail back to Martinique or some other happy island, never to return!

Vincent felt a cold shudder pass over him. His helplessness made him mute. He had not, of course, dared to tell Gauguin anything of his plans for the community in the yellow house, and now it seemed impossible to tell him about it to his face in so many words. Nevertheless the whole object of their living together could not possibly be mistaken for anything else, and it was surely gratuitously offensive to interpret their joint lives in any other way. Vincent had, however, discovered Gauguin's attitude in the first minute after his arrival.

Vincent was incapable of regarding his existence in Arles or elsewhere as a temporary makeshift. Every one of his instincts opposed such a view, otherwise he would never have been able to put his brush to canvas. No doubt he was as sceptical as Gauguin about most things, especially on certain days. But his scepticism was confined to his intellect and not his emotions. Once he felt like that he would have to commit suicide and he had not got as far as that yet. It was just because art was threatened by all the world, that artists must hold together and form a community. Perhaps it was all nonsense, none the less; Gauguin had considered life from every angle and naturally knew more about it.

He was a most remarkable man but there were contradictions in his nature. If he was good and everyone else evil, it was hard to fathom why he had sent his wife and his children—glorious creatures to judge by

their photographs—to Denmark, and why he behaved in Arles as if he were not married at all. But it was mean to think like that, and there were no doubt sufficient reasons for his line of action, which, doubtless, had something to do with another of his panoramas, the marriage panorama. Vincent felt that he, least of all, had any right to judge him, and he regarded his own unspoken criticism as petty rancour.

Gauguin did not lay claim to any moral superiority. He believed Vincent to be much more moral, especially in the European sense of the word. Gauguin only claimed that he allowed a little reason to enter into his calculations. Reason was the foremost guide to every conception an artist cherished. But even if in Europe all action was dominated by the instincts of the herd, art at any rate should serve the needs of the imagination. If imagination was not to develop into sheer folly artists would have to learn to control their minds a little. Naturalism was the substitute for control for runaway slaves, and it meant mental bankruptcy and final collapse.

Vincent jibbed. He loved nature though he had not much to say about naturalism. If you blocked his road to nature, you barred every path for him.—Gauguin would not give way. Of course everyone loved the object of his weakness, although the object really mattered little compared to the quality of your inclination towards it. Love, everyone knew, made you blind. That was the worst of it.—Vincent laughed. He had imagined that he had learned how to use his eyes here.—Of course if you plant yourself in front of an apple tree, it requires no clairvoyance not to see the whole of it. He, Gauguin, had felt himself to be a painter from the moment that he succeeded in painting his first picture without seeing, extempore!—An old bitterness rose up in Vincent. How Gauguin saw through him, even without looking! How he turned your world upside down in a twinkling!—But Gauguin insisted that Meissonier and his confrères probably believed themselves to possess visionary powers.

As soon as Gauguin bandied about personalities, Vincent lost his temper. He could not endure mudslinging against his idols. Gauguin could say what he liked about his work, he knew that it was worthless and could never be anything else, but Gauguin must leave others alone if he wanted to live in peace with him.

Gauguin shrugged his shoulders as usual and set about his work.

In spite of everything Gauguin was a wonderful man, and a most valued friend. A man's actions were, after all, more important than his words, and Vincent never looked at a picture of Gauguin's without feeling the deepest gratitude towards him.

As Gauguin made a point of it, Vincent decided to paint extempore! Gauguin doubtless did not give him this advice in order to quarrel with him, but in order to let his ungrateful friend benefit by the knowledge to which his own pictures testified so convincingly. Gauguin, he knew,

only advised for the best, and in exchange received stupid nonsense from him. Vincent also realized how much he risked by being so dependent upon nature. Gauguin told him to paint objects which his memory had condensed into pictures. Vincent made an attempt with his parents' garden in Nuenen. The attempt failed and the picture was put on the fire, but Vincent was not to be dismayed. He decided to try a *motif* which he could compare with nature after he had painted it. He painted the avenue of tombs in Arles, which he and Gauguin had often passed, and painted it in the studio. This method possessed the additional advantage of making Vincent independent of the weather. And possibly he might by this means come to realize his secret dream of painting a starry sky, which of course could not be done from nature.

Gauguin liked his avenue with the tombs. Its simple *motif,* a broad irregular road with poplars on either side and plain Roman sarcophagi in front of the trees, was suited to large treatment. Van Gogh exaggerated the original structure, made the rows of trees into high symmetrical walls of red flames and joined them together at the bottom by a row of immense stones. Thus he produced a gigantic avenue, capable of bearing the triumphal march of a Cæsar. Gauguin praised the clarity of the *motif* and the reticence of Vincent's manner. If he continued on these lines they might arrive at a sensible and a mutual basis. They might paint frescoes together.—Vincent stared. Frescoes! You might just as well have suggested Egyptian pyramids to him. Gauguin laughed. That was just like these benefactors of humanity, they talked incessantly about the community and as soon as you showed them a sensible step in this direction, they stood there and gaped like idiots.

Vincent had supposed that you needed all kinds of things for frescoes, walls for instance.

Gauguin pointed to their whitewashed walls; you could not paint proper frescoes there, you really needed the assistance of a mason, but you could use these to practise on a small scale. He had done it in Pont-Aven.

Then he proceeded to deliver to Vincent a long lecture about mural painting, and unfolded another panorama, extending from Pompeii to Puvis de Chavannes. Gauguin liked frescoes because they released your mind from the fetter generally imposed by your hand. You could no longer paint from nature, because you could not take your model with you on the ladder. You had to retain the entire composition in your mind's eye and then paint it on the wall with simple strokes.

Seurat had previously talked to him about frescoes, and Vincent therefore connected them with some form of Neo-Impressionism. Perhaps it meant you had to *pointiller* again.—Gauguin condemned Seurat and all his ideas to perdition. You simply sat down, thought out your scheme and then mounted the ladder. There you were high up in

the cupola of the dome and you painted for an effect calculated to be seen twenty yards off. You could not afford to suffer from dizziness.

Some attempts were made, whose remnants, covered with white-wash, were found again later on the walls of the yellow house. Vincent in all probability did not share in these attempts, as frescoes were outside his pale. At the same time, he was anxious to prepare himself for them, and so he painted again the avenue with the tombs, which had pleased Gauguin. He treated his subject rather differently this time, and painted it of course entirely from memory. His second version did not please him any better, and he found that the new method was subject to certain dangers. The reticence which Gauguin had praised made you lose your nervous strength, your structure as well as your colours became thin and flimsy, and instead of painting receding planes you produced flat surfaces. The result was like scene-painting.

Gauguin, who was rather bored in Arles at times, told Vincent that there were painters whose work became as flat as a pancake as soon as you forced them to use their intelligence alone. It was a sad fact which nothing could alter.

But Vincent went to his friend Roulin, and painted him and his wife and their children, and thus produced half a dozen portraits which looked, by the side of the old ones, as if they had been washed. Gauguin looked at them and shrugged his shoulders while Vincent talked about the *chic* of the symbolists. Gauguin said their work was painted literature because they tried to avoid the difficulties of the painter's craft. They looked down on nature because they could not look anything straight in the face. They thought they were above simple models like Roulins, but the Roulins of this earth were a hundred times too much for them.

Gauguin was in the vein to amuse himself. If you teased a fellow like Vincent a little you could make him go to the North Pole. Vincent walked up to him and took both his hands: 'Gauguin, be a good chap, will you?'—his words came hoarsely. Gauguin laughed. He would love to be good only he simply could not express the goodness of his soul with heavy impasto.

Vincent nodded inanely, and went out and rushed about on the plain until he was exhausted. He stayed away for six hours. Curious, but he could never find the words he wanted at the critical moment. Perhaps words were of no use with these people from Paris. They talked and painted and listened only to external noises. A man like Gauguin fled to the savages, but he carried his boulevard with him on his back. Poor Gauguin! First of all he would have to get Paris out of his system. It was a kind of disease and the yellow house might be a better tonic than Martinique or Tahiti. He would try to help him, not with harsh words, in fact without any words at all. Gauguin was probably at bottom, at the

very bottom, though a great artist, not a good man. Therefore he must be made good. The luminosity which he lacked was goodness, for which there was no room in his philosophy of reason. Even his objection to the colour of clogs was only another form of the unkind superiority of the boulevard. But as Gauguin was miles above the boulevard in a hundred ways he might overcome the rest if he was helped. Vincent wanted to help by the only means he had of helping anyone, namely, with real pictures.

That very day he painted his chair with the butter-colour straw seat, standing on the gorgeous red tiles. He painted the picture as thick as his hands. He put nothing into his canvas but the chair unembellished and inartistic, but so that the whole yellow house enters into the spectator, and Arles as well and the entire Provence and Holland from Nuenen to Drenthe.

When he showed the little picture to Gauguin anticipating his usual shrug, Gauguin let a curse escape his lips. The thick chair delighted him. The chair was as strong as the Sunflowers, perhaps even stronger, it was the very soul of a chair. Nobody had ever painted like that. Queer creature! The Impressionists might as well pack up and crawl under the table.

Vincent of course saw in Gauguin's remark only exaggeration, just as he had done when Gauguin told him that his Sunflowers were better than Monet. Nevertheless he found the experience very pleasant and resolved never to quarrel again. You had to talk of course, that's what you were together for, and there was something in the air after you had finished your work which compelled you to talk. If you answered one of Gauguin's absurd declarations, he would simply shrug his shoulders and let you go on with the conversation, and even then he was not satisfied. People who wanted to get to the bottom of anything always found it difficult to arrive at agreement. Who could speak the same language nowadays, even with his own brother? All panoramas were much too clumsy, even a stupid chair could upset them. Accordingly you had to find other means of making yourself understood.—Gauguin suggested that they should drive to Montpellier. There in the museum such means were to be found on the walls. In the Bruyas room there were Courbet and Delacroix. They could drive over in the diligence for one franc each.

Contrary to his expectations, the day turned out well. It was already December, but the sun shone and the sky was blue. Gauguin knew the Gallery already, and acted as guide just as if he had been a relation of the generous Monsieur Bruyas, and Vincent felt as though he owed his thanks to Gauguin for his enjoyment. And he did enjoy his visit. He had not been in a picture gallery for nearly a year. His eyes seemed to have rested in the interval for they were now capable of taking in much more and much more rapidly. It was a happy coincidence that the collection

was rich in portraits, because just at this time portraiture appeared to Vincent to be a domain specially suited to himself. And the Courbets, no matter what Gauguin said, were like portraits in bronze. And even Gauguin let the Bruyas portrait pass, though he preferred the one by Delacroix. The visitors were in agreement. Naturally Delacroix out-topped the others, if in nothing but dignity.—What a dignity! How small you felt! A Prince! He painted them differently from his other pictures, just as you would behave differently in grand society from the way you behaved at home. The visitors agreed again. No one else was as restrained as Delacroix. He could slow down his pace and yet retain the full force of expression, while you exhausted all your strength, down to the last drop of blood in you, in every little still-life. If you didn't, your canvas lost all its life and action. Gauguin had tried to do the same thing with other means. Now Vincent understood Gauguin's opposition to his own impetuous manner. Gauguin was quite right. You ought to be more conventional, you could never be conventional enough. But where could you find your convention? Delacroix was born with it. In his day there was such a thing as an effective, tangible, operative European Paris, and not only a Paris of painters. There were still men of noble bearing, not only in pictures.

'Noble bearing' was one of Gauguin's pet expressions. The succeed-ing generation of artists had seen through the pose of the bourgeois, which was not a difficult achievement; they thought that by spitting everywhere they would appear more honest, and they expressed nobility of mien by the rhythm of their brush-work. One day they would penitently return to Ingres. If an effective convention no longer existed, you had to go out and look for one. If you could not find one in Europe, then somewhere outside of it among the savages. Savage life was rich in legends. Would Vincent care to go with him to Martinique?

Vincent's joy at this spontaneous invitation overcame his horror of an exotic climate. He was ready to go anywhere, to the end of the world. But the legend they needed could only be produced by a community. Wherever you found it, here or elsewhere, a temple would spring up. Wherever two or three were gathered together, there was God. Very well, they would transplant the yellow house to Martinique.

Delacroix led them gently back to Europe. They stood in front of his *Algerian Women*. Next to them hung the lovely three-quarter length of the *Mulatto Woman*. Gauguin had once copied her enthusiastically. The Europe of Delacroix! It extended beyond the outskirts of Paris where most of the others were stuck. Delacroix had been further afield. Ordinary mortals were in danger of becoming exotic if they went too far. But they could afford to face this danger lightly, for worse dangers threatened at home. Gauguin did not pride himself on his failure to cope with Europe. His longing was perhaps a cloak for his weakness.

Delacroix became a European after he had left Europe. Gauguin had never spoken like that before. What a remarkable man he was! Vincent could have hugged him. And the fact that Gauguin showed this warmth under the shadow of Delacroix spoke volumes in itself. But Gauguin need not be at all ashamed of his inclination. Europe was full of negroes. Vincent regarded himself and his coloured patches as more than exotic. He beat a tom-tom with his yellow. Delacroix would have covered his ears. Gauguin was quite right; people who could show their strength with fat lumps of paste did not paint but spat. But there was nothing else for it, he had to struggle on, and in a few years he might arrive at a higher level, perhaps.

They they looked at the *Daniel in the Lion's Den*. Now that was a picture Vincent would like to have copied. He did not hesitate to say that it would be sinful to put a brush to any other use. The impression it made on him reminded him of the hour he had spent before the *Night Watch* in Amsterdam. Gauguin said that the one was the natural result of the other, only Delacroix was infinitely greater. You must be quite clear on that point, and in spite of, or rather just because this picture of Daniel could never have been created without Rembrandt.

Vincent regarded such assertions as superfluous. He himself felt a stronger leaning towards Delacroix, but you did not compare the Rhône with the Rhine just because you happened to live near the one or the other. Nobody compared peaches to grapes. Such comparisons served no purpose; they were stupid intellectual tricks that savoured of stock-exchange speculations.

Gauguin smiled. There was a good side to the stock exchange. He was grateful for his experience there, which had given him a proper appreciation of the value of art.

Vincent felt ashamed. Of course, Gauguin had been on the stock exchange. How could he have forgotten it!

Gauguin did not take the slightest offence at such references. On the contrary he was proud of his past, but he changed the subject to fencing with foils. That was just like him. You could never finish a discussion to the end with Gauguin. Theory of fencing and Delacroix!

Gauguin, of course, had a theory of his own the merits of which were amply proved by his success in the fencing-school. It was not for nothing that he was everywhere considered a first-class fencer.

Vincent could well imagine it, in fact it really went without saying in such an athlete, a man of his agility. He could not help being an excellent performer with foils, but Vincent knew nothing whatever about it.

Gauguin explained his theory. The French method stood in the sign of her declining militaristic star. The school of Joinville-le-Pont was considered to be the first, and it held a position similar to the École des Beaux-Arts. You were supposed to be rather careful with anyone who

had learnt fencing at Joinville-le-Pont. They had tricks of their own, and were rather like clever acrobats, but the whole school was not worth wasting a shot on. Gauguin's theory was not a matter of mere routine. A good hand scored every now and again, skilled legs scored more frequently, and a man with a sound head on his shoulders scored always. Mental superiority alone made a good fencer of you. And anybody with brains took a man's physical peculiarities into consideration. Any course of training that did not base its method on this fundamental considera-tion was rubbish. The stupidity of the academicians at Joinville-le-Pont prescribed similar arms and legs for all their pupils. The situation was much the same with boxing. So-called French boxing presupposed an ideal type of boxer. There was, apart from America, only one school of boxing and that was the English school. Thank goodness he had always had English trainers.

Vincent slunk alongside the athletic Gauguin. They went to lunch somewhere. Gauguin was always in a cheerful mood when he could talk of such subjects. After lunch they returned to the museum, as there was not much else to do in Montpellier, especially as Vincent did not play billiards. Gauguin had once made a break of a hundred and fifty in a match. Via billiards and riding they returned to Delacroix and Rembrandt. After all, comparing one master with another was not just deciding which was the superior, as with two fencers. It was the only method of educating yourself, so far as it was possible to do anything for one's own education. Making comparisons necessitated above all profound thinking, and that was the way Delacroix had schooled himself. In just this way Delacroix had succeeded in going beyond Rembrandt and by this means he had avoided the anguish that weighed down the Dutchman's fervour. Comparative thinking had helped him to his lightness and his agility. Rembrandt had brooded over his indigestible mysticism. He would not have been any use at foils. Poussin and Claude he would probably have abhorred. He lacked the traditions of the ancients.

Gauguin was rather trying at times. His dialectics were rather like his fencing, only much more Parisian. His jokes were as ready to his hand as his rapier. But it was impossible to fence with every subject, in fact no serious subject was capable of such treatment at all. Very often he evaded the root of the matter intentionally. He did not avoid serious topics because they were alien to his mind, but from choice, which he called good taste. When he spoke of Delacroix he was never wide of the mark, but he never bit into what seemed to Vincent the heart of the subject. Vincent approached life from a different angle. Gauguin always from the standpoint of cold reason, although his method often plumbed profound depths. Gauguin considered it vulgar to speak of the bold *motifs,* or the originality of Delacroix. Anything new was always coarse

in Gauguin's opinion. Émile Zola was stigmatized by him as a novelty. He supposed that some people who devoured a great many books might find a poet in Zola because he was new. Delacroix's greatness was based on his cohesion with others. The profundity of a man's genius could be measured by the size of the community its manifestation created.

Vincent was grateful for these words: cohesion, community. That was the whole meaning of art, if it meant anything at all. Bruyas, who had collected all these glorious pictures and given them to the public, must have been guided by similar considerations. Bruyas had erected a different kind of yellow house; he was to a large extent the founder of the southern school of art, which they must continue. His portrait, by the way, the one with the red beard and red hair, bore a most marked resemblance to the two Van Gogh brothers, and as Delacroix had painted the portrait, it was almost like being in contact with Delacroix himself. It struck Vincent as very odd, and gave him food for thought. Delacroix was the man who had built the yellow house of the spirit.

Gauguin and Van Gogh returned late at night. Vincent, however, insisted on lighting the fire, for there was a great deal left to be said. Gauguin was already in bed when Vincent came in once more, just for a minute. He sat down on the edge of the bed. This was the moment to unfold the scheme for the community. He sketched the principles of the undertaking, the branches in London, The Hague, in America, the small and the great boulevard, and the method of sharing in the proceeds. The time had come to set about its foundation. Once the right people were together, it was bound to succeed.

Gauguin had hardly heard a word. Vincent's lips continued to move while his friend's powerful chest rose and fell at regular intervals.

Soon after this incident Gauguin began to paint Vincent's portrait. What an artist and what a friend! Vincent was as happy as a child. Christmas was upon them, and Vincent looked forward to the first happy Christmas since his childhood. Theo really ought to have joined them, but he wanted to go to Holland, where he had some mysterious errand. He had just received from Theo a letter which was much more cheerful than usual. Apparently his errand was a love-affair. If only something would come of it! If even one of them could put real children into the world, perhaps another little Bruyas.

Vincent's news was most important. He kept on running into Gauguin's room with it, and he also imagined that his friend needed to see him for the portrait, which, however, was not at all the case. Gauguin much preferred to be left alone at his work, and herein lay the great difference between the two inhabitants of the yellow house; one wanted to paint because his scepticism penetrated the nature of mankind, the other painted pictures because they were the best substitute for human beings he could find. A relationship between the

two men was possible only if Gauguin sank his scepticism. Vincent
hoped in his heart of hearts to convert his distinguished painter-friend
to a belief in men. If his pictures lacked anything at all it was human
sympathy. The duties of friendship compelled Vincent to act in the light
of his newly-gained knowledge. The more he saw of Gauguin's work the
more determined did he become to show his friend where he failed as a
human being, and that his failure was only due to what he called 'taste',
and to a certain hesitation and Parisian delicacy of feeling. And these
flaws were not found in isolated examples only, but in whole pictures;
the portrait of Vincent, for example. As Vincent was always glad to
receive criticisms of his work—even Roulin's opinion was helpful—and
as he regarded every one of Gauguin's criticisms as a munificent present,
he assumed a similar disposition in Gauguin. But Gauguin failed to
understand Vincent's simple criticism, and when he became rather
more explicit Gauguin was apt to lose his temper. And it really was
difficult to avoid it, for Vincent reiterated every discovery interminably.
Then he could not understand why Gauguin should want to paint a
portrait so flat, although this flatness was Gauguin's characteristic
means of expression. Very well, that was Gauguin's own affair, but
whether your coloured surface was smooth or rough, surely you had to
convey the painter's relation to his model.

Gauguin was doubtful whether anyone who worshipped Meissonier
was capable of understanding the nature of synthetic creative action.—
Vincent found such talk as intelligible as a foreign language, but any
picture was surely synthetic if it was a picture at all. Was his own
portrait of L'Arlésienne not synthetic?—Gauguin smiled. He would
agree that the Arlésienne was synthetic, but then this picture stood
rather outside Vincent's usual range of work, which was due, perhaps, to
a fact Vincent seemed to have forgotten, namely, the slight but effective
assistance of Gauguin. Did he not remember that Gauguin had once,
with a few pencil lines, outlined the simplification of this interesting
portrait?

Vincent remembered nothing of the kind. Gauguin smiled again. In
that case, no doubt he had made a mistake, and he apologized
profusely.—Gauguin's smile! Vincent preferred his thunder or his shrill
laughter. Vincent's temper would suddenly, and at the least provoca-
tion, reach boiling point. How vulgar his smile was!—And the door
crashed into its frame.

As soon as Vincent reached his room he pulled himself together.
Perhaps he had thought of Gauguin when he painted the Arlésienne. He
often thought of Gauguin, and it would be better if he thought a great
deal more about him and his advice. He, Vincent, was petty and wicked
and altogether incapable of living in a community. Immediately he went
back to Gauguin and apologized for banging the door. He proposed to

paint the Arlésienne again, and this time he would follow Gauguin's instructions to the letter. He owed him not only the Arlésienne but everything else he had done. Ever since Gauguin arrived he had felt better and his work had improved, and there was only one salvation for him and that was to be with Gauguin permanently. He also asked Gauguin to go into the park with him, as he had something very important to tell him. He did not say why he must make his announcement in the park, which was hardly inviting at this time of the year.

They strolled out into the park. Vincent simply preferred to talk in the open. When he walked about he could collect his thoughts better and give shape to them, which he often failed to do, especially in important matters. His plan was perhaps rather a curious one, or rather it might appear to be curious in the present age, whereas it would have seemed quite ordinary in the Golden Period. He thought he could now claim to know Gauguin's painting thoroughly, and Gauguin thoroughly knew his. If you regarded his own pictures objectively you would see that they lacked just what Gauguin's possessed, just the essentials. That his own lacked a great deal was, naturally, matter of course. But even Gauguin's pictures were not quite complete; they lacked certain elements that were possibly to be found in his own painting, although whatever his pictures did possess was nothing very important. Figuratively speaking, Gauguin's art was a garden and Gauguin a gardener, or rather a landscape-garden-designer, like the famous gardener whose name he had forgotten, but who had built the park at Versailles. Now, could this man, whose name he had forgotten, have built the gardens of Versailles without any assistants, without, for instance, the people who executed the plastic decorations of the long avenues; could he have achieved his great work without the help of the engineers who laid the water system for the fountains, or without the designers of the flower-beds? No, he could not, and why should Gauguin not have an assistant?

Gauguin could not see what Vincent was driving at.—That only showed that nobody ever thought of communal life. Was not Gauguin such a garden-architect? His pictures were splendidly designed, with big avenues, and side-paths and open spaces. Gauguin always thought out an imposing structure with many clever details. But something was missing. His plan was generally capable of supporting a richer vegetation, many more clusters of blossom, perhaps a more generous array of colour. And therefore he ought to construct his pictures like the gardens of Versailles. He would have to bear the lion's share, to conceive the general plan, and then Vincent would come along and make the flower-beds, and the flowers, and the foliage, and put in his fountains.

Into the same picture? Gauguin inquired. Vincent's red head nodded: Of course!

Gauguin stood still. Vincent did not notice that he had stopped, and he continued to talk as he had often done before when they were out of doors. He talked on and on, while Gauguin stopped at a corner and looked at a tree.

Suddenly Vincent heard a terrific laugh behind him. Fortunately they were out of doors, for the window-panes in the yellow house would have broken into a thousand pieces. Gauguin was yelling with laughter.

Two paint one picture! Why not three or a score? Little Bernard might join in too, and perhaps Lautrec. *Quelle blague!* And Meissonier too, it would not be fair to leave him out.

Vincent stared. What was Gauguin laughing at? His laughter spoilt everything. The trees, the ground and the air trembled. Why did he want to spoil it all?

Gauguin was wound up like an alarm clock, and nothing could stop him. Painting stocks and shares! *Société anonyme!* They would make a coup on the Exchange! Everyone would buy shares. A gold-mine!

Gauguin's jokes flew through the air. *Coup à faire! Mine d'or!*— Vincent was at a loss to understand him, he only heard the thunder of Gauguin's voice.

'Stop it!' he stammered, and his face was really funny. He had to sit down on a bench. The cypress tree in front of him was suddenly upside down and he could only see half the peonies. He held his head in his hands and glued his eyes to the ground.

'Gauguin, my dear Gauguin, just listen a minute!' He made an immense effort.

Gauguin had already departed and heard nothing he said. Immediately behind the trees was the street where the little girls lived. They laughed and twittered like birds. Gauguin went in. They had been to the Mère Chose several times before. Vincent had even painted there. He was called Fou-roux by the inmates of the establishment, and Gauguin was known, for unfathomable reasons, as Montezuma. Vincent liked going there. He had found a small brunette there who reminded him of another one in The Hague, and he adored her.

Fou-roux! Montezuma! they all shouted as the pair entered. The girls leaped towards them like soft white animals, clung to them, kissed them, and patted their cheeks. The place happened to be empty as no one arrived so early, and the girls were delighted. Fou-roux and Montezuma! Vincent laughed.

It was lovely that there were warm houses like this one in Arles. You felt as if you were in a bath and you dreamed happier dreams there than anywhere else. Vincent's brunette from Avignon wanted a five-franc piece. As he happened not to have one on him he promised to paint her portrait, and this time he undertook that she would not look like a Camembert, but like a La France rose, or like a lily.

Gauguin, as usual, had the whole crowd round him. He was the best-looking man in Arles and the strongest. Everyone there longed to have him for their *amant de cœur.* Montezuma brought them luck and he always made them laugh. He behaved to them like a prince in whose country the customs were rather rough. Montezuma made such an impression in the brothels of Rio de Janeiro that he is remembered to this day. Montezuma was a jewel, but they had to mind their p's and q's with him. While he was telling a story, he picked up the girl they called wild Nanette and hurled her across the whole room over the table on to the red sofa under the mirror; she lay there like a bundle in a corner, but Montezuma finished his story without even looking at her. If you considered the question honestly such an establishment was really much more comfortable than the yellow house, and there was really no reason why they should not celebrate Christmas there. Vincent's brunette told him that if he could not give her a five-franc piece he might at least honour her with one of his large lop-ears for a Christmas present. Then they rolled about on the floor and Vincent emerged shaking his head like a big bear who is seized by dogs. Madame Chose entered and held her sides with laughter.

Gauguin and Vincent returned home in high spirits. Vincent could not go to sleep and he got up and rapped on his friend's door. The street lamp shone on Gauguin's powerful face. Vincent stood by his side for half an hour. Gauguin dreamed that some dark creature had bent over him, perhaps a bear with little eyes and a gaping jaw.

On the following day Vincent neither painted, nor spoke, nor ate his food. While they were sitting in the Café Giroux in the afternoon, he suddenly threw an absinthe glass at Gauguin, who dodged it, seized Vincent by the collar and hurled him out of the Café. Vincent went home and slept like a sack of potatoes. The next morning he said he had a vague memory of having insulted Gauguin and he begged his pardon. Gauguin replied that he did not mind at all, and that he was accustomed to much rougher treatment. If, however, one of those absinthe glasses should happen to hit him, he was not prepared to answer for the consequences, and he therefore thought it advisable to part company. He would write to Theo and notify him of his return.

Gauguin then sat down, wrote a letter to Theo and put the letter in the pillar-box himself. It was just before Christmas. Vincent spent half the day with Madame Chose so as not to interrupt Gauguin's packing. The little brunette from Avignon pulled his ears again, but he was melancholy. At last he told the girls what had happened. Wild Nanette wanted to rush over to the yellow house, but Madame Chose would not allow it. They were all very kind to him although he was neither strong nor good-looking and could never tell such stories. Finally he composed himself, went to the yellow house, and entreated Gauguin. He addressed

him as Master, like the pupils of Carolus Duran. They had been to Montpellier together and spent such a wonderful day there. They had talked of Delacroix and Bruyas. Other people would not perhaps count such a day as anything very special, but for him it had been almost too good, almost unbearable, and he needed a month to see it in its proper proportions, and anyhow they had been together there all the day.

Gauguin let him beg a long time. A common occupation did not mean that they took a similar view of life. Their ideas might differ very materially, and that was a consideration which could hardly be overestimated.

'Yes, Master,' replied Vincent, and he felt an irresistible desire to bow before Gauguin, even to kneel in the dust. He declared that vulgar men like himself were not capable of better efforts; they could not endure a beautiful day and he was quite unworthy to breathe near such benefactors as M. Bruyas. Of course it was only right to part company from people like himself and to cast them into the bottomless pit.

Finally Gauguin gave way, and he wrote a second letter to Theo, in which he declared the first one to be utter nonsense. But he refused to share the same table with Vincent for the next few days, on account of the dissimilarity in their views of life and for hygienic reasons. So Gauguin had not forgiven and forgotten everything. He insisted on his condition, and in the evening he went out for dinner alone. While he strolled about after his meal on the Place Lamartine—it was a particularly dark night—he heard steps hurrying towards him. He turned round and saw a dark figure with something glittering in one hand.

'Vincent!' he called severely.—Vincent dropped his head: 'Yes, Master!'

Gauguin watched him turn tail and run for the yellow house. With the circumspection of a man who had travelled a great deal, he considered what he had better do, and decided to spend the night at an inn, where he slept the sleep of the just.

About midnight a present was brought for the little brunette, who was just in the middle of a dance. The present was from Monsieur Fou-roux. She opened the wrapping, then another, and another. The last one was blood-stained and contained a piece of canvas which was also soaked in blood. Hallo, Nanette!—All the girls gathered round, including Madame Chose. She looked at it. *Quel cadeau!* It was a real ear!—As soon as the little brunette realized what it was she fainted. Nanette leaped to the door. Who had brought the parcel?

He had brought it himself. Then it was not his own, but someone else's. Whose ear had he taken? And what had happened to its owner?—Madame Chose came to the conclusion that this was one of the rare occasions when she thought fit to trouble the police.

When Gauguin strolled into the Place Lamartine, refreshed after a good night's rest, he found a crowd in front of the yellow house. Somebody asked him what he had done to his friend; somebody else announced that Vincent was dead and they knew who had murdered him. Gauguin, with his usual calm, made his way through the crowd, and upstairs he found the doctor, the police, and Roulin the postman round a blood-stained bed. Vincent had been properly bandaged and was already fast asleep. Gauguin answered all the questions that were put to him with perfect equanimity. He told Roulin that he intended to wire to Paris and leave by the next train, as he did not think his presence in Arles would be of any advantage to the invalid. Roulin was the only man in Arles who could not bear Gauguin, but he approved his decision and added one or two pointed phrases in his own Tarascon dialect. After further consideration Gauguin decided to await Theo's arrival on the spot.

Theo arrived twenty-four hours later and spent his Christmas holidays in Arles. Every possibility was discussed, but Roulin's wish prevailed and Vincent was taken to the hospital. Every now and then the invalid regained consciousness. He recognized his brother, apologized to everybody, especially to Theo's young fiancée whose Christmas he had spoiled. He quoted the Bible to Theo and asked for the Protestant pastor in order to question him about the Gospel of St. Luke. Intermittently he became delirious again.

After the Christmas holidays Theo, worn and anxious, returned to Paris with Gauguin. Dr. Rey, the hospital doctor, nursed Vincent with the utmost gentleness. Roulin called every day. The year 1888 drew to its unhappy close, but Vincent's condition improved with the beginning of the new year. His attacks became weaker and weaker and then ceased altogether. Vincent called for his pictures and Roulin accompanied him to the yellow house. When Vincent arrived he was aware that though many aspects of life had suffered a change in the meantime, his pictures were as solid as ever. The Sunflowers, the Poet's Garden, the Arlésienne, these at any rate spelt reality.

On January the 7th he was pronounced by Dr. Rey to be fit, and he was discharged from hospital. Such cases had been known to occur; the connection with Gauguin had apparently been a misfortune. Who could judge the psychology of an artist? As soon as the disturbing element had left Vincent's vicinity his ailment was at an end. There was not the slightest trace of any abnormality of the brain. He needed good food and must avoid exertion and excitement, and the doctor was friendly.

There was hardly any fear of excitement. The quiet of the yellow house was undisturbed, even surprisingly so. Was it really necessary to have made such a mountain out of a mole-hill? Theo's journey, Gauguin's flight and all the frightful fuss. Could it not all have been

avoided? Surely he was as easy to lead as a child, and Gauguin could absolutely manage him. And then the whole affair had swallowed a lot of money. Or was he perhaps really impossible? First in The Hague, then in England, then with his parents, then in Antwerp, then in Paris—it was a long list. Something had always been wrong. But why? Was he one of those people, outcasts, who were simply impossible?

But he had always been able to get on with the Roulins and Madame Giroux the Arlésienne, and the miners in the Borinage. Of course talking to them was different, and there were many unmentioned subjects. Once these subjects arose everything went wrong. Superficial contact alone was possible, but could he really scramble through life with no more than superficial interchange with his fellows? If no deeper contact was possible then everything he had believed in was rubbish. Perhaps we are near the heart of his disease!

Vincent lay on his bed by the hour, lost in speculation, which was bad for him. The longer he lay there the more did he doubt the solidity of his surroundings. The walls would slant and the ceiling descend upon him. And then he would shut his eyes for two seconds, and open them again quite fearlessly. As long as he did not doubt his world, it was there. Curiously enough, while his surroundings became blurred, he saw quite clearly his parents' house in Zundert: 'Every path, every plant in the garden, the fields, the neighbours, the churchyard and the church, the vegetable garden, even to the jackdaw in the acacia tree.'

His pictures helped him more than anything else to regain control over his senses. If only it were possible always to paint and be with pictures he would not go mad. When his illness started he was just painting his Berceuse again, for which Madame Roulin sat to him. Vincent somehow associated the idea of the family with this woman; she was by no means beautiful and not a Parisian. Gauguin had even called her a horror. There was something bourgeois about her which upset Gauguin, but when you shook hands with her all explanations became superfluous. She regarded men as children who required help. She helped everybody in her own way although she had not a sou to spare. Only to look into her eyes rested you. He painted her hair a powerful orange and he made her clothes green and then placed her before a richly decorated background of green and pink. Gauguin had told stories about the solitude of seamen. If you had a picture like that in your ship you would never feel lonely. He called his picture La Berceuse because the thought of such a woman gave you as strong a sense of security as if you were a little child in your cradle. The canvas was painted like a popular coloured print, as if it were destined for poor people who sailed upon the high seas. He painted another variation of this theme so that there are three fairly similar Berceuses. He wanted to hang them up between three or four canvases like his Sunflowers. What

a decorative scheme they would make!

When he went outside the house he pulled himself together and even paid more attention to his clothes, which had always brought him a bad name. He went in to see Madame Chose in order to ask the pardon of the little brunette from Avignon. They were all very good to him. Curiously enough the little brunette, at the same time that he was seized by his illness, had similar attacks, and had lain for hours unconscious. Madame Chose advised him to take a strong dose of salts if he ever felt a similar attack creeping on him. Vincent felt it did him a world of good to talk the matter over quietly. Madame Giroux in the café was quite unchanged. Her only comment was 'une fièvre chaude', nothing more! She said that her husband had had a similar experience once during the harvest. Madame Giroux thought it was due to going about in the sun without a hat on, and these things happened especially when the mistral was blowing. Roulin too, had heard of similar cases. And besides almost everybody in Gascony was a little bit mad; it was of the essence of the country.

Did they all say these things to comfort him or did they really believe them? He watched Madame Giroux carefully to see whether she was in any way afraid of him. In the presence of others in the café of course she had no occasion to fear anything. But one day he followed her up to an attic where she hung out her washing. She looked at him quite calmly with her large eyes and just moved the washing basket with her leg between herself and Vincent. He noticed it although it was done quite unostentatiously, and he made some remark. Perhaps he could paint Madame up here surrounded by her washing. He spoke quietly and watched the little window that let in the light. But his speech was a great effort to him and his blood leaped violently within his veins.

'Pauvre Monsieur Vincent!' was all that Madame Giroux said, and suddenly he felt as if a dark cloud had descended upon him and as if a shrill powerful voice was screaming at him from a corner.

He went back to the hospital for a few days. He felt that in such a condition he was better there. Dr. Rey thought that it was due to the amount of blood which he had lost, because his knife had touched an artery, and also that he suffered from under-feeding. Dr. Rey's explanation seemed very probable and especially as at this time he was short of money. Theo wanted to get married and had to arrange his income differently. It was now impossible to continue his expenditure on the scale of last year. But Vincent was used to going short of food, and even last year he had missed many a meal before Gauguin arrived. Just now, of course, good food was particularly important, but Fate decreed that just now he was to have less than in the days when he was well. And of course the marriage of his brother was a hundred times more important than any painting.

He was quite well cared for in the hospital and Dr. Rey was very kind to him. By way of thanks Vincent painted him and made Theo send him an etching of Rembrandt's *Anatomy Lesson*. The other doctors were very kind to him too, only they seemed to be extraordinarily ill-informed about modern painting and they regarded Impressionism as perfectly crazy. It was strange that sensible people, competent in their own profession, were unable to understand the methods of any other profession. He took a great deal of trouble with them and tried to unroll panoramas before their eyes. Gauguin would have done it better. Why had he gone away? Gauguin was presumably a kind of Napoleon. He had left Egypt and left his army in the lurch, but then he could do that just because he was Napoleon. In his thoughts Vincent always thought of Gauguin as Master. He forgot his weaknesses and remembered nothing but the loss that his departure meant to him. Again and again Vincent tried to understand why the yellow house had been deserted. Were not Gauguin and he meant for one another? Could Gauguin ever find a more loyal companion? There was still so much to be discussed and they had hardly begun to discuss even the problems of Rembrandt's *chiaroscuro*. And then Gauguin, who was a remarkable artist after all, loved his stupid sunflowers and the thick chair.

At last a letter came from Gauguin. In a few words he asked Vincent to send him his foils which he had forgotten to take away from the yellow house.

Vincent suffered most from sleeplessness. He squirted camphor into his pillow and took large doses of bromide. Dr. Rey advised him not to think so much. No doubt the excellent doctor meant well, but this prescription was useless, and after all you could only cure bad thinking by good thinking, if it were possible to cure anything at all. He felt some strange poison in his head. Delacroix also had been filled by some poison of his own which made him oppose mankind, but he possessed also poisonous antidotes. Vincent needed antidotes to his poisons. After a few days he returned to Arles, but it was changed. He had become the chief topic of conversation, not amongst his neighbours, not amongst the Giroux, but amongst the other people who had nothing better to do than gossip. The news of his sudden return to the hospital had spread like wildfire. How long would it last this time? Had he returned only to do some other silly thing? And this time perhaps it would not be his own ear. Once a man had learnt how to handle a knife he never left it long in his pocket.—The Giroux tried to convince these people of their folly. He was only a painter, an artist! He wouldn't knife anybody.—But most of the inhabitants took a different view. They thought that his painting was the root of the trouble and had been sufficient reason for locking him up long ago. It was just this messing about with colours that was his disease. They regarded his portraits as an insult to humanity

and then he had the impertinence to ask people to come into his house in order to be made to look like that! And what a sight the house was inside! No one who had been inside would ever forget the spectacle!

The worst of all was that Roulin had taken a post in Marseilles. He came over from Marseilles two or three times, and whenever he came he went to Vincent before visiting his family, but his visits were only rare and short. Salles, the pastor, did everything in his power, although he too, of course, considered Vincent's painting as madness, but he regarded the painter as a harmless creature who at worst would hurt himself, but never others. Vincent as a matter of fact disliked this tolerance, although the pastor was no doubt an excellent man and of all pastors the most admirable. Roulin, too, had no time for pastors. When Vincent considered the matter more exactly he came to the conclusion that the loss of Roulin touched him more nearly even than Gauguin's flight. A simple soul like Roulin, who understood him—for this postman even understood his pictures—was a treasure of untold worth.

He did not discover the commotion which he caused among the inhabitants until their faces became glued against his window-panes. All day long the yellow house was besieged by a host of idlers. It was pointed out to everybody in the neighbourhood: *la maison du fou*. The yellow house became more famous than the whole of Saint-Trophime. And on Sundays it started even earlier than during the week. At first the crowd dispersed when Vincent, with his head tied up, stepped to the window. But the bolder spirits soon lost their fear. And as soon as he appeared he was greeted with a shout.—Fou-roux! Fou-roux!

Here was proof that art was not an open book to every simpleton. Probably Monticelli would have made no more impression on them, and perhaps not even Delacroix. Nevertheless, the excitement caused by the yellow house could only help to introduce Impressionism to the South, and therefore he had nothing to do but go on with his work. The presence of these people in front of his studio could only increase the responsibility of the painter. One day he counted the crowd and there were nearly fifty. All these fifty people would one day remember the present hour. There must surely be one among the fifty who if he was shown the way would be able to understand his pictures. Surely they could understand the Berceuse, who was one of them, and the sunflowers which grew in front of their houses, or the peaches which grew in their gardens. And if only one would understand he would not be lonely for long; at first he also would be thought mad, but then he would seek the company of other lunatics. And in this way perhaps a very small and, at first, very weak society would be founded.—The idea began to take hold of him. At that time he painted his loveliest portrait of himself, the one with the fur cap and the bandage round his ears. Could such a radiant picture fail to touch these people who at bottom

were after all kindly and impressionable? He understood them all just as they were, even their stupid curiosity. Of course he could see that to them a painter was an abnormal creature. Where did he come from and where was he going to? Were they not right to stare at such a conceited creature who attempted to paint Nature and to turn her into a four-cornered canvas?

He tried to consider what to do. He was not over-sensitive nor was he shy. The only creatures he was afraid of were the creatures he saw at night, not those who stood outside his window. He was scared only by silent phantoms and the slowly creeping terrors of the dark. Perhaps the people who were shouting outside could even help him. The right plan, no doubt, would be to pick out the right person and then quietly ask him to come in to him, then offer him a seat and continue to work peacefully. He would ask him to have a look at the pictures and not to talk before the pictures talked to him, and he would not even insist on his looking at the pictures. But what would happen if he should by chance choose one who would not be affected even by Monticelli? He ought to have been a Millet. Millet no doubt would have been able to manage them.

One day in the early spring when it was already quite warm and when he was painting well, the window opened and Fou-roux addressed the multitude. It was as if a hoarse cock, who wore a fur cap, had begun to crow. The audience became hysterical with mirth. They were told something about *Le Bon Dieu* and heaven knows what else. Perhaps he thought he was some sort of a disciple. And finally he became quite wild, this queer red devil. He almost fell out of the window. The people outside clapped their hands furiously and then they began in unison—'Fou-roux! Fou-roux!'

Vincent heard their shouts until late into the night.

Dr. Rey had forbidden any form of excitement. Vincent accordingly barricaded his window on the next morning, so that there was only a tiny slit to let in the light. The crowd howled outside and increased three-fold in numbers. He then retired to the first floor, where he could paint in Gauguin's room. The children managed to find ladders and climbed up after him. Sometimes heads seemed to appear even through the ceiling and from the corners, and from the red floor. He threw a picture down at them, and then two, and then three. The youngsters put their heads through the canvas and danced about with the canvases looking like enormous jagged collars round their necks.

And then he screamed and bellowed like a dog who is being thrashed within an inch of his life. His shouts could be heard far across the market square.

Eighty-one venerable citizens of the town addressed a petition to the Mayor of Arles with a view to putting an end to the turmoil. They requested that the madman should be removed and taken to an

institution specially designed for such people, for which they as citizens paid taxes.

M. Pardieu, the Mayor of Arles, did his duty, and ordered, against the protest of the pastor, that Van Gogh was to be taken forcibly into the section for lunatics in the hospital, where he was locked up in the india-rubber cells. He was taken there in the early days of March in the year 1889. The yellow house was locked up and sealed by the local officials.

Theo did not receive this news until three weeks later. Vincent wrote that he had of course all kinds of comments to make upon what had happened. And of course he felt not the slightest resentment against anything or anybody. In the best of worlds everything was arranged as well as possible, and Theo was above all not to interfere and thereby make matters worse. Vincent was entirely convinced of the good intentions of the Mayor and of the Head of the Police. In fact they entertained the kindliest feelings towards him and would do everything to put matters straight. The whole scandal, no matter how painful it was for Theo and for Vincent, could after all only prove useful to the Impressionism of the little boulevard.

His chief regret was that he lost so much time in which he might have worked. He had to face all kinds of difficulties in the hospital. On the previous occasion, when he had been taken into the hospital as a private patient, the authorities had winked their official eyes, but now they forbade him to paint and to smoke, and even to write letters. The routine of the hospital was guided by some immense power which was nevertheless capable of shades of delicate feeling, in fact one might almost call it an Impressionistic organization. Naturally Dr. Rey could not be blamed. Dr. Rey was only an infinitesimally small particle in the whole organism. Dr. Rey had to obey its rules and regulations like everyone else. Nothing could be simpler. And besides, how could he know whether perhaps smoking and painting were not harmful, and possibly even writing letters was bad for him? Rey at any rate showed how warm-hearted he was by allowing Signac to pay him a visit a few days later. It so happened that Signac was working somewhere in the neighbourhood in Cassis, and Theo had asked him to look after Vincent. Rey even permitted him to go for a short stroll into the town, and he was allowed, of course under the supervision of the Police, to show his pictures in the yellow house to his friend. Signac liked them, or at any rate pretended to do so. In fact he really seemed to appreciate them, and he asked Vincent to come to Cassis, which, though an admirable suggestion, was of course quite impossible. At any rate there were other people in the world besides the eighty-one cannibals in Arles.

Roulin, too, paid him a visit from Marseilles. His simple quietness was like a balm. Roulin who would never escape from the deadly burden

of his routine really suffered more than anyone, although he never showed it. Roulin was really a perfect example of goodness and showed a tenderness for Vincent not like the tenderness of a father towards a son because he was too young, but like the tenderness of an old soldier for a tenderfoot. Vincent felt that he had not the slightest right to be embittered, quite apart from the fact that his situation might have been much worse.—There were other examples for him to follow. In an old newspaper he found the translation of an inscription on one of the ancient tombstones in Arles: 'Phebe, daughter of Telhui, Priestess of Osiris, who never complained.'—Who never complained! When you read an inscription like that you felt an ungrateful blackguard! What was this power that restrained Phebe, and Roulin, who never complained? Nothing but the simple joy of living in the south! It was nearly as beautiful again as it had been the previous year. If only it didn't cost so much money! If only it were possible to recover the twenty francs for the new gas installation from his greedy landlord!

Theo tortured himself in trying to discover what he ought to do. He was about to get married into the bargain. His fiancée of course did not possess a penny. They had to find new rooms, and how were they to do it? Perhaps Theo would have to give up his marriage for the sake of his brother, but marriage for Theo was the only anchor in the sea of his disappointments. He had his troubles; in fact it seemed as if everything that happened to Vincent sooner or later became Theo's tragedy. Would it not be an excellent thing to have a family? Perhaps Vincent would be able to share the joy of it if Theo could found one.

Vincent was quite convinced of it; it would be an excellent plan for everybody. He saw a great future to Theo's marriage and he already loved his fiancée like a being from another world. He regarded the marriage as a gift of the gods. If you marry you carry the south in your heart. And as Theo would not be able to give him so much money, he would simply find some other solution. Vincent gave his heartfelt blessing to the marriage. Salles, the pastor, made superhuman efforts on Vincent's behalf. After a few weeks the doctors certified that even if his attacks should recur it was impossible to regard him as a danger to the public, and even if his painting was a trifle unusual it could not be considered anything in the nature of a public menace. The authorities accordingly gave their sanction for his release. Only he was advised for the sake of the inhabitants, not to return to the yellow house. Salles made inquiries; Dr. Rey had a house in a quiet street in which he could give Vincent two rooms for six francs a month, water included. Vincent would be quite at home there. But at the last minute Vincent shrank from the proposal. He could not start another ménage; it was too much for him. The effort seemed to him too big an undertaking. He could not face the removal and the possibility of having to lay on gas once more

and the daily thought of the money that he was spending. Such a mode of life demanded presence of mind and a cool and level brain. On the other hand, in these public institutions everything was arranged for you without your having to bother about details. If you were subject to an illness you must just arrange your life accordingly. Presumably if you had a free choice you would select a different mode of life, but even this one was by no means the worst that could be imagined. 'This disease is perhaps as much a part of some men as the ivy is of the oak.' He could no longer bear being alone, nor could he tolerate the howling crowd outside his windows. Perhaps it was all only imagination, but then you have to reckon even with imagination and emotion. Vincent at any rate could never move into another house like Dr. Rey's house without Gauguin. Why, oh why had Gauguin run away so suddenly? He would have given anything to become his humblest slave.

Vincent did not wish to pretend that he was untouched by all the needs of other men. Sometimes he had terrible longings, 'Storms of longing, wild as furious waves beating against the rocks, longings to embrace someone, anyone, a woman, no matter who. Of course it's nothing but over-excitement and hysteria! Perhaps that is all that love is in reality. Dr. Rey considers love to be nothing but a bacteriological disease. And you can object to that as little as to the natural Christ of Renan, who, after all, is a far more comforting creature than the paper saviours who are served out in the local ecclesiastical establishments.'

Dr. Rey continued to be most kind. The best plan would be to stay in the hospital, but of course he could not do that permanently. The rules of the hospital laid down that either you were released as cured or sent to a proper lunatic asylum. He would rather go to such an asylum than be alone and at liberty. He was by no means well, and would not be for a long time, although, of course, he did not give up hope. In fact he wanted to be taken to an asylum as soon as possible.

Theo was thunderstruck when he received the news. It was true then! And was everything really finished?—That a man should be destroyed thus by the spirit which others denied him! It is the revenge of an immeasurable injustice. Theo, too, must share the blame. He blamed himself because he had left his brother alone ever since the early days in Holland and because he had clung to his business instead of going with him. Here a man was sacrificed and slowly tortured to death only because he was less of a failure than his fellow-men, only because he had great thoughts others were breaking him. They had done the same to Christ. The world treated Vincent no differently, only the form of his execution was changed.—From that time Theo's health was impaired.

But Vincent was far from desiring to be regarded as a lamb led to the slaughter. He wanted anything rather than a fuss. He was already allowed to work again. He started another Berceuse which promised

well. He was also given permission to read, and began Dickens' 'Christmas Carol'. He enjoyed the curious story and began to make comparisons with Carlyle. He also determined to read Carlyle's 'Frederick the Great'.—He was perfectly satisfied. He had packed up his pictures in the yellow house and had reviewed all Theo's kindness in the process. When he looked at them all he felt ashamed of Theo's generosity. He could not judge whether there was anything lasting in his pictures, but he knew that Theo's goodness would never pass away. Theo had given away his goodness and yet retained it. What an achievement! The effort had perhaps embittered him not only because of his financial struggle. Many a time he must have felt the pangs of doubt and despair and been hurt, perhaps by the inconsiderate violence of Vincent's demands. Who knows how much he had to suffer! And yet his kindness never failed and he had never reproached Vincent. That was goodness!

Such blame as there was could only attach to Vincent himself. The doctors found all kinds of explanations and it was no use quarrelling with them. And in the previous year he had, as a matter of fact—just to heighten his yellow more and more—added occasionally to his powers with alcohol and also with coffee. And perhaps he had suffered because he had worked in the heat out in the open. He realized that he had never known how to keep to the middle path, or to see life in its true proportions. Heaven only knows what he had done without knowing it!

The asylum by no means alarmed him. An asylum was alarming only from a distance. When you are in it you can adapt yourself. If you are among other madmen you are not treated as an exception. Nothing is worse than being an exception. Near Arles there is the asylum of Saint-Remy. He had been told that it was an admirable institution, only it cost eighty francs a month. Theo was to make inquiries. Of course there were other considerations which weighed against it apart from the fatal expense. He had thought of trying to join the Foreign Legion. They accepted people up to the age of forty and he was only thirty-six. Roulin was also in favour of this plan. And in a barracks you were sealed as secure as if you were in an asylum, and it cost nothing into the bargain. He could paint there just as well as anywhere else. If only he was allowed to paint nothing else mattered much.—He was told that in Saint-Remy his liberty would be severely restricted. He would not be allowed to go out at all and it would be impossible to paint out of doors. Perhaps the Foreign Legion would be preferable. Soldiers are not so particular, and by joining the Legion you might perhaps get to Arabia. Arabia must be a wonderful place. The only objection to it was the examination which you had to pass before you could join. Perhaps famous painters of soldiers like Detaille or Caran d'Ache, who of course had friends among the military authorities, could bring influence to bear

with a view to his being accepted. And he could see from Milliet that he would be able to get on easily with soldiers.—Are we not all soldiers?

Theo was on the rack. The story of the old mill at Rijswijk haunted him.—Then one went that way and the other this way.—Theo immediately realized what his next step ought to be; no one but a brute could fail to realize it. Jo, his young wife, realized it too, but she said nothing and waited for Theo to act. If Theo resolved to take the step she would be quite prepared to share in it. There were moments when he was firmly determined to go to Arles and fetch his brother, and then stay with him always.—No, it was no mean motive that held him back. The obvious step meant salvation for both of them or disaster for them all. And success did not depend on his good intentions, no matter how good they were, but on a factor which was incalculable. The obvious solution brought a threat in its train. There was a sinister threat in everything that Vincent did, although he did not know it. Theo's solution might endanger the new home that he had created. In his heart of hearts Theo knew, only too well, that such a step would bring danger with it. And the idea of danger throttled his determination. How could he fear his brother, whom he loved more than anyone else? Yes, more than anyone else, even more than Jo. Jo was a gift of the gods, and Theo always wanted to thank her, for he owed all his happiness in life to her. But she was a new element in his life and was to some extent, therefore, external, whereas Vincent was inextricably bound up with his very being. Nothing could alter the story of the mill at Rijswijk. Perhaps Theo would have chosen a different path, but he could not. No matter how roundabout their paths had been, they always converged ultimately, and there was something sinister in their meeting. Theo would like to be gay and to laugh occasionally like Vincent. Sometimes he could not understand how Vincent could be so contented. Was it his illness that gave him this capacity?—It was not right to live with such an invalid, not even if the invalid is your own brother. It is impossible to help such people. 'Nobody can help him,' he said to Jo. Theo said it twice.—And somewhere, from a dark corner, he heard an echo: 'No, you cannot.'

Not even Vincent's art?—Anybody can perceive that his work contains no sinister element. Anyone can perceive its significance, even people whose judgement is not warped by stories about an old mill. Down there in the south lives the master of modern times. All the deviations from his path, which used to disquiet Theo, now seemed to him to be necessary détours in the ascent. Nobody could doubt Vincent's ability from the day that he reached Arles, and no illness in the world could alter the fact. If Vincent had not made such unattainable demands upon mankind he would never have become ill. Someone ought to have fulfilled his needs, and anyone who knew him could have fulfilled them. Someone had even promised to do so at the old mill of Rijswijk. And

were his demands wild? Were they not rather practical demands both in their form and content? The form of his demands was bound to be unconventional in order to preserve the purity of its content. Vincent remained pure, no matter what the world did to besmirch him. He had succeeded in preserving his innocence. All his struggles had been struggles to preserve the purity of his childhood. Neither his nature nor his colours, but his childhood and his innocence had reached perfection. His work was the work of a man who refused to allow the world to dull his earliest faith. If everyone worked as he had done the world would not sink lower and lower but mount higher and higher to heaven. Theo—have you done everything that you could do—you, the only one who recognized him? You have given him money. And is money enough?

Theo wanted to tell Jo that he ought to sacrifice the hope of a family and his profession rather than give in to the fear he felt. Something within him told him that he ought to go to his brother and say: 'Brother, here am I.'

But if he did this what would happen to Vincent's painting?

Theo's thoughts were like a snake that bites its own tail, and men make a habit of thought, in order to avoid the necessity for action.

Theo considered every possibility. All night he sat and conducted a complicated correspondence with all sorts of doctors and asylums. Dr. Rey believed in Vincent's ultimate recovery, but considered constant medical supervision necessary. He thought that the attacks would come again and that they would not be any less violent for some time to come. The ideal solution would be to find rooms for Vincent in the house of a sympathetic doctor, where Theo could go over to see him every Sunday. One day perhaps he and his family would settle down near him. The elder Pissarro, who lived in the country, offered a room to Vincent, but he refused. He knew his limitations, and although he knew how happy he would be there, he contented himself with saying that he hoped to accept the invitation in a few years, perhaps.

Theo aged during these weeks, and Jo suffered too. He could not sleep at night and his office hours in the Goupil Gallery were purgatory. While he was still writing letters and looking about, Fate took the necessity for a decision from him. On May the 8th, Pastor Salles took Vincent into the asylum of Saint-Remy.

CHAPTER VII
The Cloister of Saint-Remy

Someone who passed through Saint-Remy at that time told a story about a red-haired painter, who sat there and covered canvases with thick colours, while another lunatic sat near him and scratched the paint from the pictures. The lunatics used to help each other in this and in other ways. Anyhow they were more kindly than the eighty-one monsters of Arles. If one was obsessed by untidiness and dirtiness, another suffered from a passion for making everything tidy and clean. If one of them smashed everything he could lay hands on, all breakable objects were removed, and if two started to beat one another they were separated. The management of the asylum counted on this kind of assistance from its patients, and only paid attention to peculiar patients. If anyone went too far he was put into a strait-jacket and into a cell which they called the bathroom. It was not one of the best asylums, and suffered from a certain stagnation; moreover, the institution was short of patients. Apparently there were more lunatics at large than there were locked up here. About thirty large rooms stood empty which could have been turned into excellent studios and would have been large enough to house Vincent's entire community. If you were not altogether sound in health and suffered from fear you were quite happy here. The shouting of your comrades was no worse than the hooting of the crowd outside the yellow house. If, on the other hand, you felt well, then residence in the cloister was less agreeable.

Vincent did not give up hope by any means. He felt that he must fight against his illness and obey all the regulations carefully, but he did not feel the necessity for paying any particular attention to his doctor. Dr. Peyron, the manager, was very friendly and patient, but he seemed to derive little pleasure from his profession, which was hardly surprising. Vincent had above all to learn how to take care of himself. He regarded all disease as either a step to recovery or to destruction. As long as he felt hope he considered that he was in the right place and therefore must put up with petty annoyances. But once he gave up hope he would long for nothing but the grave. The asylum had the advantage of affording him an opportunity of observing others, with a view to finding clues to his own condition. His life-long habit of observing nature was of assistance

to him. He found, for instance, that much talking about art harmed him. As his powers were limited he determined to use them only for what was essential, and he tried to acquire the slow pace and the solemn quietude of a man like Roulin. His illness was by no means chronic and at present, at any rate, it occurred without apparent provocation at intervals which he might learn to gauge. His chief aim was to recognize the causes of his fits and thus to avoid them. Perhaps he could learn to obviate the causes and to make his attacks less wild, but above all he wanted to be able to regularize them. He had heard of a Russian writer who used to calculate the occurrence of his epileptic fits quite calmly and arrange his work accordingly. He could, of course, form no picture as to the nature of his attacks, because his information depended upon the testimony of comrades whose mental deficiencies had to be taken into consideration. He knew that they were violent because, for weeks after they occurred, he felt shaken and only regained his strength gradually. He made great efforts to discover when his mental powers weakened; he wanted to know whether his letters to Theo were clear or not and whether he formed sound judgements about the books he read. He read a great deal again as he used to, and he had got Theo to send him an English edition of Shakespeare. He was struck anew by the Rembrandtesque qualities of the poet and the Shakespearian qualities in Rembrandt. He also enjoyed reading Voltaire. The work of such strong sane men was an antidote to his illness. Vincent's companions of course regarded his books and his pictures as his disease. Even Dr. Peyron did not approve of his reading, and as soon as his condition weakened at all he was not permitted to paint. Vincent thought it a pity because books and pictures, especially pictures, fortified his spirits against his fits. When everything went well he was allowed to use one of the empty rooms as a studio, where he saw the plain and the hills through large windows. And when he had been very well indeed he was allowed to paint in the garden. This garden was filled to overflowing, and cared as little about the doctor and his patients as the patients cared for it. Vincent found it difficult to convey the prodigality of this wilderness of flowers and bushes. Now of course he did not work as furiously as during the last summer, and he gave up his wild pursuit of yellow. It was good for him to paint more temperately, and Gauguin had been right in his objection to all exaggeration. If you could place your colour carefully and quietly on the canvas you would not be regarded as a madman; that was the point.

So far everything was all right, but the conception of sense is capable of various interpretations. For example, his pictures of the garden with the stone seat are sensible, and you can count each carefully drawn leaf, and several other still-lifes belong to the same category. Such sensible canvases always date from critical periods. And his immensely moving

crazy landscapes from Saint-Remy, in which every stroke of the brush betrays his excitement and his emotion, were the products of his most peaceful moments. And it is not surprising, for the ability to tame and co-ordinate such powerful masses requires a cool and capable brain, whereas painting one leaf by the side of another requires no more effort than the act of sitting down. He painted much less than he used to even when he felt well. He painted less in order to gain control over himself, and to save money. Theo must spend his money on his family and not waste it on 'abstract' painting. The restraint which Vincent put upon himself hardly did him any harm, for he could gauge his work better when he was more restrained. He did not paint any more at the bidding of his demon, but, as he said, in order to divert himself. And for this reason his usual tension was slackened a little, and the organization of his canvas sometimes changed as a result. Vincent's technique gained in agility and his colour ranged beyond the narrow scale of his Arlesian pictures. At this time he made the discovery of his cypress trees. He animated the foreground of his landscape with small wavy lines. The bushes in the middle distance became rather more curly and possessed a certain rococo charm. The sloping horizon was built up of inclined planes and the sky, which occupies two-thirds of the picture, can only be compared to the wild fugues of a baroque composer. The cypress trees stood in such a landscape, 'fair as an obelisk', and the wild curves of his structure gained in solidity and unity by being joined to the tall cypresses. Did his picture resemble the landscape which Vincent saw? Certainly not in a way which would have caused Gauguin to stigmatize his work as naturalistic; he would rather have called it a decoration of undulating trees and towering mountains and wild flowers. And yet his fields and bushes, his trees and his mountains were linked so organically by the many curves of his brush that they convey the essence of what he portrayed. His pictures resemble a carpet, in which the sunlight has made the pattern grow into flowers and trees.

No man could be unhappy who painted these pictures. As long as his illness did not interfere with his painting Vincent was content to be an invalid. He owed much to his complaint, he owed peace and rest to it. He noticed how badly he needed to practise drawing again. He fetched out his old drawing grammar by Bargue which had served him in the Borinage and began the old exercises again. He enjoyed copying the well-known patterns and it helped him in his technique. Delacroix had once said that he had only found the secret of his technique long after he had lost his teeth.

Vincent even succeeded in cheering Theo, who had never got over his depression since Vincent went to Saint-Remy. Jo was expecting her first child, and as neither of the parents enjoyed particularly good health they reproached themselves and commiserated with their infant before it

was born.—Could anything be more absurd? Surely because they were ill and sad that was no reason why their baby should not arrive as happily in this world as the youngest Roulin, who was born while his parents were at the height of all the misery they ever experienced. Vincent enjoined his brother to let nature take her course and to be grateful even for a sickly child. Would they love it any the less? And was not love more important than a thousand diseases? If only they could hear the birds sing in his garden and see the old gold of the withered grass!

Dr. Peyron gave him permission to take his easel into the open, and so he painted the fields, the corn-field with the sower and the large sun. His picture was painted in luminous yellow and the hills were a violent-coloured blue. He intended the corn-field with the reaper to be a pendant to this picture. He wanted to put a suggestion of death into his reaper, but without any tragedy, and he painted him as lightly as the sower. He wanted to suggest a devil who fought with all his titanic powers in the heat of the day. He pictured a devil in the sun who could not bear to wait until he had reaped the last blade of his harvest.

When he was half-way through his picture, he had a rather worse fit than usual. He screamed so violently that the people rushed into the field where he was struggling with the yellow devil. His throat was so inflamed with shouting that he could not eat any food for four days. His fit was perhaps due to his visit to Arles. He had gone there to pack up the pictures and he had spoken for a moment to Madame Giroux. Perhaps he ought not to have seen the yellow house again so soon. It was easy to be wise after the event. He had to stay in his room during the whole of August and September, the best time for the autumn colors. He even avoided the others. He had to be still more careful than he had been previously and to avoid any exertion. He had to learn to be a coward, yet he was not afraid of losing what little was left to him of his allotted span, but he was afraid about his work. There was still so much for him to do, which could not be done without exertion. The whole of his life seemed to him useless if he did not achieve this work.

When he recovered he finished the reaper, not in the open, but behind his barred windows, where he also painted two portraits of himself and the portrait of his kindly warder with the face of a beast of prey. And then he painted a picture which expressed more or less what he meant to express, a picture which almost satisfied him: 'The Garden of the Asylum'. It was the incarnation of joy and suggested the very smile of life. Originally the asylum had been a cloister and the former uses of the place were expressed in Vincent's canvas. It looked more like a radiant palazzo of the south, where only happy men had lived. The whole picture was radiant, not only the smiling garden, but the verandas and the people on them. Vincent concluded that joy and art had much in common; they were found long after your teeth had fallen out.

Then he turned to the olive trees. His passion for work returned and his fits returned also, but this time they were milder and shorter, though accompanied by strange religious fears. Memories of his preaching days came back to him and other experiences which he had got over long ago. He had really been much nearer to madness in London and shortly after, whereas now only a stupid external aspect of his illness remained. God had ceased to inspire him with terror. God was nothing but endless and kindly sunshine, and it was only the pastors who tried to darken the vision of Him with their stories. Just as someone had turned this cloister into a lunatic asylum filled with so-called sisters of mercy, so the pastors had turned the teachings of Christ into a sinister legacy. And his last attack was presumably only caused by this cloister of madmen.

Theo, who was kept informed by Dr. Peyron and had Vincent's letters as well, realized the tragic circumstances only too well, and he lacked the cheerfulness which seemed to help the invalid over every attack. Vincent did not send the fruit of his labours as regularly as he used to do, and Theo felt his judgement waver occasionally, for he looked first, not for the artistic merits of the pictures, but for an indication of the condition of the patient. Such a method of looking at pictures brought Theo little joy. In bygone days his misery at the Goupil Gallery had been compensated by his intercourse with his brother. But now every envelope that came from Saint-Remy was like a threat. Matters grew worse and worse every day at the Gallery. The firm departed more and more from their proper programme, and they only suffered Theo because his was a nature that would suffer all. They did nothing to help Vincent to publicity, and not a single one of his innumerable pictures had yet been sold. Vincent took every opportunity to praise his brother as the only sensitive man in the trade. His praise was even more oppressive than the censure which he used to suppress. Theo's young wife saw the endless letters and began to ask questions. Theo hesitated. Was he to burden her with all these worries just when she was about to become a mother? Sometimes he felt a deep hatred of all pictures. They were like poison, and perhaps the child would be healthier if he had had no art in his blood. Occasionally pictures arrived from the south which reminded Theo of evenings in Paris when the two brothers had struggled in vain to set the heavy machinery of hope in motion again. And where was the truth, in Paris or in Saint-Remy? In the old days he had asked himself, Paris or The Hague, Paris or Drenthe, Paris or Nuenen, Paris or the Borinage? Theo cursed himself for always asking questions.

But when he really spoke to Jo about his brother he suddenly became fluent. He was aflame, and his words flowed from him so that his wife looked up in surprise, and even Theo was surprised at himself occasionally. The dark veil fell from him and he seemed to be endowed

with powers that came from a far distance. The crude colours which had frightened Jo grew together and their small room was filled by a new radiance. Theo interpreted every line, every tone, and explained the smallest details like a pupil who has hovered day and night about his master. On these occasions Theo's insight went far beyond all personal questions and he recognized the goal that lay before his brother. He pointed out to Jo what Vincent had tried to do, where he had nearly succeeded, and where he had lost sight of the goal. Jo listened. There was a strange music in Theo's voice which sounded like an accompaniment to the coloured harmonies before her eyes, and seemed to make her more familiar with them. He read in these pictures as if they were pages in an old family Bible out of which the father told sacred stories at night time. Theo, at such moments, saw Vincent not as his brother, but as a rare guest; a guest with a bloody head and a humble mien, on whom he dared not look from reverence.

Pissarro lost his mother and his eyesight was so affected that his friends feared the worst. In these circumstances Vincent was prepared to accept the invitation Pissarro had extended some time ago and wanted to join him immediately. When he received better news Vincent gave up the idea again. He determined to make a success of his olive trees this autumn. Their leaves shimmered sometimes green, sometimes blue, sometimes silver, and the soil beneath them ranged from pink to purple and from orange to the deepest ochre. There was an immense amount yet to be done in this country, and he felt he could not leave it until he had the country, as it were, inside him. Of course he looked forward to the north, which would not be quite a new place to him and for which he would need quite different means. The south had given him a training, it had sharpened his tools.

Here and there Van Gogh began to be noticed. Octave Maus, the organizer of the exhibition of the *Vingt* in Brussels, allowed himself to be persuaded by Theo to invite Vincent to send something to their next exhibition. Père Tanguy wanted to have some more pictures for his shop, and Isaacsohn, a gifted journalist, intended to write a criticism in one of the reviews.

Vincent was quite prepared to talk about the exhibition, although he failed to understand why Maus should happen to light on him. Nevertheless a few of the pictures might perhaps interest artists as attempts at a southern landscape, and possibly they might incite one of them to make a journey to Provence. He would make his choice very carefully. For instance, he might send two Sunflowers, one of the pictures with the ivy, one of the blossoming gardens of Arles, one corn-field with the rising sun, and the vineyard with Mont-Majour. These pictures formed a kind of ensemble. On the other hand he would not hear of an article, and Mr. Isaacsohn was requested to refrain from

putting his kind intentions into practice. In another year's time perhaps Vincent would have given the characteristics of the south clearer shape. A few good days awaited him in the autumn, although of course there were no vineyards in Saint-Remy. As he had been very quiet for some time he was allowed to go to the nearest hills. There he created in one day while the mistral blew—he had to tie his easel down with stones— Le Ravin, the precipice of rocks with the little river painted in rich purple tones and in a style which seemed Japanese to Vincent because of its decorative effect. Later on he repeated it in an even richer version. It was a gobelin made of glittering stones instead of threads, and it looked peculiarly stiff at first sight. Only gradually do we perceive life and vegetation emerging from a mass of line and colour. What a sensation when the whole mass begins to move! It is one of his masterpieces, and he reached the limit of his powers in this picture. We breathe more heavily in front of it, as if we were walking between two walls of immense rock.

Theo warned him against exaggeration of style. He approved of all spontaneous effort, but he felt that Vincent must at last find his way from improvisation to completed forms, as Cézanne had done in his own way. Vincent agreed that he was not concerned with any particular kind of style. He regarded all abstraction which tilted at reality as nonsense. Style was only a means to heighten reality, and heightening of style demanded the sacrifice of all superfluities. Vincent was not blind to the dangers of his work. He realized that all art, even the simplest, was beset by dangers on every side. And he determined to evade them all by circumspection. At this time Gauguin and Bernard sent photographs from Pont-Aven of their latest pictures, religious *motifs* of an entirely new and highly dubious kind. Perhaps they were thinking of the Pre-Raphaelites? Why all this tomfoolery? Instead of calling themselves primitives, they ought first to learn to be primitive human beings. Where did all this religiosity in Gauguin come from? Bernard's saints were creatures without bones. If there was anything religious in art at all it surely lay only in the way art was approached. The name you gave to your models and your pictures was immaterial.

He did not express himself quite so violently, but such was the trend of his thoughts. It is possible that the bigotry of the sisters of mercy in the cloister for madmen had roused his opposition to anything that was associated with the Church. He had a loathing for these sisters, with their starched religion, who saw in their patients not invalids but men possessed of devils. He would like to have sent them to learn a little decent feeling from the inhabitants of the house of Madame Chose.

Although it was beginning to freeze he painted out of doors the main street of Saint-Remy, which was just being paved. He painted the heaps of sand, the houses, the people, the disorder of the paving stones, and

there was light and life in his picture. Then he settled down to paint the olive trees. After he had made a great number of studies he finally painted the two versions of the olive harvest. They were painted much more lightly than usual, with shaded patches and only a thin coat of paint underneath. He painted the picture of the rain and the picture of the street with the new pavement, both done at this time and in a similar manner. He found that by this means he economized in colour and also gained for his objects a richer spiritual significance. Cézanne knew very well what he was about when he painted thinly. It was a means of clarifying your work and of averting accidents. And incidentally this method carried his Impressionism from the little to the great boulevard.

Once more during the most peaceful work his illness attacked him. Theo asked Pastor Salles to go at once to Saint-Remy. Vincent had already left his bed and was annoyed with Peyron, who had written to Theo behind his back. A fit in a lunatic asylum was after all a usual occurrence, and he was only too thankful that they did not occur every week. He asked Theo not to pay any attention to such an occurrence; he would regard it as a great kindness if they took as little notice as possible of such accidents. All that he objected to was that the last days which could be spent in the open slipped by unused. Now it snowed, and he had to play cards. The close of the year was hardly brighter than that of the previous one.

He sat behind his barred windows. The snow settled on the iron bars and made them thicker and the spaces between them smaller. Sometimes he sat perfectly still for six hours without moving a muscle. The others came to see what he was doing and asked him to join them. During the last weeks he had almost forgotten his companions. For a little time he could forget them and then they were there again, just as they were before with just the same faces. He pulled his chair a little nearer. Perhaps it was wrong of him to want to get away from them, but he, who believed in brotherliness, hated them. No, he did not really feel hatred, he felt something worse, disgust. He could not help but feel disgust, it was the barometer of sanity, and he knew that if he lost his disgust he would lose all hope of recovery. As soon as his disgust slackened a little he spurred himself on, and regarded his fellows closely until it made him quite sick. What disgusted him was nothing less than their whole existence. They spent half their time in swallowing the food the asylum provided for them, and the other half they spent in digesting it. Was it conceivable that he would one day descend to a similar condition? Perhaps everyone in such an asylum became like that sooner or later; that was what you were there for. The kindly warder with the face of a beast of prey would tell you so as often as you cared to hear it. That was what you were there for. You could do nothing against the asylum even if you cut yourself off from the others. Except when he

suffered from an attack, Vincent took only bread and water so as not to become a slave to the greed of his fellows, and he often reduced his rations to the minimum in order to be as little of an animal as possible. Of course Peyron was not to know anything about it. Peyron's ambition was to have all the inmates as fat as possible, and especially those who had been recommended to him. These doctors were really most remarkable people. The asylum served a most peculiar purpose, and presumably charitable people like the eighty-one cannibals in Arles contributed towards its upkeep. There was never the slightest attempt to induce its inhabitants to any other activity than eating, except praying, a proceeding to which the sisters attached some weight. The warder, before he came to Saint-Remy, had been in the asylum at Mont-Évergues. There the patients had to work and there were no praying sisters. The asylum there had a smithy, a cobbler's shop and a carpenter's shop. It only cost twenty-two sous a day and the asylum even clothed you.—Did they recognize painting as work too?—The warder smiled.—Van Gogh suggested impatiently that in that case he would learn to be a smith or a carpenter. Anything was better than his present form of life. Places like the cloister of Saint-Remy dated from the Middle Ages and ought to be razed to the ground as soon as possible.— The asylum of Mont-Évergues, however, was only for mild and curable cases. Anyone ought to be able to see that, for it was impossible to give real lunatics tools to play with. Imagine the tables and the boots they would make! Such at any rate were the views of the kindly warder.

Vincent, however, inquired whether all the inmates of Saint-Remy had been serious cases from the beginning. Surely some of them had been quite mild cases, people who were just a little daft, or people who thought too much, as he did for instance. Presumably they didn't consider him one of the serious cases?

The kindly warder smiled. At bottom he was probably not far from the frame of mind of the people over whom he kept guard. It became clear to Vincent that he could not remain in Saint-Remy very much longer if he ever hoped to get out of it again.

When Pastor Salles came the next time he told him so quite simply. He insisted that it was not safe to stay much longer. The pastor replied that Vincent's inclination was entirely in accordance with the wishes of his brother, who would be delighted if he would come to the neighbourhood of Paris. Theo would find a place somewhere in the country. The pastor told him that he could go there any time he wished and that Theo had written about it particularly on two separate occasions.

Theo was a saint. He had written on purpose. What the pastor said was not one of the comforts that were served out to invalids. Most people would have said: 'You will come out all right to-morrow, or the

day after, only you must stay here quietly to-day.' But when Theo said anything, he meant it, and if necessary he would come and fetch him himself.

It was a comfort to hear the news from Salles, only he must not be too hasty. He would have to take a long journey and there would be all kinds of complications, and he might perhaps faint on the way. Why could he not stay with a friend somewhere near by? Was Gauguin happier in Pont-Aven than he had been in Arles? Perhaps they could have remained quietly in the yellow house after all?

However, it had been settled, and he was to leave. Where he should go must be considered with due deliberation. Anything rather than haste! Perhaps it would be better to wait until the spring, for then it would be warmer when he reached the north. He would need to be particularly strong to face his new surroundings.

His chief works during the winter were copies. He had already begun in the autumn when he was not allowed to work in the open, and he regarded this copy work as compulsory. He would never have done it but for his illness. His natural inclination had always been to paint portraits of his contemporaries. He wanted to create portraits as he had created landscapes and, if possible, even simpler and profounder than his landscapes, as convincing as a picture-book was to a child. What he aimed at were pictures of human beings with the simplicity of the stone statues in old churches, but he wanted to endow them with the flesh and the spirit of the present day, because even modern men and women, no matter what they do, must have expressions in their faces, and if they have expressions, he ought to be able to portray them. Perhaps the modern doubt concerning the expressiveness of faces was only due to a lack of strength in the people who tried to portray it. Or perhaps it really had ceased to exist? If so, of course there was little left for art to do.—Pictures like the Berceuse could only be regarded as a beginning, for such a picture did not possess enough of the spirit of his time. Others would come after him to continue his work; his poor head was not a match for the task.

He did not begin to make copies from lack of imagination, for anyone who loves Nature can find *motifs* enough if he has a single flower, or a peasant's chair, or a street which is being paved. His desire to make copies was caused rather by the opposite, by the necessity to restrain his imagination. And there was perhaps another cause which he did not understand quite clearly, a form of secret longing, which was connected with Montpellier and Bruyas and the yellow house. As his yellow house had changed into a cloister of madmen, he wanted at any rate to create such a house in his pictures. As he could not manage to get along with Gauguin he would try Millet, Delacroix, and others; perhaps they would be more patient with him. As a matter of fact, his copies were not copies

at all. Theo sent him reproductions, woodcuts, etchings and lithographs, and Vincent made pictures of them. He turned their black and white into his colours and transformed their *motifs* into his rhythms. Sometimes his work was comparable to re-composing chamber music for brass instruments, but more often it was a dramatization and always a creative undertaking. Some of the pictures he used as patterns can be compared to pieces of metal which are dipped in an acid and then drawn out again covered with shining crystals. Sometimes these crystals express the substance better than its original form, as if they had been intended for this purpose, although their maker had forgotten to complete them. Such was the case with Millet. At last the Sower was produced—Vincent's dream from the beginning, the very essence of his work and his life. He also painted the Angelus, and the Woodcutter, and the Diggers, and the woman teaching her child to walk, and in fact the whole of Millet. After a struggle of many years as a draughtsman, Vincent had succeeded in removing all the sentimental superfluitites of Millet's work, and in reducing it to its simplest structure. His simple forms were now clothed with a brocade of yellow, blue, red, purple and orange. He added no unnecessary decorations, the structure remained structure as naked in its boldness as ever, only even more powerful. Vincent's rich strength filled empty spaces that cried for colour, gave life to trees and a meaning and a voice to mute symbols. His work was a transfiguration, a transformation of one energy into another, which involved no loss but showed improvement in every detail. The original picture, although its copy resembled it closely in outline, really disappears entirely.

Millet's *Sower* is an invented sower who is burdened with the artist's thoughts; he is but a creeping shadow on a ploughed field which is only a field of the imagination. Another peasant ploughs near the horizon with his oxen, or rather there is a silhouette plough with motionless animal silhouettes, in front of a sky of canvas in which birds cut out of paper attempt to flap their immovable wings. In Vincent's picture a peasant strides across his field, you can feel the very substance of the air. The strength of his motion carries you with him. Hundreds of sowers were embodied in one figure. He strides along, not for you, not for art, not for Van Gogh, but for his work, with every nerve stretched to its purpose and every limb and every rag on his body forming part of his action. The field is ready to receive the seed. There he ploughs, here he sows, and in the background the ploughing still continues. Not a detail in the action is left obscure or isolated. The animals, the earth, the man, everything is but a part of growth, and the air is heavy with the coming harvest. He strides there, not for to-day or to-morrow, but as he strode a thousand years ago as a peasant of Provence, as a Greek, or as a tiller of the soil of Egypt. Sowing is the symbol of eternity.

The element which Van Gogh gave to his copies was neither colour nor lines which might have had only an ephemeral value, but he created a solid structure. Millet's *Sower* belongs to other days, to the days of Millet's bourgeois symbolism. Van Gogh's matter-of-factness and his heroic simplicity are such that in a few centuries his copies will be regarded as the originals, and Millet's originals as weak imitations. Van Gogh's creations are more akin to Daumier, and they are cleansed of all the superfluities with which Millet burdened the tradition of his ancestors. But Daumier, with his satire, lacked the faith to create such a sower.

In this way Van Gogh cleansed and purified the work of many others, and the peculiar tendencies of his being were brought to light. Clothed in his mantle, Breton and Meissonier became quite tolerable, and worse rubbish even than theirs was turned into art. He was like an inspired actor who is attracted by a vulgar play just because it offers special opportunities for his genius. Vincent of course regarded himself only as a performer who plays the music of others, and the others were always Beethoven. When he was really faced by a Beethoven his powers failed him. His 'Lazarus' after Rembrandt lost almost everything of Rembrandt and acquired merely modern colour. Delacroix, *Pietà* and his *Good Samaritan* gained only coarseness, although the scene with the Good Samaritan was rather like the Ravin. But even when he painted after such masters his work did not only coarsen the originals. Van Gogh drew harmonies from his Beethovens, with which a rougher world will make its music. The group with the Good Samaritan was capable of supporting Vincent's powerful decoration, and the truth of his gestures and expressions was strong enough to give his picture a quality otherwise peculiar to primitive art. He did the same thing with Daumier, although he lacked all Daumier's satire, which he succeeded in transforming without any vulgarity. Who can but envy him his ability to-day, when bitterness is on every lip and every heart is tortured by a longing for what the age refuses us? Was it easier to overcome the scepticism of Daumier? Why did this attempt not lead to passive neutrality, or the bitter resignation with which we accept destruction to-day?—Because Vincent never dreamed of overcoming anything. Of course he sacrificed a hundred charms which were denied him, the understanding of the Ancients, the twilight of Rembrandt, and the wonderful cloak of satire. Vincent could never have spoken had he been clad with such a cloak. But did his creations need the protection of modern garments? He saw nothing to laugh at in them, far less anything hideous. To him they were all men like the kindly warder with the face of a beast of prey, like Roulin, like himself and like everyone else who belonged to his world. The only difference to him was that the traces of their cares, their work and their misery had been raised into the

realm of creation. All that he could do for them was to move their shapes into the brightness of the day. He put down on his canvas plain statements about the sower, and the baroque of Daumier shone from his structure of unbroken waves. Vincent's method was by no means as far-reaching or as all-embracing as that Cézanne employed, when he made a copy of a Poussin 'after nature', and there was no necessity for it to be so; Vincent's copy was no less organic and no less necessary.

At the beginning of February he received good news from Theo. In fact a whole bundle of good news arrived. Theo had become a father. The boy, contrary to all expectations, was a healthy child—Vincent laughed: contrary to expectations! It was more contrary to expectations that he was happy in Saint-Remy. And as this experiment had, contrary to expectation, been brought to a successful conclusion, perhaps it would be repeated. The little Bruyas was a kind of security for the future. The little Bruyas would do all the things that his stupid and weak grown-ups had left undone. Little Bruyas was a treasure, and although it seemed daring to believe that by the time he reached maturity people would still think of painting, it would at any rate be wise to introduce him to the blessings of art as soon as possible, and to prevent him from becoming an art-dealer. Contrary to expectations also one of his six pictures, the red vineyard with Mont-Majour, had been sold at the exhibition of the *Vingt,* moreover it had fetched four hundred francs and had been bought by a Belgian lady who was a painter herself.—Theo also sent the copy of the *Mercure de France,* which contained Aurier's article. It was a rhapsody about the colour of the pictures in Arles, and was full of glowing metaphors. Van Gogh was said to be the herald of the necessary purification of modern art, and the no less necessary purification of modern society. Van Gogh was the torch-bearer of the age, and this was said by a representative of the youthful literature of the day, almost of the future. France of to-morrow acclaimed the School of the South.

The article was the most unexpected item of Vincent's bundle of news, and could only be read with mixed feelings. If you left out of account the subject of the article and the youthful exaggeration of its author, it was impossible to deny that it had been written by someone who understood his business. And Monsieur Aurier had as an author as good a right to exaggerate the results of his observation as a painter to exaggerate the tones and colours he sees, in order to express himself. Such thoughts were a means of bringing author and artist together, and they were of help to the little boulevard. Only of course the article happened to be, not about any old subject, but about Van Gogh. It was all very flattering, but it had come to the wrong address. The only man to whom this article could really apply was Monticelli. How dreadful that the young author had not said a word about Monticelli! And if he must talk about one of the younger generation, it could be no one but Gauguin.

Vincent immediately wrote to explain at length to Monsieur Aurier how much he owed to Monticelli, who was the real founder of the School of the South, and he sent him one of his pictures of cypress trees, which in his opinion showed how much he had learnt from Monticelli. He requested Monsieur Aurier to be so good as to go over to Theo and examine Monticelli's flower-piece carefully. The rest he had learnt from Gauguin. Vincent explained that it was indefensible to ascribe a new principle or anything of the kind to him, as opposed to the Impressionists. Such a distinction of personalities could only serve to make him ridiculous. And as to his flower-pieces, he could only advise Monsieur Aurier to look at the roses and the irises of old Guost, or the admirable peonies of Jeannin. The observations Monsieur Aurier had made were perfectly right, but did they not apply in a far higher degree to Jeannin and Guost? And finally, he was deeply pained, in spite of the beauty of his article, by his incomprehensible attitude to Meissonier.

Nevertheless such an experience and his good news encouraged him in his work. If he had been prepared to believe all the author said, he might have surrendered himself entirely to his colours and become a composer of colour harmonies. Such a method, however, might fall short of the truth in practice, and he had better stick to his guns. On the other hand, there was nothing to prevent him from using the four hundred francs for the red vineyard to go to Paris to make the acquaintance of Jo and little Bruyas. Only before he went he wanted to paint a few more pictures. Perhaps he would succeed in expressing the Spring in the South—it was his third one now. Just then he was painting the branch of an almond tree which seemed quite promising. He intended to paint whole trees, and if possible whole orchards in this free and rich manner. If he could do it he would succeed in rendering the blossoms more completely than he had done two years ago in Arles.

The fit seized him again, and again during an expedition to Arles. He wanted to pay his rent for the room in which he kept his pictures, and had taken another picture with him, another version of the Arlésienne. He spent two days in his attempt to get there, and one of them he spent in an unconscious condition somewhere. The picture he had taken with him disappeared, and he remembered nothing. He was brought back to the asylum with difficulty. His illness was unfathomable, and as uncontrolled as the wind; it cared nothing for any article, nor for any little Bruyas, not for work, and not for blossoms, and it always destroyed the hopes he had so carefully nursed. The third Spring in the South was spoilt.

This time the attack lasted longer than ever, almost two months, till the end of April. At any rate he was not allowed to paint until then. All this time he had to sit there without moving, just like the others. For two months he was an animal, and it lasted so long only because he was

not permitted to recover more quickly. A little insight and a little kindness could have halved his torture. The most pointless mechanical work would have been a blessing. Was there not in Paris or in Holland an asylum like the one in Mont-Évergues, where he could be a carpenter or a cobbler? The compulsory idleness after the attack which gave you time to think and worry about it, was the best means to assure the recurrence, and so it went on and on. Dr. Peyron was very kind, and the sisters were admirable people, only Saint-Remy did not suit him. The south as a whole did not agree with him, and his illness was somehow connected with it. He must get away at any price and as soon as possible! The whole undertaking in the south was a bankrupt venture.

Theo had got hold of an address from Père Pissarro in Auvers-sur-Oise, not far from Paris, where there was a doctor, Dr. Gachet, who not only understood such cases, but was a friend of all the world and a friend of art. He was ready to take him in, and so he would go to Dr. Gachet.

The journey as such did not frighten him, and he would not hear of Theo's idea of sending a companion or coming himself to fetch him. If he did, he would not go at all, for he was not one of the dangerous kind. At most a warder could accompany him to Tarascon, where he had to change into the express. Should anything happen on the journey his fellow-travellers would help him. There were plenty of kindly people everywhere and he did not anticipate a crisis because his anger at leaving the south without having painted it properly was far stronger than his madness. And besides he could now count upon a prolonged respite.

The sheer fact of having arrived at a decision exercised a beneficial influence upon him. He came to regard his companions and the sisters in quite a different light, and he felt a certain sense of compassion for them. Everything he heard about Auvers was very satisfactory and the release from this cursed cloister alone was bound to work wonders for him. And the north, which was a new country to him now, and the new family were all a form of treatment which was bound to do him good. Before he left he painted a few more flowers. His illness puzzled him more and more every day. Just then he felt stronger than he had ever done in his best days, and as happy as a child. His brush moved almost like clockwork, of its own accord. His 'Lazarus' after Rembrandt and the 'Good Samaritan' after Delacroix were each painted in a single day. He also painted two flower-pieces of irises, which might have interested Monsieur Aurier. One of them was painted in gentle tones of green, pink and purple, the other was suffused by a warm Prussian blue. These flower-pieces contained a certain new element, they were not as violent as the sunflowers in Arles, more intellectual in style, and their general appearance was lighter and gayer. They looked almost elegant by the side of the sunflowers. Monsieur Aurier had probably only seen the old Parisian flower-pieces, which also had a style of their own, only they

were more ordinary, based on an older convention, and revealed less of the particular nature of the object. Now his general style had emerged from the particular. His irises and roses represented nothing but irises and roses, but they represented them with an intensity he had never hitherto attained. Men who had lived in a happier age might never have perceived such flowers, they were the products of a vision which only the longing of a man of to-day could perceive. The style of these flower-pieces did not conceal the humbleness of their origin, but, on the other hand, it represented an individual achievement.

Perhaps his venture in the south was not quite bankrupt after all. Vincent sat amongst flowers and was smothered by them. His gratitude once more drowned all his misery. Was it right to quarrel with the rain which had produced such glorious colour and the scent of a rose? Here was something which he would carry to the north with him. The limitations by which he had been confined had been an obstacle to his art, and he saw no reason to be satisfied with his achievements in the south. But he had still less reason to be dissatisfied with his fate. If he was worried and restless because he could not paint his beloved Southern Spring, it had at any rate one advantage, and that was that he had not yet reached the end. If he had met with no obstacles he might perhaps have drained the cup too soon. But now his cup was filled again to overflowing as in his first summer there, and he had barely put it to his lips yet.

Even the flower-pieces of Saint-Remy have something of the feeling of free copies; they were work imposed upon him by force of circumstances, because he was not allowed to paint in the open. In fact in many ways they are more like copies than his pictures after Millet. He did not fail to notice it. Could he ever hope to paint in the open again without any restraint? If so he would no doubt find the south even in Auvers.

CHAPTER VIII

The Last Attempt

The nightmare of the cloister of Saint-Remy ended on the 17th of May, 1890. A warder accompanied Vincent as far as Tarascon, the home of Tartarin, and then he travelled alone all night to Paris. He reached his journey's end according to plan. His brother was waiting for him at the Gare de Lyon, and Vincent laughed at Theo's anxious expression. Life was not as serious as all that. In fact his condition was really less serious now than it had been four years ago, for he had brought something with him on this occasion. The south was a queer place. Only yesterday he had painted another still-life of roses, two greens, two pinks, before a yellow background, that was all. The picture seemed to him quite passable, although a long way behind Monticelli. It was possible that the pictures he had painted during the last days in the south might repay his travelling expenses. Theo would see for himself, as soon as they were dry they would be sent to him. There was not sun enough to paint pictures like that in Paris, but instead he might perhaps paint one of the shops with their show windows, one of the yellow bookshops in the gaslight. Artificial light had attracted him for a long time, and he wanted to paint an empty street with its lighted lamps in the early mornings.

The two brothers were laughing gaily as they entered the Cité Pigalle, where the young mother had waited for an hour at the window. What a good woman! Jo was most surprised, she noticed nothing strange in her brother-in-law except his ear, which she did not dare to look at. He betrayed none of the unintelligible elements in his letters, seemed healthier than Theo; he was thoughtful like a carpenter, spoke Dutch and cracked jokes. First of all he rushed to see little Vincent. Was it really necessary to cover him up with such a gorgeous quilt? And where was the rocking-chair? And why had they given him the stupid name of Vincent? Did not Bruyas sound better? Bruyas, Bruyas!

'Ah, but don't cry, my little one. I won't eat you. To judge by his voice he might turn into a Courbet.'

Then he rushed to the pictures and hardly waited to have any food at all. In fact he never ate as much as the townsmen, who could never get enough. Butter and cheese and jam, and even eggs in the middle of the

morning! Did they think they could replace fresh air by it? But he owned that he had never tasted such good bread either in Arles or in Saint-Remy.

He fetched out every one of his pictures, and in five minutes Theo's tidy little flat was in disorder. There was not enough room to spread them, too many pictures and no money to show for them. What was the matter with the art-dealers? Perhaps he ought to paint the Ardappeleters again, without their dirty colours. It might be worth while to do so now, because the Ardappeleters had only been a beginning. When you looked from the Ardappeleters to his present collection, you could not but praise his progress. Although by the side of the south what he had done was only a tiny step forward.

He could not wait to clear away, but rushed to the Louvre. The Old Masters looked down upon him as secure on their height as ever, while he grovelled below. Delacroix and Rembrandt! No. Rembrandt and Delacroix! To the School of the South Delacroix was perhaps the greatest painter, because he contained Monticelli and all the others. There was more in the south of Delacroix than in the north. All the glories of the south were united in him, the Venetians and Raphael and Rubens. Perhaps one day there would be a new School of the North, for whom Rembrandt's portrait of himself with the scarf on his head would signify more than all the joys of the south. He at any rate would have been lost down there without old Rembrandt. Anything that was worth while in the Ardappeleters he owed to him. Delacroix was the painter he needed to have with him always, who answered all the problems of everyday life. But he needed the old man with the scarf for special occasions, and without such special occasions all painting was useless. If people took it into their heads again to paint portraits, real faces, they would have to go back to Rembrandt, they would never be able to get on without this neglected old drunkard with his dirty scarf. Was there not blood on it? Had he, too, cut off his ear?

The next day Vincent visited his brother in the *entresol* in the boulevard, and then ran up the Rue Laffitte to Durand Ruel, and then to all the little dealers till he reached Père Tanguy, and then, as in the old days, he climbed on the Clichy-Odéon omnibus to cross the Seine to the Luxembourg. From the Luxembourg he took the short cut to Saint-Sulpice to the Delacroix chapel. Paris still smiled upon him as she had done four years ago, and was just as inviting, just as inscrutable. Paris was no place for simple people, and it had not done Theo any good either. He looked older than Vincent, and always evaded questions about his health.

Two days later Vincent went to Auvers. In Auvers all the arrangements were admirable; his rooms were a little dearer than in the south and not so large, but quite sufficient to begin with, and no one could be

more delightful than Dr. Gachet. A unique medico, who knew more about art than all the doctors in Provence put together, and painted in his leisure hours. He had even known Bruyas, and thought of him with an almost greater reverence than Vincent. The little doctor regarded the deeds of Montpellier as more important than the battles of Napoleon. Gachet was a friend of Pissarro and Cézanne, both of whom had stayed there; Daubigny and Daumier had also stayed there, and the present generation was represented too, several young painters worked there. In fact there was almost a School of Auvers. In a certain sense Gachet belonged to it, as he had known all the modern masters and had pictures of theirs, and knew queer stories about them such as only an apothecary could tell. The doctor had a yellow face with many folds, and life had brought him all kinds of troubles against which he struggled with his unconventionality. Art was a charm against all evils for him, and the soul of a Tartarin lived in this apothecary, whose diagnoses were probably controlled by the same spirit. He declared that Vincent suffered from no organic disease. His troubles were nothing but the foibles of an artist, for which no medicine existed. Everyone was more or less crazy, and the more vital a painter's art, the greater was his madness. Cézanne could easily have been certified; if anyone looked at him unawares, he ran away. Daumier was so mad that he ought to have been taken round by a circus on show. Genius and lunacy were well known to be next-door neighbours.

The theories of the doctor were all very well in their way, and were a compliment to his wit and also possibly to his perception as a doctor, although they differed not a little from the ideas of the specialists in the south. But he was quite wrong about genius; genius was the exact opposite of lunacy. Even an ordinary artisan needed a cool brain. And it was advisable not to throw about big words like genius, although there was no denying that the doctor was right as regards his health, which appeared to be most satisfactory. He seemed to have left his disease behind him in the south. A northerner belonged to the north, and anyhow a cloister was no place for him.

There were peasants' cottages covered with thatch and comfortable-looking village streets, open cornfields with undulating hills in the background, and the Oise running through the plain. The doctor had a few good pictures by Cézanne and Pissarro. He had never seen such a doctor's house. It was filled from top to bottom with all kinds of absurd rubbish. Mediæval furniture, Gothic ashtrays and candlesticks made of pewter, stuffed animals, and in one corner lay his pictures, unframed and strewn about like waste paper. Gachet also owned a few Guil-laumins, and he referred to his pictures as 'documents humains'. The doctor had a clucking laugh, and promised that he would have them framed one day. Vincent painted him, in very light tones and with his

queer white cap on his head, in a blue jacket on a blue background. On the table he painted a yellow book and a scarlet flower. Gachet fell in love with his portrait and immediately ordered another version of it. Gachet made an etching after this picture, for he was quite an experienced hand with the etcher's needle. Everything conceivable could be found in this absurd house, even a printing press.

The doctor understood Vincent's pictures, which was not really surprising. He said that he understood them by virtue of the experience he derived from natural history. Anyone who failed to understand them must be insensible to warmth, light and movement. Vincent's work was a synonym for nature. This Dutchman forced men to weigh fundamental values, he was the Rousseau of painting. And as a result, this Rousseau's life was in accordance with his confession.

The doctor had a passion for historical observations. Van Gogh, who had led art from the narrow domain of plutocratic luxury into the broad avenue of popular creation, was a continuation of the Ancients. No banality, no assumed simplicity! His work was popular art without a Plebs, the art of an individual who longed for a community. Everything the doctor said was contradictory, just as contradictory as the aim of a Dutchman who tried to find cohesion in the disintegration of Impressionism. His whole conversation was a string of paradoxes, and the doctor loved nothing better than a paradox. He maintained that what was theoretically impossible and sounded absurd in words, was suddenly confirmed by pictures, and then in the twinkling of an eye, common sense and logic emerged from the chaos. Gachet declared that Vincent was a Dutch Rousseau who produced a peasant art made of wooden clogs, and that his work was yet as refined as the art of Japan. Innocent of all archaism and of every trace of Burne-Jones, at the same time his work was ultra-modern and yet so much a matter of course that he could not understand how it was possible to see faces and landscapes differently, and he asked himself how anyone could paint differently and why everyone did not paint in Vincent's style. Of course he was mad, because it would never do to call him sane as opposed to all the other worthy inhabitants of the globe.

He talked like that by the hour. The hymns of praise of Monsieur Aurier were dismissed as being merely bare statements of fact. Any form of exaggeration always made Vincent feel uncomfortable and he could not enter into the doctor's humour, but the doctor assured him that a true perception of his art would only have spoilt him as an artist. True visionaries were always blind.—Sometimes this art-loving medico resembled to the life one of the madmen in the cloister, at their worst.

It was one of the doctor's customs to invite Vincent to dine with him several times a week, and on these occasions he would honour him with several courses, which were served with great solemnity. There were

always two kinds of wine-glasses, a little one for Bordeaux and a larger glass for Burgundy, which was served after the roast, and was bottled in such and such a château. The doctor, however, hardly wetted his lips, and did it all as a ceremony in honour of his guest. What Vincent disliked most of all was the extravagance of the doctor's dinners. He told him that instead of his excellent *hors d'œuvre,* he ought to have a few frames made for the gorgeous pictures of Pissarro, which were strewn about in the corner.

On the other hand, Vincent's work was greatly to his taste. The inhabitants of Auvers were accustomed to painters and let him put up his easel wherever he wanted to without staring at him. The huge thatched roofs on low walls, boxed together between narrow gardens, supplied him with altogether new *motifs.* The details of the picture were huddled more closely together than in the south, and though they lacked colour they made up for it in richness of tone. He had to weave his structure more closely, in order to deal with the new landscape, and he painted as a result on smaller canvases. In Auvers there was not such a powerful contrast between the blues and the yellows and the flaming sky, but instead he found rich semitones and homely colours which did not shine so radiantly from a distance, but possessed great profundity. He was reminded of the dreamy silence of Dutch villages, and attempted consciously to convey it. Jongkind had substituted for the delicate touch of the old Dutchmen his straight strokes, but he had lost the depth of the Old Masters. Vincent set himself the task of heightening his colour, widening his activity, carrying simplification even further, and yet maintaining the profundity of his creation. His curly strokes penetrated into the very heart of the substance he portrayed. He suggested the recession of his planes by innumerable curves, from the tiniest curls to bold arabesques, and when his curved structures developed into straight lines they gained ten times in strength. Vincent's method resulted in an infinitely richer system of design than that of Jongkind and his successors. His structure resembled more the work of Aart van der Neer and Van Goyen, only the modest vegetation of the older masters had developed into a primeval forest. He felt grateful to the north, for there he had not to contend against the mistral and all the devilry which the mistral brought. No doubt a northerner ought to stay in the north.

The weird little doctor went into ecstasies of delight over every new picture. It was impossible to discuss any one of them in a workmanlike manner with him. He could see no faults, not even thin or empty patches. If Vincent showed him one the doctor was quite beside himself, and would read him a long lecture. He told him he was an ungrateful wretch, unworthy of his heaven-sent madness. People who were not a tenth part as crazy got into the Academy. Vincent pointed to the

Pissarros and the Cézannes in the corner, which he was to hang up in frames at last. Had he ever achieved their calm and their quiet dignity? Gachet did not give a tinker's curse for their calm dignity, half-hearted compromises! How could one compare such a street theme to a Pissarro, or to a hundred Pissarros. Vincent lost his temper and made for the door, saying that he had to go to his work. He almost threw the doctor out of his own house. He told him that he found it hard to listen to him, and he regarded what he said as insulting to him personally. And it really was degrading to leave the Pissarros and Cézannes unframed.— The doctor clucked, he did not frame Van Gogh's pictures either, they lay about quite naked, without even their stretchers.—He would not hear a word against Vincent's pictures, and the little street themes were such treasures that he refused to part with them, even for the time it would take to have them framed.

Vincent was glad that he could go occasionally to visit Theo in Paris, and that his brother and sister-in-law could manage the expedition to Auvers. In June the young couple came over on a Sunday and brought little Vincent with them. Gachet gave a special dinner-party as if it was a jubilee. Theo was not looking well, it was the old story—Messrs. Goupil on the boulevard! The ideal solution would be for Theo to start a shop of his own, even if he could not found the community Vincent longed for. Gachet was all in favour of the plan, a shop filled with nothing but Van Gogh's pictures was bound to have an immense success; it would be a shop of human documents in the middle of the boulevard. There remained the problem of the capital. Ought not the State to help him? Confound it, was it not the duty of any Government, which did not make a farce of culture, to give publicity to human documents?—Vincent did not take part in the conversation, but showed the hens in the yard to his little nephew, crowed cock-a-doodle-doo and took him to see the cows being milked. If the little fellow could only live out in the country his colour would be better. And it would be a good thing for Theo and also for Jo.—Gachet conceived the plan of etching all Van Gogh's most important pictures and publishing them like Lauzet's lithographs of Monticelli. He would look after the printing of the plates. Vincent agreed, on condition that etchings after Gauguin should be included. A discussion on Gauguin followed, during which Vincent lost his temper, ran out into the yard, crowed cock-a-doodle-doo, and danced about with his little nephew, who screamed with delight. Theo and Jo promised to come again before long. In the meantime Vincent was to visit them in Paris. They decided that they could permit themselves the luxury of meeting at least once a fortnight.

He painted a picture of Madame Daubigny's garden, which was not so full-blooded as his street scenes. It lacked their dramatic quality and their vitality, and suggested contemplation rather than action, but it was

richer in colour. Gachet called it 'le jardin de France'.

When Vincent's pictures arrived from Arles and Saint-Remy, he locked the door and hid them in a different room of his lodgings and told the doctor nothing. But the weird little medico found out after all and then he was quite beside himself. He had not been prepared for such work. These pictures were not human documents but the songs of heroes. He meant it literally. The brushwork of these canvases ceased to be brushwork and became rich melodies, heroic symphonies. The doctor could almost hear the tunes, and declared that the colours of the garden of the asylum could be reproduced in sound values. He tried to demonstrate it with his tinkling voice and fluted and hummed all day long, while Vincent escaped into the fields. When he returned at night the doctor was still at it, twirling in the air pieces of paper with music written on them, while he rummaged among the pictures, clucking and giggling. He was prepared to give up his practice in order to investigate his newly-discovered theories, and he insisted that he would feel honoured and delighted if the master would participate in their experiments—his son and daughter, who were adepts, would assist them. Next day the trio sat down at the piano to rehearse the Arlésienne.

Theo's letter brought bad news. The boy was ill, and Vincent wanted to take the next train to see him. Jo was not well either, and Theo was worried to death. But perhaps it would be better after all if he did not go there. How could such a clumsy creature help them? He would only be in their way and frighten the baby. He wrote a short note and then rushed at his work. If anything happened to little Vincent, life would be bleak indeed. He threw down his brushes and ran to the doctor. Gachet only laughed and said that the baby was teething. Vincent was furious, the health of the child touched him too nearly, and he told the doctor that presumably he was as vague about a baby's illness as he was about painting.

Two days afterwards, however, he received a confirmation from Theo that the trouble was caused by little Vincent's first tooth. And so Vincent had after all mistaken a sign of life for a sign of decay, and he felt a load far greater than its cause lifted off his shoulders. Vincent made his peace with the doctor and painted Mademoiselle Gachet at the piano and then another girl in Auvers, the girl with the capote. These portraits were not a success, perhaps because he was not used to ladies and could not concentrate his thoughts. Moreover he was not accustomed to the tall shape of the canvas he used for the picture at the piano. His rhythm became halting, his hand hesitated and lost its vigour. Perhaps the doctor distracted him, for he was glued to the easel and clucked continuously. One thing was quite certain, that if by chance he had another fit he could count on anyone rather than the doctor. It was

doubtful which of the two of them was more mad. He left the portraits, although he thought them bad, and started a landscape. The heat in Auvers was oppressive. Gauguin wrote him curiously gentle letters. He was always gentle when he was in trouble. His latest idea about Madagascar was as wild as suicide. But if he insisted Vincent would join him. Perhaps Madagascar was not so bad after all, although a friend of Milliet's had served there and disliked it. But who knows what Milliet's friends had done there? Yes, on further thought, Madagascar was an excellent plan, and he determined to proceed at once to Pont-Aven to discuss the matter with Gauguin. In Pont-Aven he could also paint seascapes. He suddenly felt an uncontrollable longing for the sea and for ships. But the journey to Pont-Aven was terribly complicated, much more complicated than the journey to Madagascar. Sometimes the slightest details seemed to be embedded in inextricable entanglements. Sometimes he could not do the simplest thing, such as walk over to the doctor's house.

He felt that he must not be afraid or else his fear would be realized. Or perhaps it was good to be afraid? His experience rather suggested it. His illness attacked him just when he least suspected it, in the midst of his work. He had never felt it coming. And especially if he was working well it came, quick as lightning. The logical conclusion was to avoid good work, and the last time he had suffered from his fits in Arles, it was no doubt due to the fact that he was working well. But then that was all far away, Arles was many hundred miles distant. No, his illness had stayed behind in the south, and how could he be ill here in his lodgings where there was no cloister and no warder and no padded cells? He was allowed to be at liberty therefore he must be well. But was it really safe to let such a creature run about quite freely?

Sometimes he felt the imminence of danger. He felt the fits would return, and he was tempted to hurl himself with all his might against his door, beyond which he could fancy that he saw the phantom of his ailment. He talked little and avoided the doctor, with the result that his fear oppressed him more than ever. No! it was better to paint, and if it came, it came. He plunged himself into his work, and he was working well, the colours obeyed his every wish. At five o'clock in the morning he could be found at his easel; no doubt it was a mistake to paint like that, but it was the only way of making life supportable.

One day at the beginning of July he fled to Paris. His brother and Jo had other cares, and it was Vincent who cheered them up and who was gay and hearty. The health of the little one was still uncertain, but then every child had to go through its periods of teething. Theo kept on asking Vincent whether he was well. Why did he always ask? Did he not look well? He cheered them up and crowed cock-a-doodle-doo to the little one. The only way to live was to live in the country, in Auvers he

lived like a lord.

While he talked to them he thought of other things and sat there like a smiling criminal expecting the police at any moment; he talked for the sake of talking. Theo began to regain his old vitality, and thought that perhaps he might after all found the community. He had met an American, a queer mad fellow, who was very rich and who might do it for amusement. He was a kind of Vanderbilt—he wore a green waistcoat—and was prepared to subscribe a very substantial portion of the capital, but of course there were other difficulties to be overcome. There always were other difficulties. Theo anticipated a final rupture with Messrs. Goupil. It had to come one day, and that would be an evil day for him.

Jo suggested that now that, thank heaven, Vincent was well, he ought to get married. There were plenty of nice girls in Holland who would make him happy—she had a friend there.

Vincent did not say 'no' to her suggestion, only that he would have to think it over thoroughly. In the best of all worlds everything was always for the best.

He ran across old acquaintances—Lautrec and Anquetin. They talked to him differently now, without their stupid grinning, and they treated him, partially in jest and partially seriously, like a man who had returned from a difficult expedition to a foreign part of the world. The result of this imaginary journey to the South Pole was that Vincent felt more at home with his Paris friends and would even like to have stayed with them instead of at Auvers. They all knew Aurier's article and considered it very amusing. They told him that Bernard got hysterics when he read it and that Gauguin had written a reply to the *Mercure,* saying that he had arrived at the South Pole twenty-four hours before Van Gogh.— Finally Isaacsohn arrived and stayed for the evening and made unintelligible remarks about his pictures. It was too much for Vincent, and he returned to Auvers.

He told Jo that he quite agreed with her that it was better to create children than pictures, if one could not make human beings out of words. Painted words at any rate were not enough. Modern pictures made people mad because pictures were forces without an aim. Poets perhaps might reach the goal with their strange phrases. Christ was greater than all other artists because he reached the goal without any phrases. His words marched on through life, strewing humanity about them like grain in a newly ploughed field. As long as artists felt the strength and purity of his words, art had flourished.

He fetched down his Bible for the first time after a long period, but the familiar verses did not move him now as they used to do. While he read the Bible the phantom of his parents' house haunted and distracted him.

So he turned again to his pictures. He painted till the brush dropped from his fingers. Young painters talked to him in vain and could elicit no replies. He saved every breath that was in him for his work. He avoided his violent baroque style and his pictures became gentler than the older ones. When the Mairie in Auvers was decorated with flags for the celebration of the 14th of July, he painted it with its blue, white and red streamers and rows of coloured lanterns dangling from long strings. There is something of Monet and Pissarro in the picture. The planes were divided by small, even, parallel strokes; even Signac would have enjoyed it. None of his earlier pictures were so symmetrical. The systematic structure of the canvas weakens his usual naturalism. The trees round the little square partake more of the nature of decoration than of his usual tree-like organisms. But the profundity and solidity of his drawing lost nothing by his new method of construction. The little house is rooted to the ground like a rock and stands there as firmly as the peasant chair in the yellow house in Arles, and as solidly as his sunflowers. It expresses the unsullied joy of a manly heart at the gay festivities of the people.

When Doctor Gachet saw the picture he maintained that the 14th of July had been made a holiday only by virtue of this picture and that you ought to sing the Marseillaise while you looked at it. The State ought to hang it in the Louvre, or better still in the Panthéon. He declared Vincent's intention of giving it to Père Pissarro profanation.

Vincent did not reply, but came back to the doctor afterwards and asked him for an interview. He began to tell a complicated story about the duties that we owed to artists, especially to such veterans as Père Pissarro. There was something strange in his voice. Anyhow the doctor must have Pissarro's pictures framed at last and also those of Cézanne. The pleading notes of a child were in Vincent's voice. The doctor had something to say about the moods of artists, but he promised nevertheless to send for the carpenter. Next day Vincent returned and walked straight into the doctor's room, where, just as he had expected, the pictures were still lying about anyhow in the corner.

That was too much! It was very wrong of him! Only blackguards behaved like that! Père Pissarro, who was the father of us all!

Vincent's eyes were bloodshot. The little doctor clucked no more. He happened to look into a mirror over Vincent's shoulder and saw that there was a revolver behind his back. The many folds on the doctor's face became tense.—'Mon ami,' he stammered.

Vincent gazed at him, laughed awkwardly, and then marched out. As soon as he reached his room he fired a bullet into the pit of his stomach. It was the second Sunday after the festivities. He was unconscious when they found him. When he regained consciousness he asked for his pipe. Gachet wrote to Theo, and as he did not know his address and as Vincent

refused to give it to him because he did not want to have any fuss made, the letter was sent to the Goupil Gallery. Theo did not get the letter until the following morning. When he arrived Vincent was already lying quietly on his bed, without any pain. Gachet was hopeful. He did not believe it was possible to destroy such a vitality against its will. And although the action which had laid him low was the work of his own hand, Gachet could only regard it as an impulse which had temporarily asserted itself against Vincent's own will. If a man of his vitality wanted to live, he would live. As long as he could work he would not pass away. The incomparable creations of his vital nature hardly permitted any doubt as to his desire to live and therefore the world might expect his recovery.

Theo van Gogh became impatient and wanted to know details of the nature of his wound. It was serious; several vessels had been perforated, but Vincent's determination had outlived even more serious obstacles. No operation was necessary or possible. Everything depended upon his determination. Vincent nodded. He entirely agreed with the doctor's diagnosis.

The little doctor clucked and assured him that he could always rely on his diagnoses.

No sooner had Theo been left alone with his brother than Vincent began: 'Qu'est-ce que tu veux, mon frère? It has really been too much for me. Of course there are more unfortunate wretches, for instance that poor creature—you know—Sien, who I suppose has gone back to her brothel by now. And much of what I could not bear has been, I know, my own fault. Did you ever know such an awkward and helpless fellow as me? I can't even manage to use a revolver properly. I have never been able to do anything the right way. Anyone else in my shoes could have solved my little problems and have managed quite well. One thing is certain, that is that I did not do well at all. No, really it was more than I could manage.

'I have always strayed about all over the place, never quiet for a moment. Even when I was in London wearing a morning coat and a top-hat I could never find peace. When I was in Brabant I longed for London and my top-hat, and when I was in the city where everybody is as they ought to be, I longed for the open fields of Brabant. There is something in me which simply makes it impossible for me to accept my lot as it is; I am cursed with a preposterous discontent. But if, for instance, Ursula, or whatever her name was, had accepted me, who knows what might have happened? The whole thing was of course dreadfully banal. There were a thousand other Ursulas. But does it not strike you as curious that a fellow can run all over Europe seeking and seeking, really trying hard, and never find a soul? The things that made the difference were perhaps only trivial little peculiarities, such as my

always wanting to get an answer. It was just the same with father and mother. But can you converse with anybody without getting a reply? It really looks as if one must believe that the rest of the world talks without ever getting an answer. Do you believe that? Do you talk like that, for instance with Jo! I could have been content with just a few sentences, but no, I never heard them. The result was I only talked to myself, which made me nasty and spiteful. And that is the way, a very roundabout way, by which you approach your God. You only talk with yourself when you commune with God, with the result that you end up by seeming almost to be God yourself or at any rate, someone of tremendous importance. The whole process is one which makes you quite different from your fellows and aggressive into the bargain. If I could only have found somebody in London who had any use for ears, I would have cut both of them off. But it is of course disgustingly aggressive to send anyone such things.

'Theo, qu'est-ce que tu veux? I was ready to love anyone and everyone. Isn't it odd that no one, of the many whom I have met, liked me? You may think that it is rather pretentious to say so, but honestly there was not one. Not even you, Theo, although you have done everything for me. Why did you do it? You will say that that is another of those questions to which only I expect an answer and that decent people are satisfied by deeds. But you see, that is just my disease, that I lack this decency which everyone else possesses. I know very well that you wanted to love me and that to-morrow you will love me terribly, so much so that it may kill you. But as long as I was there you only put up with me. You were always glad when I turned my back. There was something that made you prickle all over when I arrived. Come, admit it! I couldn't understand it either, because I could not even manage to suppress the external and superficial things which made you prickle and tingle.

'Theo, qu'est-ce que tu veux? All my life it has been the same story. I always felt as I did in London about the fields in Brabant, and then when I was with you we quarrelled. And then I wonder whether whatever it was that made you prickle is something very trivial or if it something very, very important which ought not to be suppressed but rather brought to the surface? No! it is just viciousness and beastliness. The other day I longed terribly for you and Jo, so much so that I thought I could not wait another minute, and then when I came I forgot everything I wanted to say to you because of your stupid sideboard in the dining-room, and I just wanted to get away again as quickly as I could. Of course it was not only the sideboard, although I don't like it, I don't like any of your furniture, although it is admirable and could not be better. Christ was so infinitely great because no furniture or any other stupid accessories ever stood in His way. Although perhaps the disciples only thought afterwards that nothing ever stood in His way, because then

only His greatness remained. Perhaps there were times when they were furious with Him during his lifetime, Judas for instance, and they may have been justified. He, on the other hand, did not get cross with them; although He probably had reasons in plenty.—Do you think that I don't know what Gauguin was like to me? From the very first day he was aggravating and he said things which he knew went against the grain; he had a special talent for saying such things. But who can say that he did not come with the honest intentions of loving me and that he did not try as hard as he could to do so? What is it that drives him to his savages? Surely nothing but the irritating poison which is in him and which gives him no peace. And at the same time he lives on his poison. He has too much of it in his being, and my illness comes from nothing but the lack of this substance. My evil temper, too, is caused only by the lack of such a poison in my constitution. But once in Montpellier in the Bruyas room Gauguin very nearly held me in his arms, because he was thinking of Delacroix. Delacroix was a kind of antidote to his poison. Yes, I think we did embrace each other then, without knowing it. And immediately afterwards he made me mad. You, too, Theo, held me in your arms once, in our old lodgings in Montmartre, because you were unconscious of me. And before that time we embraced each other once in Holland; that was by the old mill. We were thinking about the future then. Life with simple people is always less irritating and it is always easier to approach them. The miners in the Borinage were good fellows and the Roulins and also the warder with the face of a beast of prey. The only trouble is that these people bore you. While you are in the thick of your work intercourse with them is sufficient because they too are always hard at their own. In the intervals you just pass the time of the day with them and there it ends. There are many things which they understand better than we do, even subjects which really only concern us, but they have a low opinion of them because they are too busy with their own concerns. Their simplicity is really nothing but self-protection. But then the object of living together does not happen to be to protect oneself.'

Gachet had forbidden Vincent to talk too much but talking did not fatigue him in the least. Did Theo not notice that they were just going to have one of the good moments of their lives when they would embrace each other again, and this time perhaps they would think of one another?

He inquired about Jo and little Vincent. They had gone to Holland a few days earlier, where Theo had intended to spend his holidays. And instead Theo sat there and waited for the good moment. It really was too bad! But as he was there, he might write a line to Gauguin and also to little Bernard. Gauguin had liked one of the pictures of the Arlésienne, and he was to have her, and after all Bernard got the Sunflowers, which had been refused him the other day in a stupid mood.

In order to rest Vincent, Theo went out of doors for an hour. It was dark and the wind whistled through the trees. Once he fell down, and was so tired that he stayed for a while on his knees; a deep bitterness rose up in his heart. Against himself? Against Vincent? Even at this hour? Yonder stood a mill.—Why, of course, the mill of Rijswijk. He raised himself up and stood there alone in the field, his clothes fluttering about him like a scarecrow. Then he rushed home and embraced his brother with unusual intensity. Their arms were clasped for a long time, and they thought of the past.

Vincent asked for the room to be lighted. The last pictures of the fields near Auvers were too thin, but the village streets seemed pretty solid. They were like little tough fellows who could stand up quite well to the powerful creatures of Arles. They were all here, the garden of the asylum, the Berceuse and the Sunflowers, the cycle of the poet's garden, the portrait of himself with the bandage, the landscapes of the plain of Arles, and the Arlésienne. Theo picked them up one by one, put them against the wall, stepped back, seemed puzzled, examined each picture again closely, took the lamp down and knelt on the floor so that he could see the pictures at the right level. Something unusual was happening, although Theo knew the pictures intimately. While he was in Arles he had seen the pictures in the yellow house only for a few minutes, but the other day, during his last visit, he had looked at them for hours. He must either have been asleep then, or else his present state of mind was abnormal. Not one, but all the pictures from Arles had changed. As a rule every picture of Vincent's which he did not happen to have on his walls gave him a kind of shock at first, like a badly driven train which is suddenly brought to a standstill and throws the passengers out of their seats. All the pictures possessed this quality to a greater or lesser degree. It was the symbol of the fact that Vincent was a Dutch outsider in France, it was a relic from the Ardappeleters. People like Aurier regarded this quality as constituting Vincent's originality and they made a virtue and a novelty out of it, but Theo suffered from no illusions. He knew that this shock which the pictures gave him was the element which prevented Vincent from overcoming his final problems. It was a peculiarity which he had never got under control, and it was perhaps one of the causes of his illness. But to-day the shock was missing. The colours caught his eyes as soon as they rested on them, and they were carried on, forcibly it is true, but without any superfluous brutality. The pictures moved him deeply at once and carried him into the very heart of their being, into the heart of their creator, and the power of these pictures had not grown less but seemed like a building from which the clumsy encumbrances of scaffolding had been removed. Theo suddenly perceived much more than he had ever done in Vincent's pictures. All that Vincent had aimed at was there, complete.—Theo, cautious as ever,

mistrusted his eyes and tried to feel the shock he used to experience. He went from one picture to the other and then turned to his brother with all the glory of the pictures shining in his eyes.

Vincent laughed; it was only because he had washed them. The pictures which had come from the south had dried in the meantime and he had washed them a little with water, removed the oiliness and then varnished them. If Theo would do the same to the pictures in his flat they would look just as these did. The canvases he had only just completed in Auvers would have to wait a little. The thicker the colour the more time was needed. In the course of years the tones of his colours would grow more and more together. Possibly much of what gave him a shock now would improve later on.

They looked at the pictures and smoked. Now and again Vincent would point with his pipe to one which seemed to protrude from the rest. Theo moved it to another place where it seemed to fall in with the rest; he arranged them in a way in which they might be hung at an exhibition. Perhaps he could persuade his people on the boulevard to arrange one at some time. Vincent, however, did not consider the backgrounds in the *entresol* suitable. They were much too elegant, and his pictures looked their best against the whitewashed walls in the yellow house. Theo did not agree, he had once put an old piece of brocade behind the picture with the basket and the yellow apples painted in Arles, and the effect was magnificent. They could stand quite different framing. Vincent was not to suppose that simply conceived pictures were only meant for the wretched houses of the poor. In such surroundings his simplicity would merely seem like part of the general misery. Heavily gilt and carved frames hung against silk walls, with precious carpets lying on the floor, were just good enough for the simplicity of great masters. What was art after all, if it was not capable of transcending the limits of its origin?

Vincent listened; no one had ever told him that before. Theo continued: 'Yes, Vincent, you have had more than your share of misery, and your misery has become the happiness of your pictures. There have been few good moments in which you were allowed to approach your fellows; there were no arms to wrap you round, and even I perhaps was not allowed to love you. But your pictures are warm embraces. Many people tread the middle path between suffering and joy, and they stroll through the world grinning inanely or more often sighing, and finally they stumble round a dark corner, which makes them even smaller than they were before, and they leave behind them nothing but a heap of sighs and a little futile laughter. But you have traced eternal furrows and your agony will quench the thrist of coming generations. The greater your suffering has been, the mightier have been the joyous footsteps of your journey. Ploughing furrows has been your destiny, and you strode

across the fields like a sower. Think of the days you have been sowing, there are few in which you have been idle. The expression of your face no doubt has grown distorted; was it anguish or the mark of honest labour? The bread you have eaten has been hard, your fellows have been hard to you, and hard has been the treatment God has meted out to you every day of your life. But the work, the structure that you leave behind you, is as firm as the hardness you experienced. When your heart shall cease to beat within your bosom, it will throb in your pictures.'

He got up and turned to the collection of canvases. Vincent looked at his brother in amazement. How well he had said it all! Theo was more intelligent than all the modern critics and poets, and in general there was something in the metamorphosis which he had sketched. If, however, such interpretations were possible, no doubt the reverse could be deduced with equal logic. It would be good to know the truth before it was too late. Vincent had believed that he was just painting, say a tree or a woman, without offending anyone, and instead of a tree or a woman he painted something jagged, which hurt people and stung them, something over which they stumbled, something irritating. So the question arose as to whether most of his work had not possessed this quality, and whether it would not have been wiser not to offend against the present, instead of helping the dim and distant future. No doubt the future was very great and there were many good things that could be said about it, but no one had been there yet.

Theo nodded. He stood there as he had done a little while since in the field, and Vincent noticed how thin his brother had grown of late years.

'Of course it is irritating,' murmured Theo. 'For all the others did something useful, even my people on the boulevard. They sat there behind their shell and stuck to it like frogs to their pond; they would say neither yes nor no, they would not see, they would not think. The shell in which they lived had to see and to speak and to act for them. All the world helped to make this cursed shell. Only men like Vincent did nothing for it, but worked against it. He always started everything from the beginning, and stood on the far side of the pond calling to the others. Of course it was irritating! How could it be otherwise, when he stood, looking down on their pond, with the solid earth beneath his feet? He said white when the others said black, he laughed while they cried. Perhaps he did it only for fun, and because he was one and the others were the whole world. He was an oddity, like the men who used to be kept at court in the olden days. And then of course it took time for him to penetrate the general shell. Would he ever penetrate it completely? Would he ever draw all men unto him, even though he gave his life to do it? Or would he come up against a new and more impenetrable shell and finally, worst of all, the approbation of the masses? If the world took him seriously, he would be regarded as its destroyer. He alone. No

wonder he aggravated them, when he was a thorn in the side of mankind. Cast him out, kill him! Bury the traitor out of sight, under the shell!—No, don't beat him, he is not worth it. Laugh! Let a madman like that go on with his painting!' Theo was trembling. What was he trembling like that for? He looked like a scarecrow.

Suddenly Theo threw himself down, or else a mightier power cast him upon the floor. His lips moved and they said: 'Never again, brother! So help me God!' He lay on the floor with his head thrown back on the bed and his mouth wide open.

Vincent could not understand, for a cloud had descended upon his senses. There was only one thing he believed he realized, and that was that their paths were no longer divided. They were travelling along the same road in the same direction, and this was the good moment.

Then Vincent whispered to Theo that now he wanted to go home. He said it in Dutch: 'Zôô heen kan gaan.'—Theo bent over him and closed his eyes.

It was in the early hours of the morning of the 29th of July, 1890. Theo waited until daybreak and then he went to fetch the doctor.

But the coloured canvases would not wait until the dawn. Blue stepped forward and bowed down and sang a melody with the tones from which he had created the damp depths of his ploughed fields, and the stone of his rocks, the height of his skies, and the glitter of his water. Then came Green, carrying the sap of his cypress trees, the silver of his olives, and the silent wealth of his bushes and grass. Then Orange leapt forward in her garment of fire, raising a shout as she passed through the room. Orange was not alone, Carmine and Geranium Red danced with her. They moved like waves of luminous smoke from licking flames, and sometimes they seemed like large winged butterflies with great patterns on their backs. The floor was covered with the red of the tiles in Arles, and in between shone sapphire and emerald. When they had all come to pay their tribute a fanfare sounded, and Yellow, his black-eyed mistress, entered in her Chinese robe of state. Ten women came with her, the fairest of the Empire, garbed in gentler tones of the same yellow, and stood at her side bearing sunflowers. His beloved made a deep obeisance before the catafalque and the ten women did likewise. And as they bowed, all the sheaves of wheat in the field, all the flowers and the fruit bowed down likewise, and the sun shed his rays on the cottage in Auvers.

Three days afterwards Vincent was buried in the little cemetery between the corn-fields. A few painters were present, and Dr. Gachet planted sunflowers round the grave. Theo took the pictures away with him and had some difficulty in getting them into his rooms in the Cité Pigalle. He was preparing for the exhibition. Gauguin did not consider it advisable to waste time upon the products of a man who was mentally

deficient, and he was therefore not in favour of an exhibition, as he believed that it would only add confusion to the already muddled views concerning art entertained by the rest of the world. Theo, however, was not to be put off, and Bernard agreed to write an introduction, in which he determined to explain to the public his relation to Van Gogh. He also published the letters he had received from Vincent in the *Mercure*, again with an introduction.

Theo spent every evening reckoning out the expenses of founding the community. Pressure of work prevented his taking any holidays, although Jo had looked to them to improve his health. He determined to confine the enterprise of the community to France and Holland, with a branch in the yellow house in Arles and another one in Nuenen. Paris would have to remain its centre for the time being, because he could control it better from there. Later on, however, he would leave Paris, and the undertaking would be conducted solely from the country. He wrote a great number of letters. Late at night the American with the green waistcoat would arrive to discuss the project with Theo, and he always made new and unforeseeable demands, wishes which upset everything that Theo had with care persuaded him to accept the previous day. In order not to lose his millions, Theo was obliged to give way to his requirements. Less than six months after the Sunday in Auvers, Theo van Gogh followed his brother. He lies beside him among the fields.

THE END

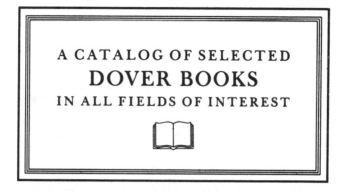

A CATALOG OF SELECTED
DOVER BOOKS
IN ALL FIELDS OF INTEREST

A CATALOG OF SELECTED DOVER
BOOKS IN ALL FIELDS OF INTEREST

CONCERNING THE SPIRITUAL IN ART, Wassily Kandinsky. Pioneering work by father of abstract art. Thoughts on color theory, nature of art. Analysis of earlier masters. 12 illustrations. 80pp. of text. 5⅜ x 8½. 23411-8 Pa. $4.95

ANIMALS: 1,419 Copyright-Free Illustrations of Mammals, Birds, Fish, Insects, etc., Jim Harter (ed.). Clear wood engravings present, in extremely lifelike poses, over 1,000 species of animals. One of the most extensive pictorial sourcebooks of its kind. Captions. Index. 284pp. 9 x 12. 23766-4 Pa. $14.95

CELTIC ART: The Methods of Construction, George Bain. Simple geometric techniques for making Celtic interlacements, spirals, Kells-type initials, animals, humans, etc. Over 500 illustrations. 160pp. 9 x 12. (USO) 22923-8 Pa. $9.95

AN ATLAS OF ANATOMY FOR ARTISTS, Fritz Schider. Most thorough reference work on art anatomy in the world. Hundreds of illustrations, including selections from works by Vesalius, Leonardo, Goya, Ingres, Michelangelo, others. 593 illustrations. 192pp. 7⅛ x 10¼. 20241-0 Pa. $9.95

CELTIC HAND STROKE-BY-STROKE (Irish Half-Uncial from "The Book of Kells"): An Arthur Baker Calligraphy Manual, Arthur Baker. Complete guide to creating each letter of the alphabet in distinctive Celtic manner. Covers hand position, strokes, pens, inks, paper, more. Illustrated. 48pp. 8¼ x 11. 24336-2 Pa. $3.95

EASY ORIGAMI, John Montroll. Charming collection of 32 projects (hat, cup, pelican, piano, swan, many more) specially designed for the novice origami hobbyist. Clearly illustrated easy-to-follow instructions insure that even beginning papercrafters will achieve successful results. 48pp. 8¼ x 11. 27298-2 Pa. $3.50

THE COMPLETE BOOK OF BIRDHOUSE CONSTRUCTION FOR WOODWORKERS, Scott D. Campbell. Detailed instructions, illustrations, tables. Also data on bird habitat and instinct patterns. Bibliography. 3 tables. 63 illustrations in 15 figures. 48pp. 5¼ x 8½. 24407-5 Pa. $2.50

BLOOMINGDALE'S ILLUSTRATED 1886 CATALOG: Fashions, Dry Goods and Housewares, Bloomingdale Brothers. Famed merchants' extremely rare catalog depicting about 1,700 products: clothing, housewares, firearms, dry goods, jewelry, more. Invaluable for dating, identifying vintage items. Also, copyright-free graphics for artists, designers. Co-published with Henry Ford Museum & Greenfield Village. 160pp. 8¼ x 11. 25780-0 Pa. $10.95

HISTORIC COSTUME IN PICTURES, Braun & Schneider. Over 1,450 costumed figures in clearly detailed engravings–from dawn of civilization to end of 19th century. Captions. Many folk costumes. 256pp. 8⅜ x 11¾. 23150-X Pa. $12.95

STICKLEY CRAFTSMAN FURNITURE CATALOGS, Gustav Stickley and L. & J. G. Stickley. Beautiful, functional furniture in two authentic catalogs from 1910. 594 illustrations, including 277 photos, show settles, rockers, armchairs, reclining chairs, bookcases, desks, tables. 183pp. 6½ x 9¼. 23838-5 Pa. $11.95

AMERICAN LOCOMOTIVES IN HISTORIC PHOTOGRAPHS: 1858 to 1949, Ron Ziel (ed.). A rare collection of 126 meticulously detailed official photographs, called "builder portraits," of American locomotives that majestically chronicle the rise of steam locomotive power in America. Introduction. Detailed captions. xi + 129pp. 9 x 12. 27393-8 Pa. $13.95

AMERICA'S LIGHTHOUSES: An Illustrated History, Francis Ross Holland, Jr. Delightfully written, profusely illustrated fact-filled survey of over 200 American lighthouses since 1716. History, anecdotes, technological advances, more. 240pp. 8 x 10¾. 25576-X Pa. $12.95

TOWARDS A NEW ARCHITECTURE, Le Corbusier. Pioneering manifesto by founder of "International School." Technical and aesthetic theories, views of industry, economics, relation of form to function, "mass-production split" and much more. Profusely illustrated. 320pp. 6⅛ x 9¼. (USO) 25023-7 Pa. $9.95

HOW THE OTHER HALF LIVES, Jacob Riis. Famous journalistic record, exposing poverty and degradation of New York slums around 1900, by major social reformer. 100 striking and influential photographs. 233pp. 10 x 7⅞. 22012-5 Pa. $11.95

FRUIT KEY AND TWIG KEY TO TREES AND SHRUBS, William M. Harlow. One of the handiest and most widely used identification aids. Fruit key covers 120 deciduous and evergreen species; twig key 160 deciduous species. Easily used. Over 300 photographs. 126pp. 5⅜ x 8½. 20511-8 Pa. $3.95

COMMON BIRD SONGS, Dr. Donald J. Borror. Songs of 60 most common U.S. birds: robins, sparrows, cardinals, bluejays, finches, more—arranged in order of increasing complexity. Up to 9 variations of songs of each species. Cassette and manual 99911-4 $8.95

ORCHIDS AS HOUSE PLANTS, Rebecca Tyson Northen. Grow cattleyas and many other kinds of orchids—in a window, in a case, or under artificial light. 63 illustrations. 148pp. 5⅜ x 8½. 23261-1 Pa. $5.95

MONSTER MAZES, Dave Phillips. Masterful mazes at four levels of difficulty. Avoid deadly perils and evil creatures to find magical treasures. Solutions for all 32 exciting illustrated puzzles. 48pp. 8¼ x 11. 26005-4 Pa. $2.95

MOZART'S DON GIOVANNI (DOVER OPERA LIBRETTO SERIES), Wolfgang Amadeus Mozart. Introduced and translated by Ellen H. Bleiler. Standard Italian libretto, with complete English translation. Convenient and thoroughly portable—an ideal companion for reading along with a recording or the performance itself. Introduction. List of characters. Plot summary. 121pp. 5¼ x 8½. 24944-1 Pa. $3.95

TECHNICAL MANUAL AND DICTIONARY OF CLASSICAL BALLET, Gail Grant. Defines, explains, comments on steps, movements, poses and concepts. 15-page pictorial section. Basic book for student, viewer. 127pp. 5⅜ x 8½. 21843-0 Pa. $4.95

THE CLARINET AND CLARINET PLAYING, David Pino. Lively, comprehensive work features suggestions about technique, musicianship, and musical interpretation, as well as guidelines for teaching, making your own reeds, and preparing for public performance. Includes an intriguing look at clarinet history. "A godsend," The Clarinet, Journal of the International Clarinet Society. Appendixes. 7 illus. 320pp. 5⅜ x 8½. 40270-3 Pa. $9.95

HOLLYWOOD GLAMOR PORTRAITS, John Kobal (ed.). 145 photos from 1926-49. Harlow, Gable, Bogart, Bacall; 94 stars in all. Full background on photographers, technical aspects. 160pp. 8⅜ x 11¼. 23352-9 Pa. $12.95

THE ANNOTATED CASEY AT THE BAT: A Collection of Ballads about the Mighty Casey/Third, Revised Edition, Martin Gardner (ed.). Amusing sequels and parodies of one of America's best-loved poems: Casey's Revenge, Why Casey Whiffed, Casey's Sister at the Bat, others. 256pp. 5⅜ x 8½. 28598-7 Pa. $8.95

THE RAVEN AND OTHER FAVORITE POEMS, Edgar Allan Poe. Over 40 of the author's most memorable poems: "The Bells," "Ulalume," "Israfel," "To Helen," "The Conqueror Worm," "Eldorado," "Annabel Lee," many more. Alphabetic lists of titles and first lines. 64pp. 5¹⁶⁄₁₆ x 8¼. 26685-0 Pa. $1.00

PERSONAL MEMOIRS OF U. S. GRANT, Ulysses Simpson Grant. Intelligent, deeply moving firsthand account of Civil War campaigns, considered by many the finest military memoirs ever written. Includes letters, historic photographs, maps and more. 528pp. 6⅛ x 9¼. 28587-1 Pa. $12.95

ANCIENT EGYPTIAN MATERIALS AND INDUSTRIES, A. Lucas and J. Harris. Fascinating, comprehensive, thoroughly documented text describes this ancient civilization's vast resources and the processes that incorporated them in daily life, including the use of animal products, building materials, cosmetics, perfumes and incense, fibers, glazed ware, glass and its manufacture, materials used in the mummification process, and much more. 544pp. 6⅛ x 9¼. (USO) 40446-3 Pa. $16.95

RUSSIAN STORIES/PYCCKNE PACCKA3bl: A Dual-Language Book, edited by Gleb Struve. Twelve tales by such masters as Chekhov, Tolstoy, Dostoevsky, Pushkin, others. Excellent word-for-word English translations on facing pages, plus teaching and study aids, Russian/English vocabulary, biographical/critical introductions, more. 416pp. 5⅜ x 8½. 26244-8 Pa. $9.95

PHILADELPHIA THEN AND NOW: 60 Sites Photographed in the Past and Present, Kenneth Finkel and Susan Oyama. Rare photographs of City Hall, Logan Square, Independence Hall, Betsy Ross House, other landmarks juxtaposed with contemporary views. Captures changing face of historic city. Introduction. Captions. 128pp. 8¼ x 11. 25790-8 Pa. $9.95

AIA ARCHITECTURAL GUIDE TO NASSAU AND SUFFOLK COUNTIES, LONG ISLAND, The American Institute of Architects, Long Island Chapter, and the Society for the Preservation of Long Island Antiquities. Comprehensive, well-researched and generously illustrated volume brings to life over three centuries of Long Island's great architectural heritage. More than 240 photographs with authoritative, extensively detailed captions. 176pp. 8¼ x 11. 26946-9 Pa. $14.95

NORTH AMERICAN INDIAN LIFE: Customs and Traditions of 23 Tribes, Elsie Clews Parsons (ed.). 27 fictionalized essays by noted anthropologists examine religion, customs, government, additional facets of life among the Winnebago, Crow, Zuni, Eskimo, other tribes. 480pp. 6⅛ x 9¼. 27377-6 Pa. $10.95

FRANK LLOYD WRIGHT'S DANA HOUSE, Donald Hoffmann. Pictorial essay of residential masterpiece with over 160 interior and exterior photos, plans, elevations, sketches and studies. 128pp. 9¼ x 10¾. 29120-0 Pa. $12.95

THE MALE AND FEMALE FIGURE IN MOTION: 60 Classic Photographic Sequences, Eadweard Muybridge. 60 true-action photographs of men and women walking, running, climbing, bending, turning, etc., reproduced from rare 19th-century masterpiece. vi + 121pp. 9 x 12. 24745-7 Pa. $10.95

1001 QUESTIONS ANSWERED ABOUT THE SEASHORE, N. J. Berrill and Jacquelyn Berrill. Queries answered about dolphins, sea snails, sponges, starfish, fishes, shore birds, many others. Covers appearance, breeding, growth, feeding, much more. 305pp. 5¼ x 8¼. 23366-9 Pa. $9.95

ATTRACTING BIRDS TO YOUR YARD, William J. Weber. Easy-to-follow guide offers advice on how to attract the greatest diversity of birds: birdhouses, feeders, water and waterers, much more. 96pp. 5³⁄₁₆ x 8¼. 28927-3 Pa. $2.50

MEDICINAL AND OTHER USES OF NORTH AMERICAN PLANTS: A Historical Survey with Special Reference to the Eastern Indian Tribes, Charlotte Erichsen-Brown. Chronological historical citations document 500 years of usage of plants, trees, shrubs native to eastern Canada, northeastern U.S. Also complete identifying information. 343 illustrations. 544pp. 6½ x 9¼. 25951-X Pa. $12.95

STORYBOOK MAZES, Dave Phillips. 23 stories and mazes on two-page spreads: Wizard of Oz, Treasure Island, Robin Hood, etc. Solutions. 64pp. 8¼ x 11. 23628-5 Pa. $2.95

AMERICAN NEGRO SONGS: 230 Folk Songs and Spirituals, Religious and Secular, John W. Work. This authoritative study traces the African influences of songs sung and played by black Americans at work, in church, and as entertainment. The author discusses the lyric significance of such songs as "Swing Low, Sweet Chariot," "John Henry," and others and offers the words and music for 230 songs. Bibliography. Index of Song Titles. 272pp. 6½ x 9¼. 40271-1 Pa. $9.95

MOVIE-STAR PORTRAITS OF THE FORTIES, John Kobal (ed.). 163 glamor, studio photos of 106 stars of the 1940s: Rita Hayworth, Ava Gardner, Marlon Brando, Clark Gable, many more. 176pp. 8⅜ x 11¼. 23546-7 Pa. $14.95

BENCHLEY LOST AND FOUND, Robert Benchley. Finest humor from early 30s, about pet peeves, child psychologists, post office and others. Mostly unavailable else where. 73 illustrations by Peter Arno and others. 183pp. 5⅜ x 8½. 22410-4 Pa. $6.95

YEKL and THE IMPORTED BRIDEGROOM AND OTHER STORIES OF YIDDISH NEW YORK, Abraham Cahan. Film Hester Street based on Yekl (1896). Novel, other stories among first about Jewish immigrants on N.Y.'s East Side. 240pp. 5⅜ x 8½. 22427-9 Pa. $6.95

SELECTED POEMS, Walt Whitman. Generous sampling from *Leaves of Grass*. Twenty-four poems include "I Hear America Singing," "Song of the Open Road," "I Sing the Body Electric," "When Lilacs Last in the Dooryard Bloom'd," "O Captain! My Captain!"—all reprinted from an authoritative edition. Lists of titles and first lines. 128pp. 5³⁄₁₆ x 8¼. 26878-0 Pa. $1.00

THE BEST TALES OF HOFFMANN, E. T. A. Hoffmann. 10 of Hoffmann's most important stories: "Nutcracker and the King of Mice," "The Golden Flowerpot," etc. 458pp. 5⅜ x 8½. 21793-0 Pa. $9.95

FROM FETISH TO GOD IN ANCIENT EGYPT, E. A. Wallis Budge. Rich detailed survey of Egyptian conception of "God" and gods, magic, cult of animals, Osiris, more. Also, superb English translations of hymns and legends. 240 illustrations. 545pp. 5⅜ x 8½. 25803-3 Pa. $13.95

FRENCH STORIES/CONTES FRANÇAIS: A Dual-Language Book, Wallace Fowlie. Ten stories by French masters, Voltaire to Camus: "Micromegas" by Voltaire; "The Atheist's Mass" by Balzac; "Minuet" by de Maupassant; "The Guest" by Camus, six more. Excellent English translations on facing pages. Also French-English vocabulary list, exercises, more. 352pp. 5⅜ x 8½. 26443-2 Pa. $9.95

CHICAGO AT THE TURN OF THE CENTURY IN PHOTOGRAPHS: 122 Historic Views from the Collections of the Chicago Historical Society, Larry A. Viskochil. Rare large-format prints offer detailed views of City Hall, State Street, the Loop, Hull House, Union Station, many other landmarks, circa 1904-1913. Introduction. Captions. Maps. 144pp. 9⅜ x 12¼. 24656-6 Pa. $12.95

OLD BROOKLYN IN EARLY PHOTOGRAPHS, 1865-1929, William Lee Younger. Luna Park, Gravesend race track, construction of Grand Army Plaza, moving of Hotel Brighton, etc. 157 previously unpublished photographs. 165pp. 8⅜ x 11¾. 23587-4 Pa. $13.95

THE MYTHS OF THE NORTH AMERICAN INDIANS, Lewis Spence. Rich anthology of the myths and legends of the Algonquins, Iroquois, Pawnees and Sioux, prefaced by an extensive historical and ethnological commentary. 36 illustrations. 480pp. 5⅜ x 8½. 25967-6 Pa. $10.95

AN ENCYCLOPEDIA OF BATTLES: Accounts of Over 1,560 Battles from 1479 B.C. to the Present, David Eggenberger. Essential details of every major battle in recorded history from the first battle of Megiddo in 1479 B.C. to Grenada in 1984. List of Battle Maps. New Appendix covering the years 1967-1984. Index. 99 illustrations. 544pp. 6½ x 9¼. 24913-1 Pa. $16.95

SAILING ALONE AROUND THE WORLD, Captain Joshua Slocum. First man to sail around the world, alone, in small boat. One of great feats of seamanship told in delightful manner. 67 illustrations. 294pp. 5⅜ x 8½. 20326-3 Pa. $6.95

ANARCHISM AND OTHER ESSAYS, Emma Goldman. Powerful, penetrating, prophetic essays on direct action, role of minorities, prison reform, puritan hypocrisy, violence, etc. 271pp. 5⅜ x 8½. 22484-8 Pa. $7.95

MYTHS OF THE HINDUS AND BUDDHISTS, Ananda K. Coomaraswamy and Sister Nivedita. Great stories of the epics; deeds of Krishna, Shiva, taken from puranas, Vedas, folk tales; etc. 32 illustrations. 400pp. 5⅜ x 8½. 21759-0 Pa. $12.95

THE TRAUMA OF BIRTH, Otto Rank. Rank's controversial thesis that anxiety neurosis is caused by profound psychological trauma which occurs at birth. 256pp. 5⅜ x 8½. 27974-X Pa. $7.95

A THEOLOGICO-POLITICAL TREATISE, Benedict Spinoza. Also contains unfinished Political Treatise. Great classic on religious liberty, theory of government on common consent. R. Elwes translation. Total of 421pp. 5⅜ x 8½. 20249-6 Pa. $9.95

MY BONDAGE AND MY FREEDOM, Frederick Douglass. Born a slave, Douglass became outspoken force in antislavery movement. The best of Douglass' autobiographies. Graphic description of slave life. 464pp. 5⅜ x 8½. 22457-0 Pa. $8.95

FOLLOWING THE EQUATOR: A Journey Around the World, Mark Twain. Fascinating humorous account of 1897 voyage to Hawaii, Australia, India, New Zealand, etc. Ironic, bemused reports on peoples, customs, climate, flora and fauna, politics, much more. 197 illustrations. 720pp. 5⅜ x 8½. 26113-1 Pa. $15.95

THE PEOPLE CALLED SHAKERS, Edward D. Andrews. Definitive study of Shakers: origins, beliefs, practices, dances, social organization, furniture and crafts, etc. 33 illustrations. 351pp. 5⅜ x 8½. 21081-2 Pa. $8.95

THE MYTHS OF GREECE AND ROME, H. A. Guerber. A classic of mythology, generously illustrated, long prized for its simple, graphic, accurate retelling of the principal myths of Greece and Rome, and for its commentary on their origins and significance. With 64 illustrations by Michelangelo, Raphael, Titian, Rubens, Canova, Bernini and others. 480pp. 5⅜ x 8½. 27584-1 Pa. $9.95

PSYCHOLOGY OF MUSIC, Carl E. Seashore. Classic work discusses music as a medium from psychological viewpoint. Clear treatment of physical acoustics, auditory apparatus, sound perception, development of musical skills, nature of musical feeling, host of other topics. 88 figures. 408pp. 5⅜ x 8½. 21851-1 Pa. $11.95

THE PHILOSOPHY OF HISTORY, Georg W. Hegel. Great classic of Western thought develops concept that history is not chance but rational process, the evolution of freedom. 457pp. 5⅜ x 8½. 20112-0 Pa. $9.95

THE BOOK OF TEA, Kakuzo Okakura. Minor classic of the Orient: entertaining, charming explanation, interpretation of traditional Japanese culture in terms of tea ceremony. 94pp. 5⅜ x 8½. 20070-1 Pa. $3.95

LIFE IN ANCIENT EGYPT, Adolf Erman. Fullest, most thorough, detailed older account with much not in more recent books, domestic life, religion, magic, medicine, commerce, much more. Many illustrations reproduce tomb paintings, carvings, hieroglyphs, etc. 597pp. 5⅜ x 8½. 22632-8 Pa. $12.95

SUNDIALS, Their Theory and Construction, Albert Waugh. Far and away the best, most thorough coverage of ideas, mathematics concerned, types, construction, adjusting anywhere. Simple, nontechnical treatment allows even children to build several of these dials. Over 100 illustrations. 230pp. 5⅜ x 8½. 22947-5 Pa. $8.95

THEORETICAL HYDRODYNAMICS, L. M. Milne-Thomson. Classic exposition of the mathematical theory of fluid motion, applicable to both hydrodynamics and aerodynamics. Over 600 exercises. 768pp. 6⅛ x 9¼. 68970-0 Pa. $20.95

SONGS OF EXPERIENCE: Facsimile Reproduction with 26 Plates in Full Color, William Blake. 26 full-color plates from a rare 1826 edition. Includes "The Tyger," "London," "Holy Thursday," and other poems. Printed text of poems. 48pp. 5¼ x 7. 24636-1 Pa. $4.95

OLD-TIME VIGNETTES IN FULL COLOR, Carol Belanger Grafton (ed.). Over 390 charming, often sentimental illustrations, selected from archives of Victorian graphics—pretty women posing, children playing, food, flowers, kittens and puppies, smiling cherubs, birds and butterflies, much more. All copyright-free. 48pp. 9¼ x 12¼. 27269-9 Pa. $7.95

PERSPECTIVE FOR ARTISTS, Rex Vicat Cole. Depth, perspective of sky and sea, shadows, much more, not usually covered. 391 diagrams, 81 reproductions of drawings and paintings. 279pp. 5⅜ x 8½. 22487-2 Pa. $7.95

DRAWING THE LIVING FIGURE, Joseph Sheppard. Innovative approach to artistic anatomy focuses on specifics of surface anatomy, rather than muscles and bones. Over 170 drawings of live models in front, back and side views, and in widely varying poses. Accompanying diagrams. 177 illustrations. Introduction. Index. 144pp. 8⅜ x11¼. 26723-7 Pa. $8.95

GOTHIC AND OLD ENGLISH ALPHABETS: 100 Complete Fonts, Dan X. Solo. Add power, elegance to posters, signs, other graphics with 100 stunning copyright-free alphabets: Blackstone, Dolbey, Germania, 97 more—including many lower-case, numerals, punctuation marks. 104pp. 8¼ x 11. 24695-7 Pa. $8.95

HOW TO DO BEADWORK, Mary White. Fundamental book on craft from simple projects to five-bead chains and woven works. 106 illustrations. 142pp. 5⅜ x 8. 20697-1 Pa. $5.95

THE BOOK OF WOOD CARVING, Charles Marshall Sayers. Finest book for beginners discusses fundamentals and offers 34 designs. "Absolutely first rate . . . well thought out and well executed."–E. J. Tangerman. 118pp. 7¾ x 10⅝. 23654-4 Pa. $7.95

ILLUSTRATED CATALOG OF CIVIL WAR MILITARY GOODS: Union Army Weapons, Insignia, Uniform Accessories, and Other Equipment, Schuyler, Hartley, and Graham. Rare, profusely illustrated 1846 catalog includes Union Army uniform and dress regulations, arms and ammunition, coats, insignia, flags, swords, rifles, etc. 226 illustrations. 160pp. 9 x 12. 24939-5 Pa. $10.95

WOMEN'S FASHIONS OF THE EARLY 1900s: An Unabridged Republication of "New York Fashions, 1909," National Cloak & Suit Co. Rare catalog of mail-order fashions documents women's and children's clothing styles shortly after the turn of the century. Captions offer full descriptions, prices. Invaluable resource for fashion, costume historians. Approximately 725 illustrations. 128pp. 8⅜ x 11¼. 27276-1 Pa. $11.95

THE 1912 AND 1915 GUSTAV STICKLEY FURNITURE CATALOGS, Gustav Stickley. With over 200 detailed illustrations and descriptions, these two catalogs are essential reading and reference materials and identification guides for Stickley furniture. Captions cite materials, dimensions and prices. 112pp. 6½ x 9¼. 26676-1 Pa. $9.95

EARLY AMERICAN LOCOMOTIVES, John H. White, Jr. Finest locomotive engravings from early 19th century: historical (1804–74), main-line (after 1870), special, foreign, etc. 147 plates. 142pp. 11⅜ x 8¼. 22772-3 Pa. $10.95

THE TALL SHIPS OF TODAY IN PHOTOGRAPHS, Frank O. Braynard. Lavishly illustrated tribute to nearly 100 majestic contemporary sailing vessels: Amerigo Vespucci, Clearwater, Constitution, Eagle, Mayflower, Sea Cloud, Victory, many more. Authoritative captions provide statistics, background on each ship. 190 black-and-white photographs and illustrations. Introduction. 128pp. 8⅞ x 11¾. 27163-3 Pa. $14.95

LITTLE BOOK OF EARLY AMERICAN CRAFTS AND TRADES, Peter Stockham (ed.). 1807 children's book explains crafts and trades: baker, hatter, cooper, potter, and many others. 23 copperplate illustrations. 140pp. 4⅝ x 6.
23336-7 Pa. $4.95

VICTORIAN FASHIONS AND COSTUMES FROM HARPER'S BAZAR, 1867–1898, Stella Blum (ed.). Day costumes, evening wear, sports clothes, shoes, hats, other accessories in over 1,000 detailed engravings. 320pp. 9⅜ x 12¼.
22990-4 Pa. $15.95

GUSTAV STICKLEY, THE CRAFTSMAN, Mary Ann Smith. Superb study surveys broad scope of Stickley's achievement, especially in architecture. Design philosophy, rise and fall of the Craftsman empire, descriptions and floor plans for many Craftsman houses, more. 86 black-and-white halftones. 31 line illustrations. Introduction 208pp. 6½ x 9¼.
27210-9 Pa. $9.95

THE LONG ISLAND RAIL ROAD IN EARLY PHOTOGRAPHS, Ron Ziel. Over 220 rare photos, informative text document origin (1844) and development of rail service on Long Island. Vintage views of early trains, locomotives, stations, passengers, crews, much more. Captions. 8⅞ x 11¾.
26301-0 Pa. $13.95

VOYAGE OF THE LIBERDADE, Joshua Slocum. Great 19th-century mariner's thrilling, first-hand account of the wreck of his ship off South America, the 35-foot boat he built from the wreckage, and its remarkable voyage home. 128pp. 5⅜ x 8½.
40022-0 Pa. $4.95

TEN BOOKS ON ARCHITECTURE, Vitruvius. The most important book ever written on architecture. Early Roman aesthetics, technology, classical orders, site selection, all other aspects. Morgan translation. 331pp. 5⅜ x 8½. 20645-9 Pa. $8.95

THE HUMAN FIGURE IN MOTION, Eadweard Muybridge. More than 4,500 stopped-action photos, in action series, showing undraped men, women, children jumping, lying down, throwing, sitting, wrestling, carrying, etc. 390pp. 7⅞ x 10⅝.
20204-6 Clothbd. $27.95

TREES OF THE EASTERN AND CENTRAL UNITED STATES AND CANADA, William M. Harlow. Best one-volume guide to 140 trees. Full descriptions, woodlore, range, etc. Over 600 illustrations. Handy size. 288pp. 4½ x 6⅜.
20395-6 Pa. $6.95

SONGS OF WESTERN BIRDS, Dr. Donald J. Borror. Complete song and call repertoire of 60 western species, including flycatchers, juncoes, cactus wrens, many more—includes fully illustrated booklet. Cassette and manual 99913-0 $8.95

GROWING AND USING HERBS AND SPICES, Milo Miloradovich. Versatile handbook provides all the information needed for cultivation and use of all the herbs and spices available in North America. 4 illustrations. Index. Glossary. 236pp. 5⅜ x 8½.
25058-X Pa. $7.95

BIG BOOK OF MAZES AND LABYRINTHS, Walter Shepherd. 50 mazes and labyrinths in all—classical, solid, ripple, and more—in one great volume. Perfect inexpensive puzzler for clever youngsters. Full solutions. 112pp. 8⅛ x 11.
22951-3 Pa. $5.95

PIANO TUNING, J. Cree Fischer. Clearest, best book for beginner, amateur. Simple repairs, raising dropped notes, tuning by easy method of flattened fifths. No previous skills needed. 4 illustrations. 201pp. 5⅜ x 8½. 23267-0 Pa. $6.95

HINTS TO SINGERS, Lillian Nordica. Selecting the right teacher, developing confidence, overcoming stage fright, and many other important skills receive thoughtful discussion in this indispensible guide, written by a world-famous diva of four decades' experience. 96pp. 5³/₈ x 8¹/₂. 40094-8 Pa. $4.95

THE COMPLETE NONSENSE OF EDWARD LEAR, Edward Lear. All nonsense limericks, zany alphabets, Owl and Pussycat, songs, nonsense botany, etc., illustrated by Lear. Total of 320pp. 5⅜ x 8½. (USO) 20167-8 Pa. $7.95

VICTORIAN PARLOUR POETRY: An Annotated Anthology, Michael R. Turner. 117 gems by Longfellow, Tennyson, Browning, many lesser-known poets. "The Village Blacksmith," "Curfew Must Not Ring Tonight," "Only a Baby Small," dozens more, often difficult to find elsewhere. Index of poets, titles, first lines. xxiii + 325pp. 5⅜ x 8¼. 27044-0 Pa. $8.95

DUBLINERS, James Joyce. Fifteen stories offer vivid, tightly focused observations of the lives of Dublin's poorer classes. At least one, "The Dead," is considered a masterpiece. Reprinted complete and unabridged from standard edition. 160pp. 5³/₁₆ x 8¼. 26870-5 Pa. $1.00

GREAT WEIRD TALES: 14 Stories by Lovecraft, Blackwood, Machen and Others, S. T. Joshi (ed.). 14 spellbinding tales, including "The Sin Eater," by Fiona McLeod, "The Eye Above the Mantel," by Frank Belknap Long, as well as renowned works by R. H. Barlow, Lord Dunsany, Arthur Machen, W. C. Morrow and eight other masters of the genre. 256pp. 5⅜ x 8½. (USO) 40436-6 Pa. $8.95

THE BOOK OF THE SACRED MAGIC OF ABRAMELIN THE MAGE, translated by S. MacGregor Mathers. Medieval manuscript of ceremonial magic. Basic document in Aleister Crowley, Golden Dawn groups. 268pp. 5⅜ x 8½. 23211-5 Pa. $9.95

NEW RUSSIAN-ENGLISH AND ENGLISH-RUSSIAN DICTIONARY, M. A. O'Brien. This is a remarkably handy Russian dictionary, containing a surprising amount of information, including over 70,000 entries. 366pp. 4½ x 6¼. 20208-9 Pa. $10.95

HISTORIC HOMES OF THE AMERICAN PRESIDENTS, Second, Revised Edition, Irvin Haas. A traveler's guide to American Presidential homes, most open to the public, depicting and describing homes occupied by every American President from George Washington to George Bush. With visiting hours, admission charges, travel routes. 175 photographs. Index. 160pp. 8¼ x 11. 26751-2 Pa. $11.95

NEW YORK IN THE FORTIES, Andreas Feininger. 162 brilliant photographs by the well-known photographer, formerly with *Life* magazine. Commuters, shoppers, Times Square at night, much else from city at its peak. Captions by John von Hartz. 181pp. 9¼ x 10¾. 23585-8 Pa. $13.95

INDIAN SIGN LANGUAGE, William Tomkins. Over 525 signs developed by Sioux and other tribes. Written instructions and diagrams. Also 290 pictographs. 111pp. 6⅛ x 9¼. 22029-X Pa. $3.95

ANATOMY: A Complete Guide for Artists, Joseph Sheppard. A master of figure drawing shows artists how to render human anatomy convincingly. Over 460 illustrations. 224pp. 8⅜ x 11¼. 27279-6 Pa. $11.95

MEDIEVAL CALLIGRAPHY: Its History and Technique, Marc Drogin. Spirited history, comprehensive instruction manual covers 13 styles (ca. 4th century thru 15th). Excellent photographs; directions for duplicating medieval techniques with modern tools. 224pp. 8⅜ x 11¼. 26142-5 Pa. $12.95

DRIED FLOWERS: How to Prepare Them, Sarah Whitlock and Martha Rankin. Complete instructions on how to use silica gel, meal and borax, perlite aggregate, sand and borax, glycerine and water to create attractive permanent flower arrangements. 12 illustrations. 32pp. 5⅜ x 8½. 21802-3 Pa. $1.00

EASY-TO-MAKE BIRD FEEDERS FOR WOODWORKERS, Scott D. Campbell. Detailed, simple-to-use guide for designing, constructing, caring for and using feeders. Text, illustrations for 12 classic and contemporary designs. 96pp. 5⅜ x 8½. 25847-5 Pa. $3.95

SCOTTISH WONDER TALES FROM MYTH AND LEGEND, Donald A. Mackenzie. 16 lively tales tell of giants rumbling down mountainsides, of a magic wand that turns stone pillars into warriors, of gods and goddesses, evil hags, powerful forces and more. 240pp. 5⅜ x 8½. 29677-6 Pa. $6.95

THE HISTORY OF UNDERCLOTHES, C. Willett Cunnington and Phyllis Cunnington. Fascinating, well-documented survey covering six centuries of English undergarments, enhanced with over 100 illustrations: 12th-century laced-up bodice, footed long drawers (1795), 19th-century bustles, 19th-century corsets for men, Victorian "bust improvers," much more. 272pp. 5⅜ x 8¼. 27124-2 Pa. $9.95

ARTS AND CRAFTS FURNITURE: The Complete Brooks Catalog of 1912, Brooks Manufacturing Co. Photos and detailed descriptions of more than 150 now very collectible furniture designs from the Arts and Crafts movement depict davenports, settees, buffets, desks, tables, chairs, bedsteads, dressers and more, all built of solid, quarter-sawed oak. Invaluable for students and enthusiasts of antiques, Americana and the decorative arts. 80pp. 6½ x 9¼. 27471-3 Pa. $8.95

WILBUR AND ORVILLE: A Biography of the Wright Brothers, Fred Howard. Definitive, crisply written study tells the full story of the brothers' lives and work. A vividly written biography, unparalleled in scope and color, that also captures the spirit of an extraordinary era. 560pp. 6⅛ x 9¼. 40297-5 Pa. $17.95

THE ARTS OF THE SAILOR: Knotting, Splicing and Ropework, Hervey Garrett Smith. Indispensable shipboard reference covers tools, basic knots and useful hitches; handsewing and canvas work, more. Over 100 illustrations. Delightful reading for sea lovers. 256pp. 5⅜ x 8½. 26440-8 Pa. $8.95

FRANK LLOYD WRIGHT'S FALLINGWATER: The House and Its History, Second, Revised Edition, Donald Hoffmann. A total revision—both in text and illustrations—of the standard document on Fallingwater, the boldest, most personal architectural statement of Wright's mature years, updated with valuable new material from the recently opened Frank Lloyd Wright Archives. "Fascinating"—*The New York Times*. 116 illustrations. 128pp. 9¼ x 10¾. 27430-6 Pa. $12.95

PHOTOGRAPHIC SKETCHBOOK OF THE CIVIL WAR, Alexander Gardner. 100 photos taken on field during the Civil War. Famous shots of Manassas Harper's Ferry, Lincoln, Richmond, slave pens, etc. 244pp. 10% x 8¼. 22731-6 Pa. $10.95

FIVE ACRES AND INDEPENDENCE, Maurice G. Kains. Great back-to-the-land classic explains basics of self-sufficient farming. The one book to get. 95 illustrations. 397pp. 5% x 8½. 20974-1 Pa. $7.95

SONGS OF EASTERN BIRDS, Dr. Donald J. Borror. Songs and calls of 60 species most common to eastern U.S.: warblers, woodpeckers, flycatchers, thrushes, larks, many more in high-quality recording. Cassette and manual 99912-2 $9.95

A MODERN HERBAL, Margaret Grieve. Much the fullest, most exact, most useful compilation of herbal material. Gigantic alphabetical encyclopedia, from aconite to zedoary, gives botanical information, medical properties, folklore, economic uses, much else. Indispensable to serious reader. 161 illustrations. 888pp. 6½ x 9¼. 2-vol. set. (USO) Vol. I: 22798-7 Pa. $9.95
Vol. II: 22799-5 Pa. $9.95

HIDDEN TREASURE MAZE BOOK, Dave Phillips. Solve 34 challenging mazes accompanied by heroic tales of adventure. Evil dragons, people-eating plants, blood-thirsty giants, many more dangerous adversaries lurk at every twist and turn. 34 mazes, stories, solutions. 48pp. 8¼ x 11. 24566-7 Pa. $2.95

LETTERS OF W. A. MOZART, Wolfgang A. Mozart. Remarkable letters show bawdy wit, humor, imagination, musical insights, contemporary musical world; includes some letters from Leopold Mozart. 276pp. 5% x 8½. 22859-2 Pa. $7.95

BASIC PRINCIPLES OF CLASSICAL BALLET, Agrippina Vaganova. Great Russian theoretician, teacher explains methods for teaching classical ballet. 118 illus-trations. 175pp. 5% x 8½. 22036-2 Pa. $5.95

THE JUMPING FROG, Mark Twain. Revenge edition. The original story of The Celebrated Jumping Frog of Calaveras County, a hapless French translation, and Twain's hilarious "retranslation" from the French. 12 illustrations. 66pp. 5% x 8½. 22686-7 Pa. $3.95

BEST REMEMBERED POEMS, Martin Gardner (ed.). The 126 poems in this superb collection of 19th- and 20th-century British and American verse range from Shelley's "To a Skylark" to the impassioned "Renascence" of Edna St. Vincent Millay and to Edward Lear's whimsical "The Owl and the Pussycat." 224pp. 5% x 8½. 27165-X Pa. $5.95

COMPLETE SONNETS, William Shakespeare. Over 150 exquisite poems deal with love, friendship, the tyranny of time, beauty's evanescence, death and other themes in language of remarkable power, precision and beauty. Glossary of archaic terms. 80pp. 5%₆ x 8¼. 26686-9 Pa. $1.00

BODIES IN A BOOKSHOP, R. T. Campbell. Challenging mystery of blackmail and murder with ingenious plot and superbly drawn characters. In the best tradition of British suspense fiction. 192pp. 5% x 8½. 24720-1 Pa. $6.95

THE WIT AND HUMOR OF OSCAR WILDE, Alvin Redman (ed.). More than 1,000 ripostes, paradoxes, wisecracks: Work is the curse of the drinking classes; I can resist everything except temptation; etc. 258pp. 5⅜ x 8½. 20602-5 Pa. $6.95

SHAKESPEARE LEXICON AND QUOTATION DICTIONARY, Alexander Schmidt. Full definitions, locations, shades of meaning in every word in plays and poems. More than 50,000 exact quotations. 1,485pp. 6½ x 9¼. 2-vol. set.
Vol. 1: 22726-X Pa. $17.95
Vol. 2: 22727-8 Pa. $17.95

SELECTED POEMS, Emily Dickinson. Over 100 best-known, best-loved poems by one of America's foremost poets, reprinted from authoritative early editions. No comparable edition at this price. Index of first lines. 64pp. 5¾6 x 8¼. 26466-1 Pa. $1.00

THE INSIDIOUS DR. FU-MANCHU, Sax Rohmer. The first of the popular mystery series introduces a pair of English detectives to their archnemesis, the diabolical Dr. Fu-Manchu. Flavorful atmosphere, fast-paced action, and colorful characters enliven this classic of the genre. 208pp. 5¾6 x 8¼. 29898-1 Pa. $2.00

THE MALLEUS MALEFICARUM OF KRAMER AND SPRENGER, translated by Montague Summers. Full text of most important witchhunter's "bible," used by both Catholics and Protestants. 278pp. 6⅝ x 10. 22802-9 Pa. $12.95

SPANISH STORIES/CUENTOS ESPAÑOLES: A Dual-Language Book, Angel Flores (ed.). Unique format offers 13 great stories in Spanish by Cervantes, Borges, others. Faithful English translations on facing pages. 352pp. 5⅜ x 8½. 25399-6 Pa. $8.95

GARDEN CITY, LONG ISLAND, IN EARLY PHOTOGRAPHS, 1869–1919, Mildred H. Smith. Handsome treasury of 118 vintage pictures, accompanied by carefully researched captions, document the Garden City Hotel fire (1899), the Vanderbilt Cup Race (1908), the first airmail flight departing from the Nassau Boulevard Aerodrome (1911), and much more. 96pp. 8⅞ x 11¾. 40669-5 Pa. $12.95

OLD QUEENS, N.Y., IN EARLY PHOTOGRAPHS, Vincent F. Seyfried and William Asadorian. Over 160 rare photographs of Maspeth, Jamaica, Jackson Heights, and other areas. Vintage views of DeWitt Clinton mansion, 1939 World's Fair and more. Captions. 192pp. 8⅞ x 11. 26358-4 Pa. $12.95

CAPTURED BY THE INDIANS: 15 Firsthand Accounts, 1750-1870, Frederick Drimmer. Astounding true historical accounts of grisly torture, bloody conflicts, relentless pursuits, miraculous escapes and more, by people who lived to tell the tale. 384pp. 5⅜ x 8½. 24901-8 Pa. $8.95

THE WORLD'S GREAT SPEECHES (Fourth Enlarged Edition), Lewis Copeland, Lawrence W. Lamm, and Stephen J. McKenna. Nearly 300 speeches provide public speakers with a wealth of updated quotes and inspiration—from Pericles' funeral oration and William Jennings Bryan's "Cross of Gold Speech" to Malcolm X's powerful words on the Black Revolution and Earl of Spenser's tribute to his sister, Diana, Princess of Wales. 944pp. 5⅜ x 8½. 40903-1 Pa. $15.95

THE BOOK OF THE SWORD, Sir Richard F. Burton. Great Victorian scholar/adventurer's eloquent, erudite history of the "queen of weapons"–from prehistory to early Roman Empire. Evolution and development of early swords, variations (sabre, broadsword, cutlass, scimitar, etc.), much more. 336pp. 6⅛ x 9¼. 25434-8 Pa. $9.95

AUTOBIOGRAPHY: The Story of My Experiments with Truth, Mohandas K. Gandhi. Boyhood, legal studies, purification, the growth of the Satyagraha (nonviolent protest) movement. Critical, inspiring work of the man responsible for the freedom of India. 480pp. 5⅜ x 8½. (USO) 24593-4 Pa. $8.95

CELTIC MYTHS AND LEGENDS, T. W. Rolleston. Masterful retelling of Irish and Welsh stories and tales. Cuchulain, King Arthur, Deirdre, the Grail, many more. First paperback edition. 58 full-page illustrations. 512pp. 5⅜ x 8½. 26507-2 Pa. $9.95

THE PRINCIPLES OF PSYCHOLOGY, William James. Famous long course complete, unabridged. Stream of thought, time perception, memory, experimental methods; great work decades ahead of its time. 94 figures. 1,391pp. 5⅜ x 8½. 2-vol. set.
Vol. I: 20381-6 Pa. $13.95
Vol. II: 20382-4 Pa. $14.95

THE WORLD AS WILL AND REPRESENTATION, Arthur Schopenhauer. Definitive English translation of Schopenhauer's life work, correcting more than 1,000 errors, omissions in earlier translations. Translated by E. F. J. Payne. Total of 1,269pp. 5⅜ x 8½. 2-vol. set. Vol. 1: 21761-2 Pa. $12.95
Vol. 2: 21762-0 Pa. $12.95

MAGIC AND MYSTERY IN TIBET, Madame Alexandra David-Neel. Experiences among lamas, magicians, sages, sorcerers, Bonpa wizards. A true psychic discovery. 32 illustrations. 321pp. 5⅜ x 8½. (USO) 22682-4 Pa. $9.95

THE EGYPTIAN BOOK OF THE DEAD, E. A. Wallis Budge. Complete reproduction of Ani's papyrus, finest ever found. Full hieroglyphic text, interlinear transliteration, word-for-word translation, smooth translation. 533pp. 6½ x 9¼.
21866-X Pa. $11.95

MATHEMATICS FOR THE NONMATHEMATICIAN, Morris Kline. Detailed, college-level treatment of mathematics in cultural and historical context, with numerous exercises. Recommended Reading Lists. Tables. Numerous figures. 641pp. 5⅜ x 8½.
24823-2 Pa. $11.95

PROBABILISTIC METHODS IN THE THEORY OF STRUCTURES, Isaac Elishakoff. Well-written introduction covers the elements of the theory of probability from two or more random variables, the reliability of such multivariable structures, the theory of random function, Monte Carlo methods of treating problems incapable of exact solution, and more. Examples. 502pp. 5³/₈ x 8¹/₂. 40691-1 Pa. $16.95

THE RIME OF THE ANCIENT MARINER, Gustave Doré, S. T. Coleridge. Doré's finest work; 34 plates capture moods, subtleties of poem. Flawless full-size reproductions printed on facing pages with authoritative text of poem. "Beautiful. Simply beautiful."–Publisher's Weekly. 77pp. 9¼ x 12. 22305-1 Pa. $7.95

NORTH AMERICAN INDIAN DESIGNS FOR ARTISTS AND CRAFTSPEOPLE, Eva Wilson. Over 360 authentic copyright-free designs adapted from Navajo blankets, Hopi pottery, Sioux buffalo hides, more. Geometrics, symbolic figures, plant and animal motifs, etc. 128pp. 8⅜ x 11. (EUK) 25341-4 Pa. $8.95

SCULPTURE: Principles and Practice, Louis Slobodkin. Step-by-step approach to clay, plaster, metals, stone; classical and modern. 253 drawings, photos. 255pp. 8⅛ x 11.
22960-2 Pa. $11.95

CATALOG OF DOVER BOOKS

THE INFLUENCE OF SEA POWER UPON HISTORY, 1660–1783, A. T. Mahan. Influential classic of naval history and tactics still used as text in war colleges. First paperback edition. 4 maps. 24 battle plans. 640pp. 5⅜ x 8½. 25509-3 Pa. $14.95

THE STORY OF THE TITANIC AS TOLD BY ITS SURVIVORS, Jack Winocour (ed.). What it was really like. Panic, despair, shocking inefficiency, and a little heroism. More thrilling than any fictional account. 26 illustrations. 320pp. 5⅜ x 8½. 20610-6 Pa. $8.95

FAIRY AND FOLK TALES OF THE IRISH PEASANTRY, William Butler Yeats (ed.). Treasury of 64 tales from the twilight world of Celtic myth and legend: "The Soul Cages," "The Kildare Pooka," "King O'Toole and his Goose," many more. Introduction and Notes by W. B. Yeats. 352pp. 5⅜ x 8½. 26941-8 Pa. $8.95

BUDDHIST MAHAYANA TEXTS, E. B. Cowell and Others (eds.). Superb, accurate translations of basic documents in Mahayana Buddhism, highly important in history of religions. The Buddha-karita of Asvaghosha, Larger Sukhavativyuha, more. 448pp. 5⅜ x 8½. 25552-2 Pa. $12.95

ONE TWO THREE . . . INFINITY: Facts and Speculations of Science, George Gamow. Great physicist's fascinating, readable overview of contemporary science: number theory, relativity, fourth dimension, entropy, genes, atomic structure, much more. 128 illustrations. Index. 352pp. 5⅜ x 8½. 25664-2 Pa. $8.95

EXPERIMENTATION AND MEASUREMENT, W. J. Youden. Introductory manual explains laws of measurement in simple terms and offers tips for achieving accuracy and minimizing errors. Mathematics of measurement, use of instruments, experimenting with machines. 1994 edition. Foreword. Preface. Introduction. Epilogue. Selected Readings. Glossary. Index. Tables and figures. 128pp. 5³⁄₈ x 8¹⁄₂. 40451-X Pa. $6.95

DALÍ ON MODERN ART: The Cuckolds of Antiquated Modern Art, Salvador Dalí. Influential painter skewers modern art and its practitioners. Outrageous evaluations of Picasso, Cézanne, Turner, more. 15 renderings of paintings discussed. 44 calligraphic decorations by Dalí. 96pp. 5⅜ x 8½. (USO) 29220-7 Pa. $5.95

ANTIQUE PLAYING CARDS: A Pictorial History, Henry René D'Allemagne. Over 900 elaborate, decorative images from rare playing cards (14th–20th centuries): Bacchus, death, dancing dogs, hunting scenes, royal coats of arms, players cheating, much more. 96pp. 9¼ x 12¼. 29265-7 Pa. $12.95

MAKING FURNITURE MASTERPIECES: 30 Projects with Measured Drawings, Franklin H. Gottshall. Step-by-step instructions, illustrations for constructing handsome, useful pieces, among them a Sheraton desk, Chippendale chair, Spanish desk, Queen Anne table and a William and Mary dressing mirror. 224pp. 8¼ x 11¼. 29338-6 Pa. $13.95

THE FOSSIL BOOK: A Record of Prehistoric Life, Patricia V. Rich et al. Profusely illustrated definitive guide covers everything from single-celled organisms and dinosaurs to birds and mammals and the interplay between climate and man. Over 1,500 illustrations. 760pp. 7½ x 10¼. 29371-8 Pa. $29.95

Prices subject to change without notice.

Available at your book dealer or write for free catalog to Dept. GI, Dover Publications, Inc., 31 East 2nd St., Mineola, N.Y. 11501. Dover publishes more than 500 books each year on science, elementary and advanced mathematics, biology, music, art, literary history, social sciences and other areas.